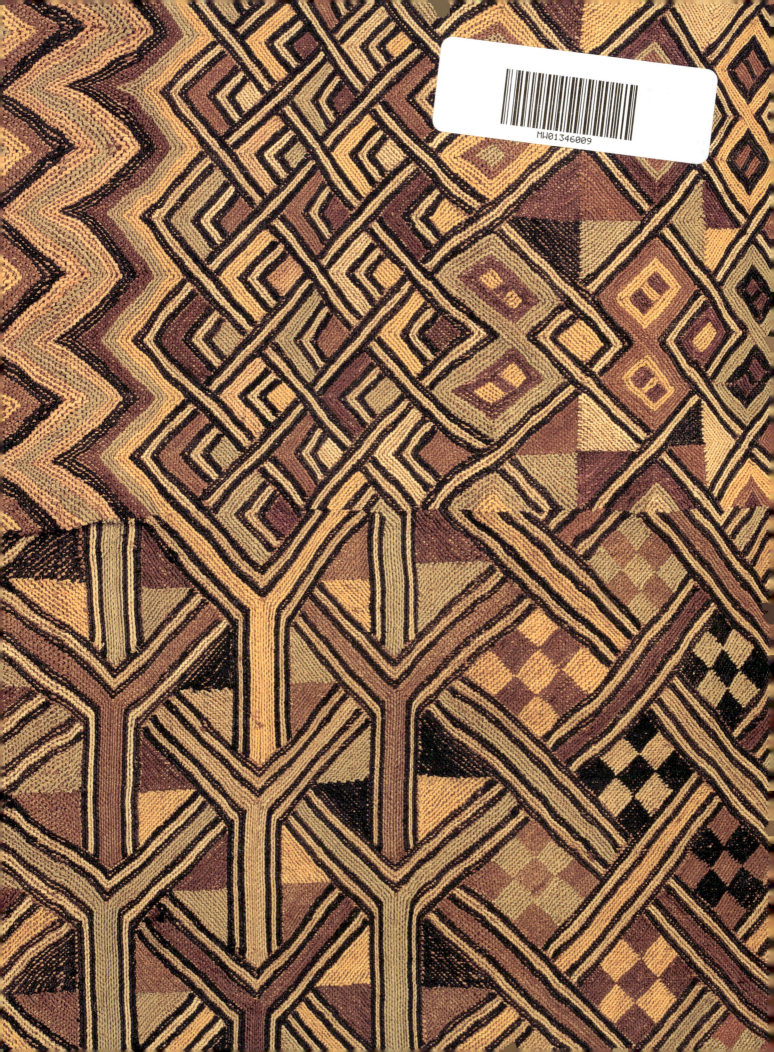

# Textile Art of the BAKUBA

*Velvet Embroideries in Raffia*

Sam Hilu and Irwin Hersey

Schiffer Publishing Ltd
4880 Lower Valley Road, Atglen, PA 19310 USA

Copyright © 2003 by Sam Hilu
Library of Congress Control Number: 2002112425

All rights reserved. No part of this work may be reproduced or used in any form or by any means—graphic, electronic, or mechanical, including photocopying or information storage and retrieval systems—without written permission from the copyright holder.
"Schiffer," "Schiffer Publishing Ltd. & Design," and the "Design of pen and ink well" are registered trademarks of Schiffer Publishing Ltd.

Designed by Bonnie M. Hensley
Cover design by Bruce M. Waters
Type set in Rage Italic LET/Aldine 721 Lt BT

ISBN: 0-7643-1685-0
Printed in China

Published by Schiffer Publishing Ltd.
4880 Lower Valley Road
Atglen, PA 19310
Phone: (610) 593-1777; Fax: (610) 593-2002
E-mail: Schifferbk@aol.com
Please visit our web site catalog at www.schifferbooks.com
We are always looking for people to write books on new and related subjects. If you have an idea for a book please contact us at the above address.

This book may be purchased from the publisher. Include $3.95 for shipping. Please try your bookstore first. You may write for a free catalog.

In Europe, Schiffer books are distributed by
Bushwood Books
6 Marksbury Ave.
Kew Gardens
Surrey TW9 4JF England
Phone: 44 (0) 20 8392-8585; Fax: 44 (0) 20 8392-9876
E-mail: Bushwd@aol.com
Free postage in the U.K., Europe; air mail at cost.

## Dedication

To the anonymous artisans that made these magical textiles, this book is dedicated with the greatest degree of respect, admiration, and appreciation.

# *Foreword*

Raffia mats are offered for sale in a bazaar in New York City.

My first exposure to the fascinating hand-woven sisal-raffia textile weavings of the Bakuba Tribal Confederation was in 1965, at a sale of Tribal Arts held at the old Parke-Bernet auction house in New York City.
I attended this auction with my dear friend of forty years, Mr. Irwin Hersey, co-author of this book, and an internationally recognized authority on Tribal Arts. His vast knowledge and expertise has been of inestimable help to many collectors, museums, and myself in particular.
At this auction — in and among the various masks, statues, and other fascinating objects that were being offered for sale — I came across a group of six striking sisal-raffia weavings that had dazzling abstract "Op-Art" embroidered motifs covering their surface. Four of these had a somewhat velvety feeling to them and were approximately 25" x 23" in size. The remaining two were approximately fourteen feet long and two-feet wide. I looked them-up in the auction catalogue and they were described as raffia-sisal weavings of the Bakuba Tribal Confederation of the Congo, Central Africa. The four smaller pieces were described as *Velours de Kasai* (Kasai velvets). Their presale estimates were from $500 to $700. The two long ones had wonderful patch appliqués on them that had an incredible look of modern art; the presale estimates on them were $1,500 to $2,000. All of

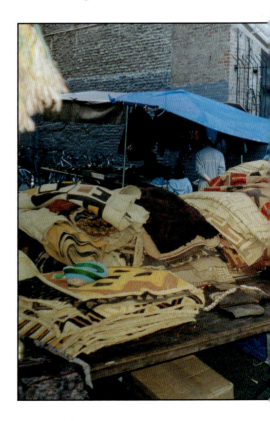

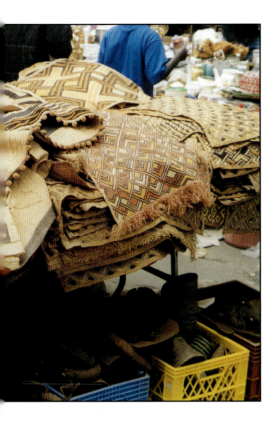

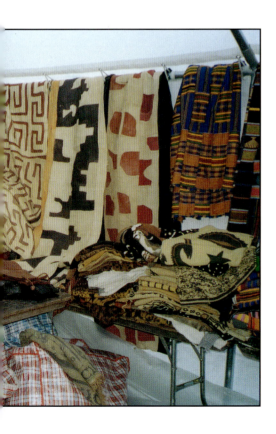

these were from the estate of a Parisian artist who had acquired them from various art-dealers in Paris and Brussels after World War I. At the actual auction sale the smaller ones realized from $700 to $900 and the longer ones brought $2,500 to $3,000 each, and the bidding was spirited. Their great graphic qualities, along with the boldness of their abstract designs, and the use of a sisal-raffia fiber as an art medium fascinated me and I became a collector of them from that time onwards.

Afterwards I was on the lookout for these textiles. With the help of Irwin Hersey, I was able to acquire them, off and on, in Europe and from various dealers and auctions houses, paying on average $150 to $250 for the smaller ones; and from $700 to $900 for the longer ones. I judged them by their design impact; the craftsmanship involved in their stitching; their condition; their design symmetry and intricacy; and their age, while searching for the best possible price.

These textiles were not easily found until the Congo erupted in inter-tribal clashes in the 1960s, when tens of thousands refugees were displaced by the fighting. Thousands of these textiles — in all sizes and ranges of workmanship — soon found their way to Europe and the United States. African runners and traders funneled them to collectors and dealers. They could be found at flea-markets at any price, offered for negotiable prices ranging from $50 to $500 each for the smaller ones and $500 to $1,000 for the longer ones. I must have gone through ten-thousand or more during the past thirty-five years, to come-up with the ones in this book. If I were to put a value on the cloths displayed here, I would assign an average value of about $400 to the smaller ones and $1,500 for the larger-ones.

How does one evaluate these fascinating textiles? For myself, I judge them from a westernized point of view based entirely on their initial design impact. The fact that they are still available in all ranges of workmanship and value makes them wonderful, inexpensive, works of art that can be hung and admired by the owner, and appreciated by art collectors and designers everywhere.

Sam Hilu
New York City

# Introduction

## Origins of the Cloth

There can be little question that, of all the textiles produced by the native peoples of Africa, the so-called "Kasai velvet" cut-pile cloths of the related Kuba tribes of the Kasai District of what is today the Democratic Republic of the Congo (formerly Zaire) in Central Africa are the most important. They have long been the most sought after, the most valued, the most studied, and the most collected.

Kuba mythology teaches that these well-known fabrics originated with one of their great ancestor figures, variously thought to be either King Shamba Bolongongo (1600-1620) or a king's son named Shaamweky. The earliest cloths of this kind to be found in European museums were acquired in Guinea and apparently originated in Angola, strongly suggesting a non-Kuba origin.

Emil Torday, the great early Kuba ethnographer who explored this part of Africa in the early 1900s, suggested that Shyaam (another name for Shamba Bolongongo), the ancestor king who the Kuba credit with creating civilization and formulating all Kuba culture, introduced raffia cloth from the Pende, another Congo tribe. Meanwhile, Kuba tradition tells us that the invention of polychrome or multi-colored textiles can be ascribed to the wife of Shyaam.

To say that these cloths are made by the Kuba is a misnomer, since "Kuba" happens to be a Luba word, and the Kuba peoples usually refer to themselves either as Bushoong or use another of their sixteen specific tribal names, which include, in addition to Bushoong, the Bieeng, Bokila, Buleng, Ilebo, Kaam, Kayuweeng, Kel, Kete, Maluk, Mbeengi, Ngeende, Ngomba, Ngongo, Pyaang and Shoowa. However, since textiles of this type have long been referred to and have become known as "Kuba cloths," we will continue to use this term here.

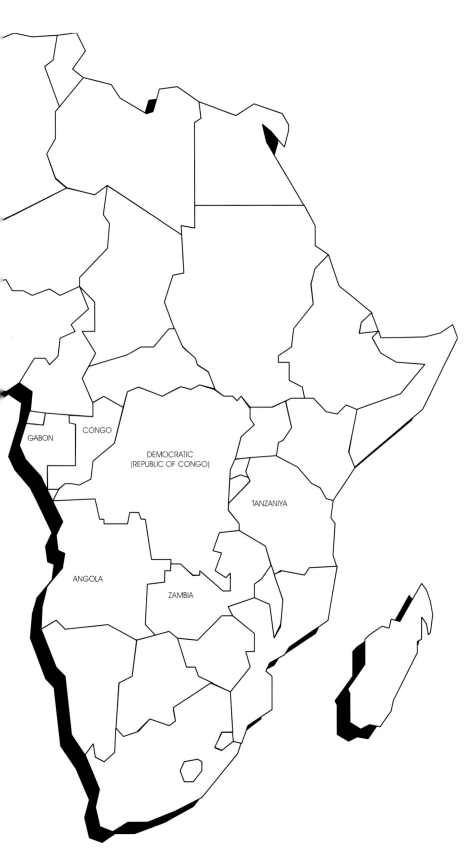

A raffia cloth in the Museum at Ulm, Germany, is perhaps the earliest such textile to reach Europe. It is mentioned in the Museum's Catalogue of 1659. Very shortly thereafter, between 1666 and 1674, the Danish National Museum in Copenhagen accessioned some twenty cut-pile textiles. Others, usually referred to as "Congolese," and also dating to the seventeenth century and probably originally part of the Danish collection, are today in the Swedish Royal Armory in Stockholm.

Georges Meurant, the Belgian artist-scholar who wrote a monumental and definitive study of Kuba textiles entitled *Shoowa Design* (Thames & Hudson, London, 1986), tells us that some watercolors painted in 1666 and now in the Oriental Library in Modena, Italy, show similar cut-pile textiles, which reportedly came from either Angola or the Congo.

European collectors of African objects began to amass collections of cut-pile textiles acquired in the Congo beginning in the middle of the nineteenth century, although a few must have been included in Portuguese Cabinets of Curiosities perhaps as early as the sixteenth century.

Meurant notes that the nineteenth century examples were apparently produced using many of the same techniques as those employed in weaving the very oldest pieces, while others combine continuous as well as cut-pile embroidery. However, all have the same rectilinear geometric patterns as those found in seventeenth century examples.

As might be expected, Kuba textiles have long been admired in artistic circles, and several large collections were formed in the first half of the present century. In addition, there has been a major revival of interest in collecting Kuba cloths in recent years.

There has been considerable speculation down through the years over exactly how many Kuba cut-pile textiles have actually been produced in the last four centuries. A clue may be found in the fact that, early in the seventeenth century, it was reported by a visiting traveler that some 12,000 to 15,000 high-quality pieces and as many as 40,000 to 50,000 pieces of medium quality were being produced each year.

This probably represented the total number of cloths made in the region. These were quickly bought up by the Portuguese and brought to Loango, at that time the capital city of the Kongo Kingdom and a major trading center for export and exchange with Angola for slaves.

In 1670, the Dutch explorer Otto Dapper reported that Loango was exporting raffia textiles with geometric designs among other products. Dapper tells us that these fabrics were unknotted, very tightly woven embroideries, with tufts of fine hair threaded between the warp and weft to form complex rectilinear designs.

The Portuguese reached the mouth of the Congo River late in the fifteenth century, and from that point on built a colonial empire along the coast of Equatorial Africa by establishing relations with several of the Bantu Kingdoms in the areas both north and south of the river mouth and several hundred kilometers inland. At that time, the Kuba constituted one of these Bantu Kingdoms.

Meurant tells us that the coastal populations and the people of the Kongo Kingdom, another of the Bantu Kingdoms, used the embroidered textiles as a form of currency in their extensive trading activities.

Even in those days, such textiles were prestige cloths, used as garments as well as shrouds for the dead by the King and his family, the wellborn, and the wealthy. It also appears that, by the end of the seventeenth century, the many Catholic missionaries in the area were using the textiles as church vestments.

All this ended, however, with the collapse of the Kongo Kingdom at end of the seventeenth century, and today no

traces of cut-pile embroideries of any kind exist in the coastal areas of the former Kongo territories. In modern times, all such cloths seem to have originated among the Kuba peoples.

It would be remiss at this point not to mention another important kind of embroidered textile produced by the Kuba, the women's skirts usually known as Nchak. These long loincloths range in length from twelve to as much as thirty feet or more, and twenty to forty inches in width. They are often reserved for important women's ritual dances or other ceremonial purposes. Treasured by their owners, they are often kept for generations.

These skirts are made up of a large number of small rectangular panels, often without borders, which are covered with small embroidered pieces seemingly sewed on aimlessly but actually artistically arranged so as to form distinctive patterns against the background fabric.

The origins of these cloths are lost in antiquity, although it has often been suggested that the odd-shaped embroidered patches began as repairs made to treasured old skirts which had been ripped or torn, and only later began to be organized into distinctive patterns. In modern Nchak, the embroidered pieces are almost always arranged to form over-all patterns.

These two distinctive types of fabrics have exercised such a strong fascination over other native Africans that in the past the Kuba were actually often called "Bambala," which can be understood to mean "people of the cloth."

An old Dogon adage goes: "To be naked is to be silent." In a recent book Berenice Geoffrey-Schneiter, musing on this adage, noted that in cultures where writing has not developed, signs and symbols multiply. They show up everywhere — on sacred and secular objects, on the walls of ordinary houses and palaces, on human bodies, and, of course, on the fabrics that cover those bodies.

The Kuba Kingdom, created in the Kansai area in the seventeenth century, to this day produces cut-pile textiles and Nchak embroidered cloths, although in recent years they have declined considerably in workmanship as well as design, while fine old examples have become difficult to find and quite expensive.

Nevertheless, in this area even today the Kuba still reign supreme.

# Kasai Velvet Cut-Pile Cloths

In tracing the history of the Kasai Velvet cut-pile fabrics of the Kuba, Georges Meurant points out that among the various Kuba tribes, the Bieeng do not make cut-pile embroideries; the Ngombe and the Ngongo produce a punctiform cut-pile fabric with individual tufts resembling dots; and that it is actually the Shoowa who have produced the largest body of Kuba geometric design work. In addition, it is the Shoowa who developed dense cut-pile fabrics punctuated by continuous embroidery, a style that soon spread throughout the area.

Meurant indicates that a comparison of seventeenth century cut-pile fabrics with the mats, engravings, and tattoos from the former Kongo territories as well as from the Kuba reveals "a common geometric rectilinear imagery, using right angles or oblique angles, or filling horizontal or vertical partitions in the fabric with oblique compositions."

Although he regards the similarity between such designs and designs found in twelfth and thirteenth century European embroidered liturgical vestments or medieval heraldic patterns as being "too blatant for it to be merely coincidence," and believes the Kuba borrowed these designs, on this point at least the decision must be "not proven." Although such a similarity does indeed exist, there is nothing concrete from the art-historical standpoint to suggest that similar European and African designs were not arrived at independently.

The use of repetitive or discontinuous rectilinear designs arranged in cyclical patterns appears to go back as far as the Neolithic Era. With the passage of time, the rectilinear designs gradually turned into spirals, meanders, circles, and half-circles.

It must be remembered that luxury Kuba objects of all sorts have long been ornamented — many would say over-ornamented — with decorative patterns. Kuba expert Jan Vansina tells us in *Children of Woot* (University of Wisconsin Press, Madison, WI, 1978) that two different types of motifs exist. One, used in scarification patterns on women, on ceremonial drinking horns, and on certain types of cloth like Nchak, consists of isolated motifs more or less juxtaposed according to the fancy of the artist. The other, used in decorating all other types of objects, consists of geometric motifs made up of either angular or flowing lines.

Vansina says that some two hundred patterns of this second type can be recognized (although this would appear to be an underestimate), and adds that this category is considerably more dynamic than the first. He also points out that throughout Kuba history it has been regarded as a considerable achievement to invent a new pattern.

Every Kuba king had to create a new pattern either at the beginning of his reign or, in the case of certain kings, on the occasion of the carving of the dynastic statue made to mark his reign. Some patterns are named after their inventors, and some inventors of new patterns are women.

In his discussion of how new patterns come about, Vansina recalls an old anecdote which relates that, when missionaries showed the then Kuba King the first motorcycle he ever saw in the 1920s, he exhibited little curiosity about the vehicle itself but instead was enthralled by the novel patterns it made in the sand. He later had the pattern copied and then gave the new pattern his name.

Not only did every pattern have a name, but many had more than one name because patterns were sometimes called different things in different parts of the country. Variant names occasionally referred to natural objects or beings, such as "the folds of the python," rather than the name of its inventor. Vansina notes that the evidence suggests considerable dynamics among textile patterns.

This is borne out in a study of Kuba artistic geometry, which suggests that artists achieved a very high percentage of all the possible permutations of simple patterns. Donald Crowe, who produced the study, believes that most patterns of the second type are taken from weaving patterns or perhaps from plaiting, as in basketry or mat making. He also suggests that decorations found on the rims of pottery may also have been a source of inspiration.

Among the patterns of the first kind are stylized human, animal, plant, and object shapes. Vansina tells us that he found one textile in which such patterns were used as a kind of puzzle or rebus — almost like the beginning of a pictographic script. However, he adds that this was almost unique in his experience.

He believes such patterns were not supposed to be either used or "read" in earlier times, although he adds that some meaning may well have been attached to this type of juxtaposition of different motifs in the fabric.

Fancy textiles have long differentiated social status and class among the Kuba. The first such cloths may well have been among the luxury imports to Kuba country from beyond the Kwilu River in the early seventeenth century. Vansina notes that "the appreciation shown for innovation in artistic matters is also best explained by linking it to social prestige."

He goes on to say that while, as far as we know, no special patterns were reserved for certain ranks, rank was unquestionably measured by the novelty of the patterns one wore, the skill in their execution, and particularly the amount of labor expended in making them. Thus, unusual new designs that required a considerable expenditure of labor made such textiles favored possessions of the upper classes.

Tracing the origins of these cut-pile fabrics is far from an easy matter. Throughout Kuba history, raffia cut-pile cloths have been highly regarded, often serving as part of the tribute paid to the king once a year by villages under his reign. As late as the 1950s, Vansina tells us, one village was asked for one raffia cloth for every adult male in the village. In addition, there was also special tribute from time to time when there was a need for special products like decorative mats at the palace.

It is believed that it was the Kete who were responsible for the cultivation of the raffia palm in Kuba country. The palm flourishes in the grassland environment in which the Kuba settled. Throughout their history, the Kuba used raffia squares (or Mbal) as a local currency, and Kuba cloths constituted a major Kuba trade item from the seventeenth to the nineteenth centuries, with the "Mbal" term recognized over a large portion of the western half of the southern savanna.

While ivory was crucial to Kuba long-distance trade, luxury goods like velvet cloth, embroidered cloth, and clothing were the most important products traded to regional and local networks. Raffia squares served as the standard of value and often may have been used as currency.

Why were Kuba textiles so highly thought of and so sought after in other parts of Africa? The answer is that they were simply better than other African fabrics. Not only were they decorated with a multitude of different patterns, but the variety of the embroidery, the suppleness of the cloth, and the quality of the finish, especially that of the velvet-like cloth, was remarkable, and unknown elsewhere in Africa.

Interestingly enough, Vansina points out that Kuba cloth is not as tightly woven as the cloth of their neighbors, the Leele, for example, who make the tightest woven textiles in all of Central Africa. However, Kuba cloth is more supple and, because of its cut-pile finish, can be made to look more shiny. Among the Kuba, new cloth was soaked and beaten to give it a more silk-like finish much appreciated in the area.

Vansina agrees that, while the technical development of such cloth may have been entirely local, the creation of a velvety cloth characterized by raised and dyed geometrical patterns is not. Dyeing by staining thread or the whole cloth with red camwood powder is regarded as the oldest form of such textiles, but the use of black, yellow, and later a bluish color is due to the invention of a number of local techniques.

"The techniques for producing the pile, some embroidery techniques, and at least the idea for polychrome textiles,"

Vansina adds, "came from the Kwilu area, as tradition asserts by ascribing these inventions to Shyaam's wife."

Raffia textiles from Kongo were mentioned as early as 1508, which means that they were already being produced when the Portuguese arrived in this part of Africa. By 1583, Duarte Lopes tells us that they were being made in the lower Wamba-Kwango area.

This early area of production corresponds to the region of Okanga. Interestingly enough, Duarte Lopes tells us that one of the names for a variety of cloths was "Enzaka," which Vansina believes is probably the origin of the Bushoong word "Nchak," or women's skirt. He also believes that samples of this type of cloth may have reached the Kuba as far back as the time of Shyaam.

In any case, he is convinced that the techniques came from the Wamba-Kwango area and reached the Kuba as early as the seventeenth or possibly the early eighteenth century. He notes that the seventeenth century examples of raffia cloth now in museums in Ulm, Copenhagen, and London, which originated in the Wamba-Kwango region, are similar to Kuba velvet-type cloth in patterns of decoration. In addition, a 1971 study of Kongo cloth indicates that the techniques used to make them were almost identical, further bearing out the idea that Kuba cloth-making techniques originated in the Kongo region. Interestingly enough, when Torday was in Kuba country early in the last century he found embroidered cloth only among the Bushoong.

Kuba embroidered textiles do reflect a European technique called Richelieu embroidery, a favorite of the Italian clergy in the seventeenth century. Italian missionaries probably had vestments made using this technique in Kongo, and it is possible that the Kuba borrowed the technique for their own textiles. However, Vansina points out that the Kuba may very well have developed the technique independently, adding that "the linguistic evidence favors borrowing (the technique) because we know that the word 'Nchak' is a loan-word from the Kikongo language."

As noted earlier, the Kuba have long been renowned for vast amounts of decoration lavished on virtually everything they saw, utilized, or wore. Their buildings were decorated; their figural sculptures and masks were decorated; their beautifully made baskets, mats, boxes, and other household objects were decorated; and their own bodies and clothing were decorated, all in the same type of rectilinear geometric designs.

If ever a culture could be singled out for believing that more is better, that culture would have to be the Kuba, who have become notorious for their *horror vacui*. Almost every inch on every surface is decorated, often with designs so dense that the background surface is all but obliterated. As one commentator has observed, it is almost as though the absence of decoration indicated poverty.

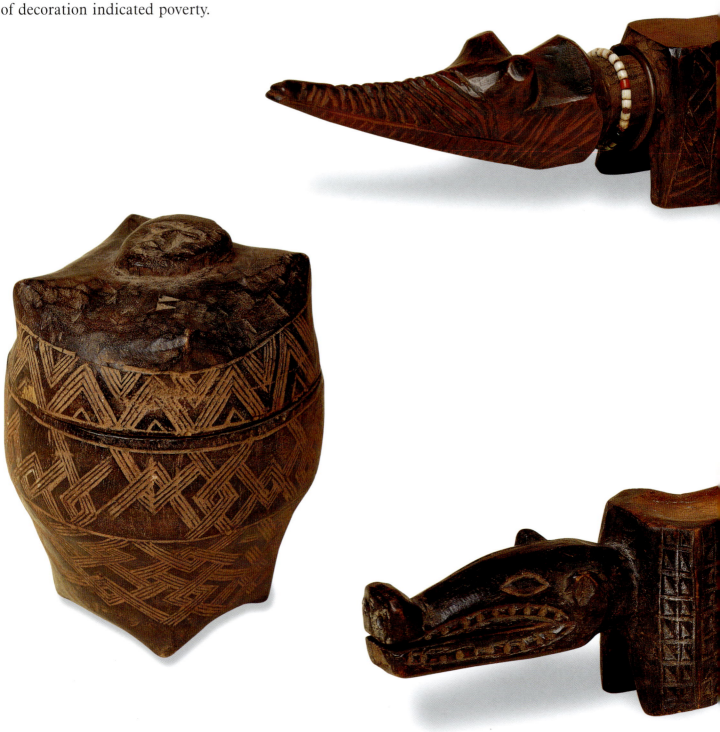

Ceremonial objects illustrate the penchant the Kuba people enjoy for allover decoration. The crocodile figurines were used by shaman for predicting the future. The two vessels are adorned with patterns strikingly similar to those found on raffia embroidered mats.

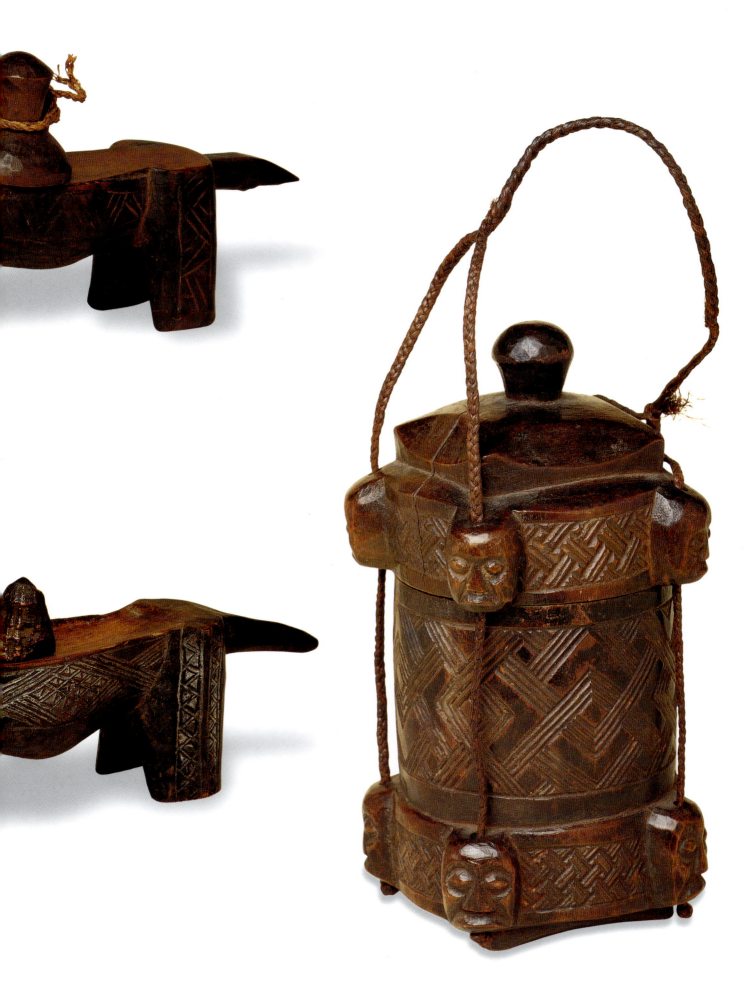

15

Why and how all this decoration evolved is another mystery. Torday believed that the trend toward over-all decoration didn't reach its zenith until the nineteenth century, although he fails to provide us with any reasons why this should be so.

In this regard, Georges Meurant points out that the oldest known Kuba art is representational and made by men, while women created an art that is essentially rectilinear and geometric. Although there was a long period of development and change in both of these art forms, when colonization came and put an end to this dynamic process, abstract design was in full development, while naturalistic expression was petering out.

Meurant believes that one reason for this was that, while other and older Bantu Kingdoms like those of the Luba and Kongo peoples had adopted patrilineal descent of kingship, the Kuba in contrast continued with matrilineal descent, and this is where their mythology differs from that of other cultures.

It is interesting to note that only among the Kuba did a distinctly abstract form of art develop. Abstract art forms remained unimportant in other cultures while naturalistic and representational art flourished.

## Creating the Cloth

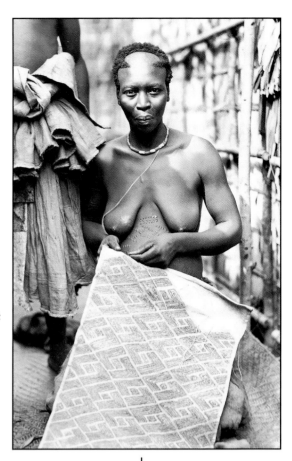

Courtesy of Barbier-Mueller Archives, Barbier-Mueller Museum, Geneva

The Kuba are primarily farmers, and they have developed a society in which everyone plays his or her distinctive role. Meurant notes that many activities are carried out jointly or by either sex, with the division of labor explained partly by biological and partly by cultural considerations. "The result is that a man can not live without a woman," he writes, "and vice versa. There are collective activities in the interest of all."

Textile production is one such activity, or at least one activity in which men and women collaborate. While women cultivate the palms from which the cloths are made, the men gather the fronds, make raffia out of the palm-leaf fibers, and then weave the mats on upright looms. The woven mats are often soaked in water and then beaten to make them soft.

At this point, the women take over. They take the fresh, undecorated mats and use them as a background for the traditional rectilinear patterns worked with palm thread. As a final step, the pile is created by clipping the tufts.

Amazingly enough, the patterns, no matter how complicated, are never actually marked on the mats. Instead, the women keep the designs they are working on in their minds,

anticipating the color changes needed to complete the design. Finally, the finished cloths are often sewed together to make larger pieces or garments.

Not actually marking the mat with a pattern is, of course, one of the most amazing aspects of Kasai velvet cloth production. To those versed in Western art, the very idea that an untrained "primitive" artist is capable of producing a highly complex work entirely out of his or her head, and without any preliminary sketches to work from, and without marking, is almost unbelievable.

In addition to actually producing the cloths, the women

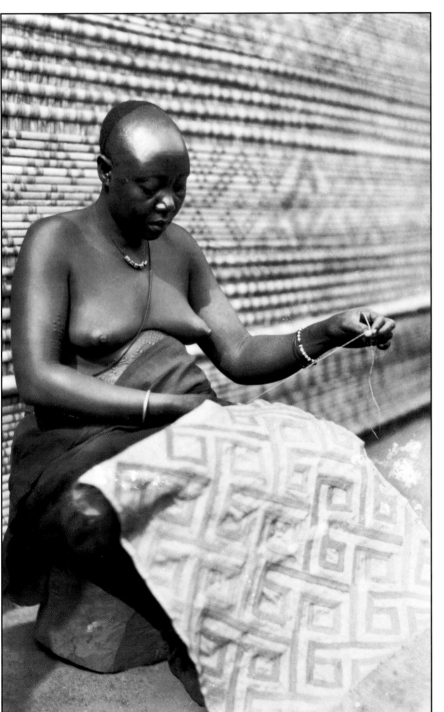

also frequently decorate them further by embroidering them or attaching small shells or bits and pieces of leopard skin, the leopard being the symbol of royalty in Kuba-land. And, of course, it is the women who decorate the Nchak skirts.

It would seem almost useless to try to put into words the many extraordinary designs woven into these Kasai velvet cloths. In this instance there is little question that one photograph is easily worth a thousand words.

The patterns on these cloths are usually based on "broken" geometric forms, with all the elements fitting together to create eye-dazzling patterns. Many involve a running design in which one element is seen to cross over and then under another, with all of it nothing but an illusion created through the skillful mixture of color and design elements.

As Berenice Geoffrey Schneiter wrote in *Tribal Arts* (Vendome Press, New York, 2000), these designs are "remarkable compositions of diamonds and checks which in their abstract geometry and graphic energy are powerfully reminiscent of canvases by Paul Klee."

Other patterns are easily as dazzling as the very best of modern Op Art. It is little wonder, then, that Kasai velvet textiles have long had tremendous appeal for artists, and that many artists have collected them down through the years.

"But this is to reduce to a mere formal exercise," Schneiter continues, "what in fact was more like a whole language of the sacred. Woven by men on upright looms, embroidered collectively by the women, and finally shaved with a knife to achieve the softness of velvet, these fabrics exercise . . . a strong fascination."

She too emphasizes the fact that the very best of these fabrics were hardly made for everyday use, but rather "were destined to accompany the dead as a lavish and elegant accessory on their final journey to the other world."

Meurant notes that, insofar as embroidery is concerned, there is little or no problem in ascertaining in what order a design has been made since the threads are superimposed. (This is not the case with wood sculpture, where it is difficult to tell how a design was created.) The difficulty with Kuba cloth is in knowing where the design began and what steps followed in its execution.

Fortunately, many unfinished embroideries exist, even among the earliest collected examples, and there are even cloths which were worked on later after apparently having been abandoned. Thus it is possible in many instances to figure out the exact order in which the many steps involved in making a cloth were taken.

It should be noted that, when worn as a costume, the design of the textile is seen on its side as compared with what the woman doing the embroidering sees when she is working with the cloth on her knees and filling the surface from left to right and from top to bottom.

The unfinished examples indicate that the lines outlining the design are embroidered first. Then the spaces between them are filled in with cut-pile work as the embroidered figures progressively overlap. The work is slow and laborious but Meurant says "the woman has all the time she needs to elaborate subtle devices so that the cloth is animated in a way that goes beyond the movement of its linear development." And remember that this is all done without any preliminary guidelines for the over-all design.

Meurant reminds us that, of all the Kuba tribes, it is the Shoowa who have been the least studied, with the result that their particular mythology is unknown and, even more impor-

tant, there are few examples of their fine textiles in museum collections. This is unfortunate, because cut-pile embroideries constitute their most important craft. (Of about thirty Shoowa villages, only one produces sculpture.) Their velvets have long been commercially successful in the region and their techniques were used in much Royal Kuba art.

One frequently asked question deals with the origin of the geometric designs found on Kasai velvet cloths. There is no easy answer. Such designs are found in the body scarifications of the Kuba peoples. The men wear a few such designs and the women many more. The ceremonial costumes of both sexes are decorated with designs of this type, sometimes with cut-pile work and sometimes without.

As we have noted, these costumes constitute an expression of wealth. They are used in dowries and as currency, and are also sometimes given in large quantities to the dead during funeral ceremonies. The best examples are quite costly and seldom, if ever, are used for what we might call everyday wear.

For some three hundred years, Kuba male and female garments made of raffia cloth have been worn wrapped around the waist and held up by a belt. Today, this practice is falling into disuse. Garments decorated with intricate designs are still designed for wear at funerals or kept to be given to the dead as grave offerings. The garments, which are made of tightly woven, strong individual pieces sewn together, are rarely larger than sixty to eighty inches long and twenty to twenty-four inches wide.

The man's garment is usually made up of two or occasionally three rectangles or almost square pieces of cloth with two-inch to six-inch borders. The individual pieces are made in two sizes, the rectangular pieces range from 12" x 24" to 20" x 40", and the square ones from 20" x 24" to 36" x 40".

These differences in size are based on the relationship between the size of the upright loom and the size of the person operating the loom. Georges Meurant has supplied us with a detailed description of how the loom is constructed and how it works. He tells us that the loom is a rather simple device in which two posts at an angle of forty-five degrees to one another support a horizontal bar to which a number of raffia-leaf strips are attached to form the warp alternately in front of and behind each of the warp elements. The lowest of these rods is a strong palm-leaf fiber, which acts as the main shed stick.

"Below this is the heddle, a split rod between the two halves on which some rings of palm fiber are fixed, each hold-

ing one of the warp elements. The lower ends of the warp threads are fixed to a bar running between the two posts. The weaver works from the bottom to the top, sitting under the loom.

"The fabrics are unified or animated by a range of symmetrical designs in the weaving, in red or white on a black ground or black on a light ground. . . . The dyed element may be doubled with an undyed thread which, instead of projecting, follows the regular course of the weaving so that a design is achieved which appears to be very evenly embroidered."

According to Meurant, the Bieeng, one of the Kuba tribes, were the first embroiderers, although they were soon supplanted by the Bushoong or the Bambala, the inhabitants of the royal capital.

He adds, however, that one should not confuse the embroidery as practiced by the Bieeng and the Bambala, which has a continuous thread, with cut-pile work consisting of tufts that are not continuous or knotted. The Ngongo claim to have originated this type of work.

Meurant tells us that cut-pile fabrics only began to appear in royal Bushoong costumes at the beginning of the nineteenth century, probably because of the popularity of the Shoowa velvets from which the technique was borrowed. At first, borders were made, and later on surfaces decorated with figures in the center panel appeared.

The Ngongo claim to have invented the technique of making cut-pile cloth. The Ngongo called the cloth "Musese" adn "Itondo." This consists of a velvet cloth made up of dots carefully placed so as to create lines, forms, and surfaces.

The surface of Shoowa velvets, on the other hand, is covered with cut-pile decoration in such a manner that the individual tufts are not visible. Shoowa velvets spread everywhere in the area, although only the Shoowa really know how to modulate the thickness of the weave and thus accentuate the surface effects.

The base is a piece of raffia cloth dyed red, orange, yellow, mauve, or violet, depending on the locale in which it is being made. Among the Bushoong, the cloth is not dyed, while textiles destined for royal use are actually lightened in color, since white is the Kuba color of nobility.

Meurant provides us with a complete description of how Shoowa cut-pile fabrics are made. "The thread," he writes, "softened by hand, is very fine because the raffia fibers have been divided by a fine-toothed comb. . . . Several fibers are

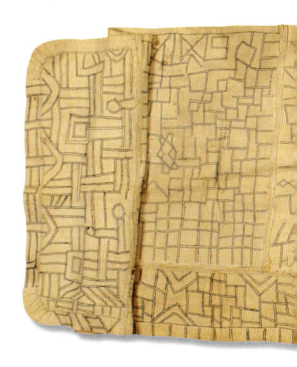

twisted together and then threaded through an iron needle with which the embroiderer catches a weft element and pulls the fiber under it so that the fiber is visible. Then, with a flat knife, she cuts the fiber to the same length as the end on the other side of the weft element. This results in an even tuft of fibers held in the middle without a knot because of the tightness of the weave."

Just how difficult the job of making this type of complicated fabric is can be judged by the fact that Meurant tells us that producing just one high-quality cut-pile velvet piece can take an embroiderer a year or more.

One type of textile made by the Shoowa has polychromed continuous embroidery and cut-pile surfaces. The embroidered line, usually with several other lines alongside it, is either lightened by bleaching the fiber or dyed darker, and it may be colored in shades of red, yellow, blue, violet and, more rarely, green. Originally, all the colors used were vegetable dyes except for green, which was copper oxide. However, beginning in about the 1920s, colors imported from Europe began to be used, and these are dominant today.

Areas of the dyed base left uncovered by the cut-pile tufts frequently become part of the over-all composition as a tonality within the design. It is interesting to note that old garments from a chief's household are often re-dyed a solid color, because the new owner does not have the right to wear white.

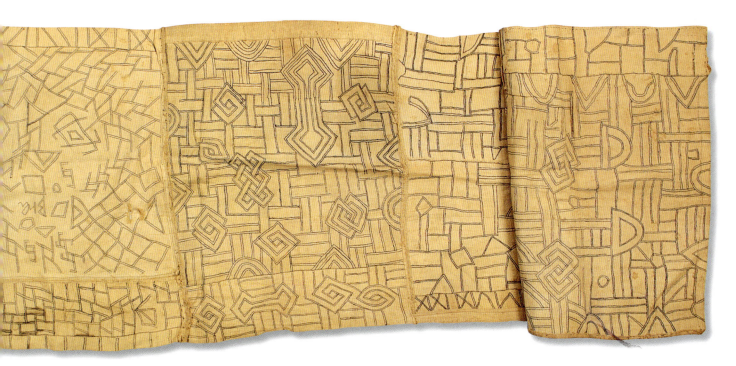

White velvets indicate royalty or position within a tribe, as in this ceremonial skirt.

Meurant, as might be expected, has devoted a considerable portion of his study to the designs used in Kasai velvet cloths, and it may be useful here to summarize some of the points he makes in this regard.

The geometric designs on these textiles, he writes, are "composed of horizontals, verticals and diagonals, initially in strips and then superimposed or juxtaposed, their movements (being) reflected in both axis and the strips themselves no longer distinguishable."

There are three different ways to initially partition the surface of the cloth. One is to divide the surface both horizontally and vertically so as to create a compartmented checkerboard pattern. A variant of this consists of many different types of right-angled meanders. Also in this category are the borrowings from basket weaving with implied interlacing. The last two types create right-angled compartments, which can then be partitioned. Meurant believes that the division into regular compartments may have been borrowed from elsewhere, with the construction of crisscross patterns possibly indigenous.

The second kind of partitioning, which is ages old, "brings together diagonal structures, chevrons, angled lines, nested strips and angles to create triangles that are sometimes drawn in contrasting shades or enlivened by further partition. When the triangle-generating strips are set symmetrically opposite one another, they form what is virtually an oblique crisscross. By widening interlocking chevrons of the strips made up of alternating diagonals, and juxtaposing strips which may have lost their distinctness, other surfaces are created which may be enlivened by contrasting shades or further partitioning."

The third method brings together oblique patterns so that they face each other either horizontally and/or vertically. Some of the motifs used here include complicated chevrons which, when brought together, produce hexagonal fields which can be further partitioned. Octagonal compartments can be formed by arranging strips, which may be out of line and form three-part structures.

This first partitioning of the cloth surface avoids the crossing problem, which is handled in the second tier of partitioning. The basic feature of the motifs in this second partitioning is the use of diagonals to create the proper conditions for crossing and interlacing. In addition, the compartments themselves may be further decorated through the use of interlock-

ing chevrons, which may be either linear or made of contrasting surfaces.

There are three basic processes for partitioning compartments and inserting new motifs, largely drawn from scarification patterns. Meurant refers to these processes as (1) exploratory, which starts from a variable number of parallel diagonals with one compartment reflecting the next in both axes; (2) analytical, which is based on a diagonal running in a symmetrically opposite direction from one compartment to the next, with alternately contrasting parts; and (3) synthetic, which starts with a simple diagonal theme which is repeated and symmetrically echoed in both axes.

In a further stage, a structure is provided not just for a single compartment but for the entire surface of the fabric, primarily by breaking down the distinction between compartments and freeing the design from the necessity of appearing within a compartment created by the very first partition.

The structure may then be regular or irregular, and explicit or implicit. It now acts as the framework for the addition of numerous motifs derived primarily from such scarification patterns as the crossing, the loop, the double crossing (or Woot), and the cable; the Imbol, or the interlacing of two crossed lines or of a line knotted on itself, and a curvilinear type of Ngongo scarification called Nambi (the bowels); and a complex version of the Woot form and the loop in structural motifs along both axes.

The third partition is an essential characteristic of the embroidery on men's costumes and particularly of Shoowa velvets. It can be carried out either within the existing structures or counter to them. All the surfaces can be decorated with new partitions by following the procedures described above.

Even this brief introduction to Kuba pattern-making will serve to illustrate why so many different designs are found in these cut-pile fabrics and, even more important, why they often become so complicated. The answer is simply that the number of variables which go into producing each and every example is almost infinite.

Today, as Patricia Darish has written in her study of the Kuba, weaving and textile decoration are activities on which less and less time is being spent. Primarily, these arts are now reserved for people confined to their home villages because of their great age or infirmity.

Kasai velvets are still being produced, but in these times they are being made for the most part for the export market rather than for home consumption, and the examples that reach the United States or Europe are only pale copies of what was once so great.

Unfortunately, the very high quality that once marked the very best of Kuba cut-pile fabrics is, all too sadly, rapidly becoming a thing of the past.

## Women's Nchak Dance Skirts

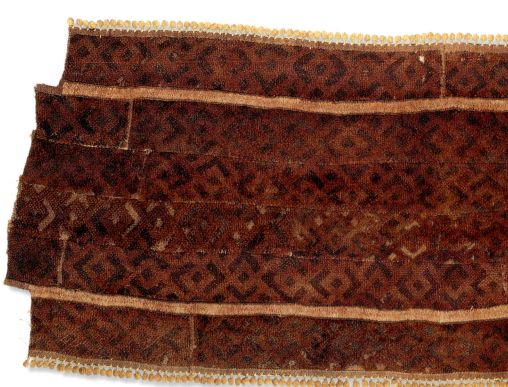

A ceremonial Nchak dance skirt with a fully fringed edge.

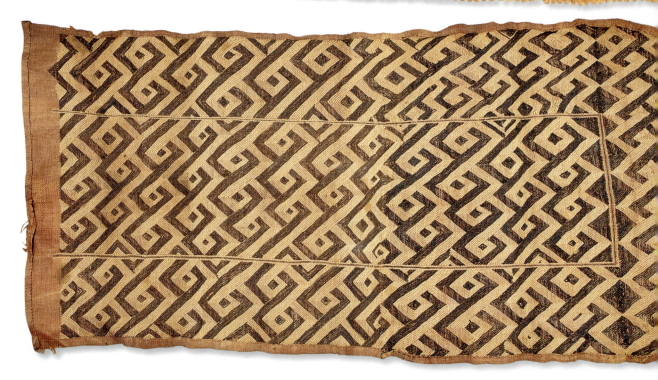

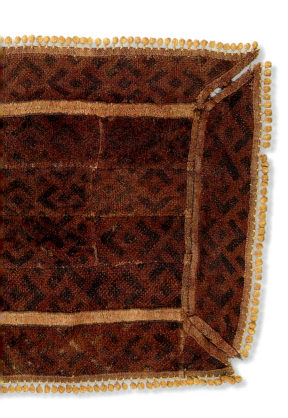

As we have already noted, the Kuba make another unusual textile which, while perhaps not quite as well known as their cut-pile fabrics, also deserves a place of honor in any listing of important African craft items.

These are the large women's skirts, or loincloths, called Nchak, or, to give them their full name, Nchakabwiin — literally, skirts with designs.

These cloths, designed, woven, and embroidered with virtuoso skill by Kuba craftsmen and craftswomen, are perhaps a yard wide and several yards long at their smallest, and usually without any center or borders, although they do occasionally have an undulating embroidered or cut-pile border.

At first glance, Nchak look like nothing more than patched old skirts as they unfurl in what appear to be random sequences of plain and patterned areas. A closer examination, however, soon reveals how carefully they have been constructed and how skillfully the odd-shaped patches and strips have been applied.

As in the case of the cut-pile textiles, here again no gratuitous elements are allowed to creep into the design. Made up of several rectangular strips sewn together, Nchak are not merely coverings for the body, but something more, however prestigious or mundane the occasion on which they are worn.

The Nchak for ordinary day-to-day wear is a white or red garment worn wrapped around the lower body and held at the waist or beneath the breasts by a folded band of cloth or a belt made of twisted multi-strand fiber. Nchak usually consist of two or three raffia panels, each 20-36 inches wide and 24-40 inches long. The panels are embroidered with what appear to be randomly placed patches or strips of cloth.

However, Nchak used by women in ceremonial dances are considerably longer than those used for everyday wear. Thus, Georges Meurant tells us, dance Nchak can consist of as many as six to twelve cloth panels and range from 28-40 inches in width and from 14 feet to as much as 30 feet or more in length.

Like the cut-pile cloths, Nchak also have a long history, the earliest examples known dating to the eighteenth century. It has long been speculated that these early examples actually were nothing more than old skirts which had been ripped or torn through long use and then repaired with patches because the owners simply couldn't bring themselves to throw them away. However, this theory also must be regarded as not proven.

Today, Nchak are made up of square or rectangular pieces of cloth sewn together lengthwise and assembled in such a fashion as to show off the unity of the panels or their lateral movement, which is accented either by the use of alternating panels dyed red or black, or by sewing together panels of different dimensions.

It is not at all rare these days to see Nchak made up of both old and recently made panels. Actually, the quality of the workmanship involved, and particularly the skill with which the patches have been applied and their placement, is usually a good indication of whether a particular skirt is old or not.

As Christiane Falgayrettes-Leveau, Director of the Dapper Museum in Paris, poetically observes in her fine study of African textiles entitled *Au Fil de la Parole* (Editions Dapper, Paris, 1995):

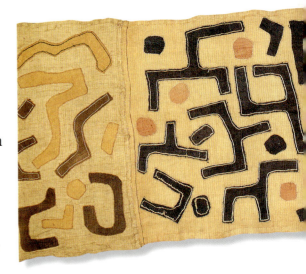

> They appear in these immense palimpsests grid networks, light or dense, but always emerging with the inevitability of after-images. These Nchak are a simultaneous impression of matter, structure and color, as each element applied, whether ochre, yellow, or shades of brown, merges with the background fabric.
>
> "Further, it is charged with the tension of the stitching that fixes it and outlines its contours. At the center of the burgeoning activity there unfurl in fabric against fabric images that spill out over the framework of the fabric in order to refer to signs similar to those found in rock paintings, or in the works of such artists as Klee, Matisse or Chillida, . . ."
>
> "The rhythm is created by innumerable symbols of the infinite. Time, as defined in the woven, concealed, constantly moving space of the Nchak, finds its ultimate justification in the immemorial space of myths."

Fluctuating between chaos and harmony, between the past and re-creation, these immense poems made up of plant fibers have long exerted their fascination over writers and artists such as Braque, Matisse, and Tristan Tzara, who collected them as avidly as the Portuguese had centuries earlier.

Georges Meurant describes Nchak as being made up "of a large number of strips sewed together lengthwise, or of small quadrilaterals, or of quadrilaterals the width of the garment. . . The natural, very closely woven raffia cloth may be bleached or dyed. The costumes (skirts) last a long time and they are often repaired, the tears and worn areas being hidden by patches in

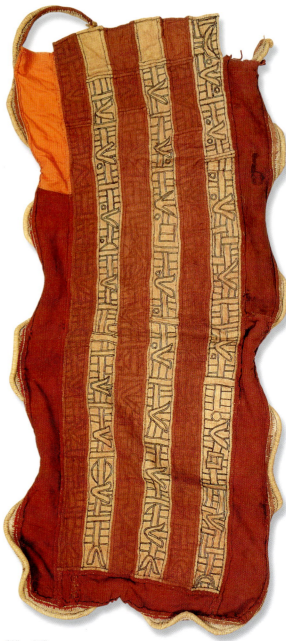

58" x 27"

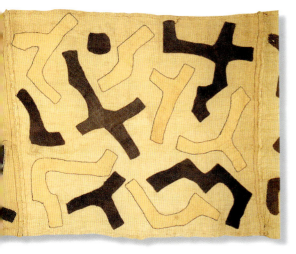

the shape of motifs which then become part of the design."

The designs of the Nchak, like the designs of the cut-pile cloths, range from the simplest to the most complex. Some of the most basic Nchak have only a few simple embroidered patches, often used to hide rips or tears. Another relatively simple design, rather than using patches, utilizes over-stitching on the base fabric to produce an over-all geometric design. Another type of design uses strips of cloth to produce abstract patterns, which look very much like modern abstract paintings.

The Kuba ethnographer Emil Torday credits the Ngeende with the invention of the Nchak, but two other Kuba tribes, the Kel and the Shoowa, employ another embroidery technique which produces designs made up of Greek meander figures. There are also designs incorporating spiral forms, usually squared rather than circular.

Some Ngeende Nchak use a base fabric with woven designs, to which are embroidered small pieces cut from similar textiles or from solid-color cloth. Others utilize small colored patches usually cut from European textiles in which the color blue predominates. These are said to be the oldest pieces, having previously belonged to the Bushoong royal families.

The Bushonng themselves make Nchak using an embroidery technique borrowed from the Ngeende, which utilizes large chevrons tracing orthogonal spaces and groups of small patches. Today, one finds two kinds of simple embroidered Nchak, one red with white designs and the other white with black designs. The Bushoong also use vertical or horizontal structures of hexagonal form and many variations derived from them, including broad forms with a rotary movement.

In addition to their original style, the Ngeende also use an old embroidery technique which has spread to the banks of the Sankuru River and the neighboring Ngongo. Old examples of these baroque embroideries still exist and are recognizable by their rectilinear or half-curvilinear designs made up of meander fragments and cruciform shapes, along with composite figures. From time to time, one finds unusual forms which may belong to a particular embroiderer and could be abstracted from nature. Some panels seem to show dance movement from left to right across the cloth.

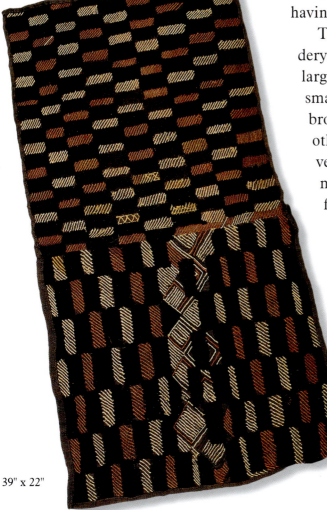

39" x 22"

In general, Nchak designs are primarily rectilinear, except for some dots and some half rectilinear and half curved forms. While actually similar in character to other embroideries, Nchak designs look quite different. It is not at all uncommon to find horizontal/vertical and diagonal structures in the same skirt.

The designs found in Nchak do not appear to be as well organized as in other mediums and on occasion seem not to be organized at all. However, this can be deceptive, since there are unquestionably designs which, to the untrained Western eye, may appear unorganized but which to the Kuba themselves create desired patterns.

Meurant tells us that the vocabulary used in Nchak, i.e., the form of the embroidered patches themselves and their placement, is interpreted in terms of multiple variations. Sometimes the embroideries even appear to be representational in character, although this goes against the very spirit of this kind of design.

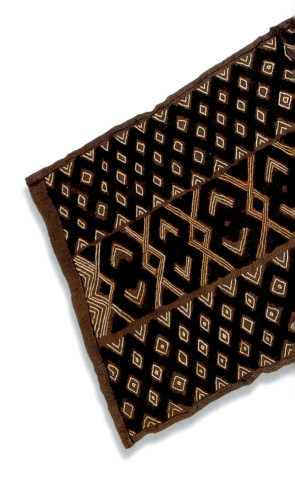

Above all, he points out, the makers of Nchak work on a very large scale and the designs are very quickly executed, again without any preliminary marking on the base fabric. The very different effect of these large surfaces, broadly decorated using different techniques and different devices, means, he notes, that this art must be approached in its own right.

Finally, Meurant adds, one should take note of the unusual designs produced by resist dyeing, with bits of reed and other material sewed to the fabric so that the covered forms remain undyed. Again, such designs are rectilinear or curved, and usually employ very simple forms.

The Ngongo are singled out by Meurant as being the originators of one unusual type of Nchak, which involves the superimposition of fabrics with broad openwork in the shape of certain motifs. One of the fabrics is dyed so that its openwork portions show up in contrast to the other fabrics used in the skirt. Inversions occur from panel to panel.

Meurant has also given us what is probably the best description of the most commonly found type of Nchak, in which some or all of the patches are applied so as to form compositions. In these compositions, he adds, the motifs are of the feminine type found in other mediums, although certain kinds of patches are uniquely found in women's costumes.

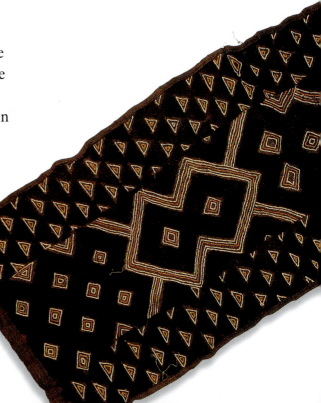

28

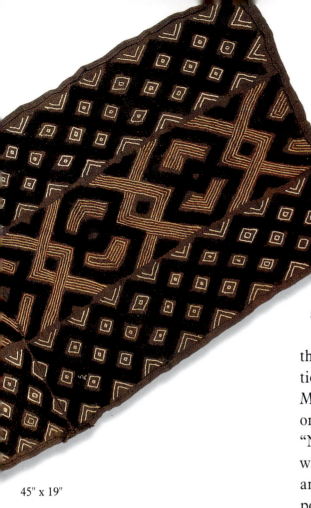

45" x 19"

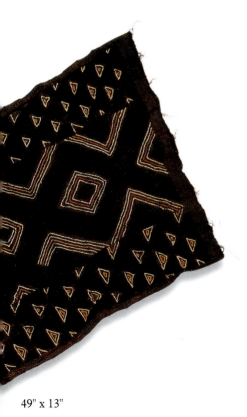

49" x 13"

"Simply embroidered or appliquéd," he goes on, "the figures are arranged in no apparent order or without any order, but related to each other along diagonals, or else the base is covered by a sequence of juxtaposed parallels and partly interlocking parallel lines along both axis, from which scarification figures emerge that are only distinguishable from the ensemble by the signs that they form."

Meurant points out that Bushoong Nchak are often decorated with right-angle and oblique crisscrossing, and sometimes with interlacing, while using a wide variety of figures in no apparent order.

In an essay included in *Au Royaume du Signe*, published by the Dapper Foundation in 1988 on the occasion of an exhibition at the Dapper Museum in Paris, John Mack of the British Museum traces the history of Nchak design and its influence on modern art. He begins by noting that the very word "Nchak" in a general sense merely means a woman's skirt, with various different terms used to differentiate the motifs and the decoration, the color if there is any, and especially the position of the women who have the right to wear such a skirt.

He adds that some skirts designed for everyday wear have the designs concentrated only on that part of the skirt that can be seen by others. However, for the most part the entire skirt is decorated according to an over-all design pattern, with the hidden portions of the skirt no less decorated and no less imposing than the visible part.

Mack points out that Nchak collected recently are distinguished by a multitude of design elements distributed over the entire surface of the skirt in the form of embroidered patches or simple over-stitching of the base fabric. In addition, figurative elements and motifs not typical of Kuba textile design, enliven some of the skirts.

This is an important point, since Mack says that early examples of Nchak now in museums are characterized by their simple and limited design, and there is a vast difference in style and conception between relatively early twentieth century examples and more recently made skirts. In addition, he is convinced that Nchak with over-all surface decoration are a recent development.

In another section of *Au Royaume du Signe*, Christiane Falgayrettes has provided us with a brief history of embroidered textiles through the ages, which concludes with an

examination of how modern artists may have been influenced by Nchak designs over the last century.

She notes, for example, that in certain watercolors by Paul Klee the background is made up of a series of rectangles of different colors aligned in horizontal bands, against which there appears, outlined in black, a person, a floral motif, curving lines, or a square.

The same kind of structural design was used in Nchak, she points out, with the fabric which forms the base made up of seven or eight rectangular panels, often almost square in form and themselves composed of rectangles sewed end to end. To this subtly colored fabric are added different motifs, in the form of either isolated autonomous elements or mixtures of forms that inter-relate with one another.

There is no question that the work of the contemporary Spanish artist Eduardo Chillida was during one period strongly influenced by Nchak designs. In fact, as Ms. Falgayrettes illustrates, there are Chillida paintings that look like nothing less than blow-ups of isolated interwoven Nchak motifs. The paintings are all the more impressive because these enlarged close-ups very clearly show us just how intricate the design of even one tiny portion of an enormous skirt can be.

In view of the long-time interest of modern and contemporary artists in Nchak designs, it is astonishing that to date few if any modern art galleries around the world have exhibited such textiles. It is all the more astonishing if one considers the fact that a number of galleries have for the past few years done a rushing business selling the color-field textiles of Indonesia that are so reminiscent of Mark Rothko paintings.

In view of the Nchak's affinity with so much of contemporary art, and particularly with Abstract Expressionist art, it is difficult to understand why modern art dealers have tended to shy away from Nchak to this point. Broken down into individual panels and framed properly as paintings, they would seem to have an unusually bright future.

Suffice it to say that it would not be at all surprising to see the best of these marvelous artifacts hanging on gallery and museum walls in the not too distant future.

Until such a time, they will continue to attract artists as well as collectors, who still have a chance to own one of the most beautiful, and certainly one of the most unusual, textile forms created by any primitive culture.

Irwin Hersey
New York

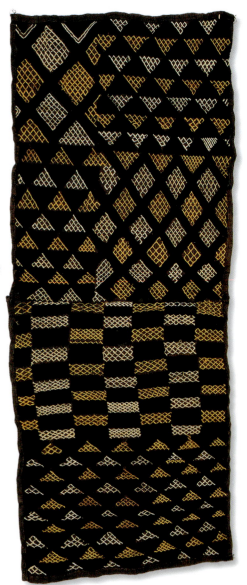

48" x 19"

69" x 29"

44" x 21½"

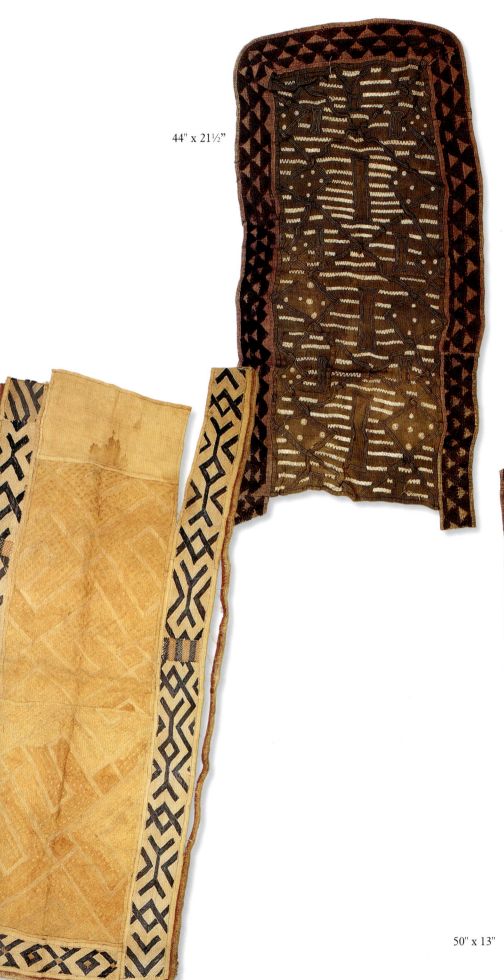

50" x 13"

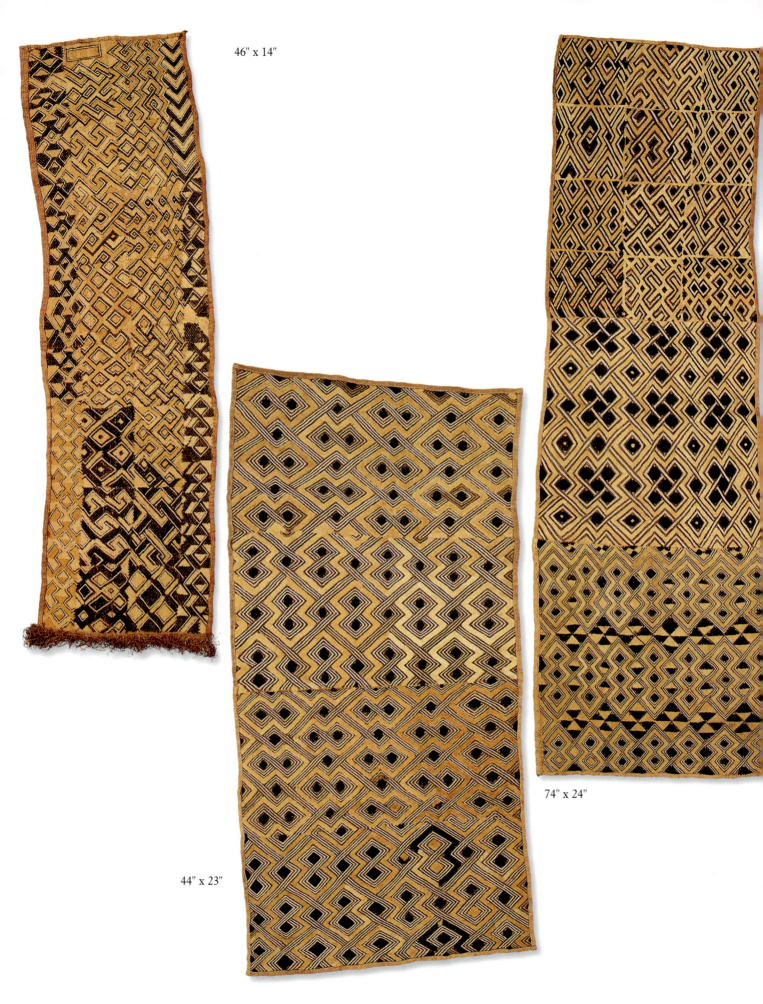

46" x 14"

74" x 24"

44" x 23"

32

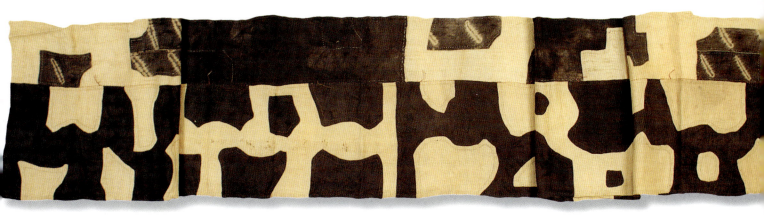

22" x 14'

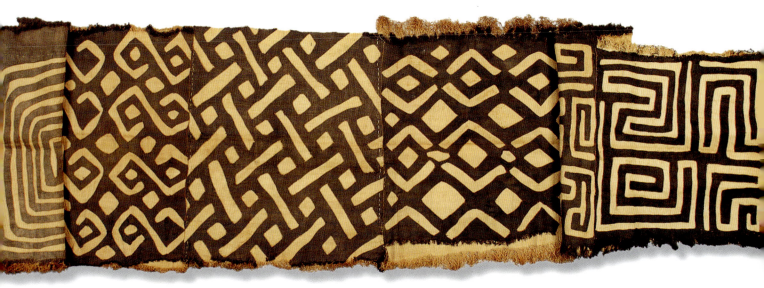

24" x 11'7"

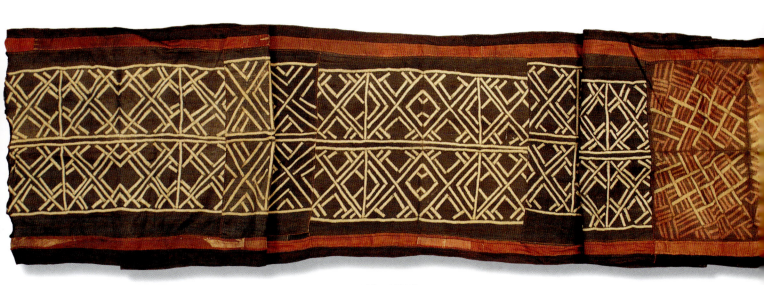

29" x 14'10"

33

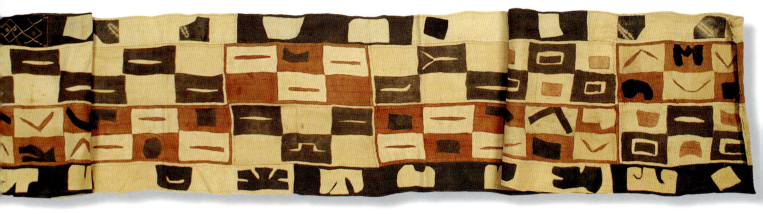

24" x 13'

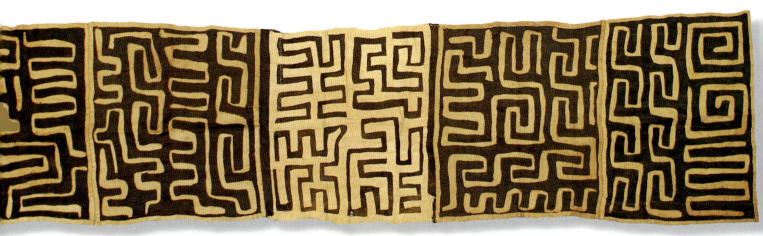

24" x 8'6"

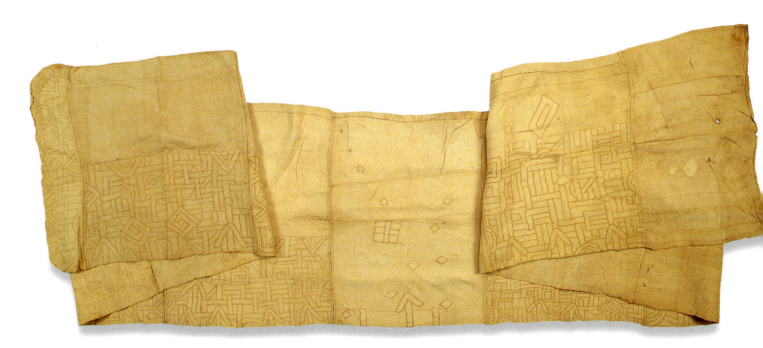

29" x 20'7"

28" x 7'6"

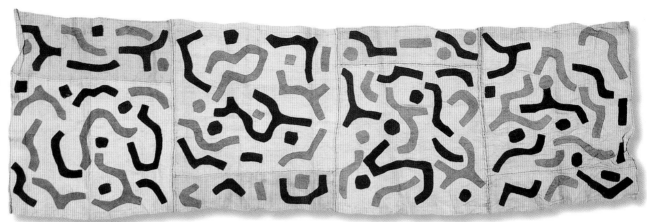

25" x 7'10"

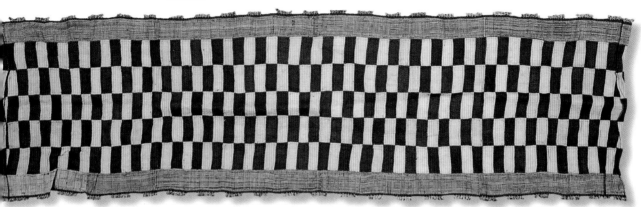

24" x 8'

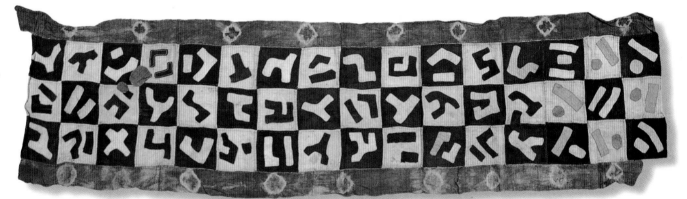

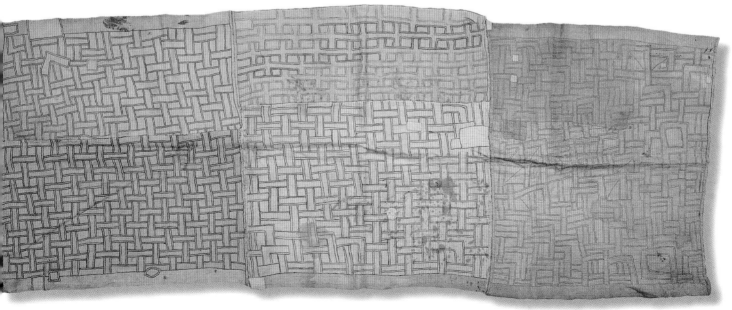

24" x 6'8"

35

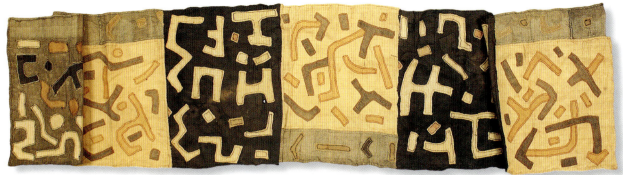

24" x 9'9"

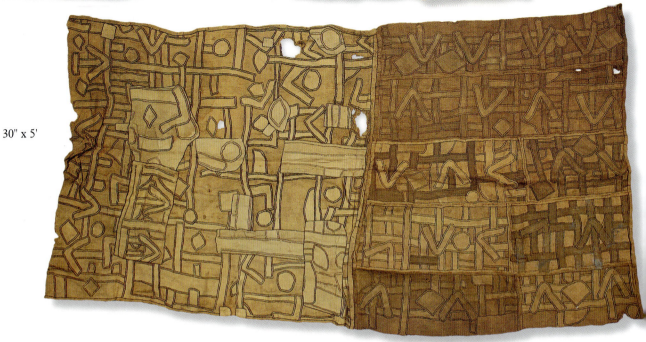

30" x 5'

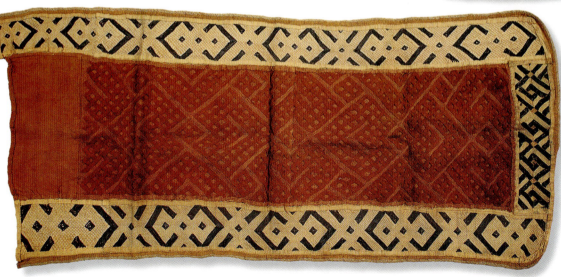

26" x 4'8"

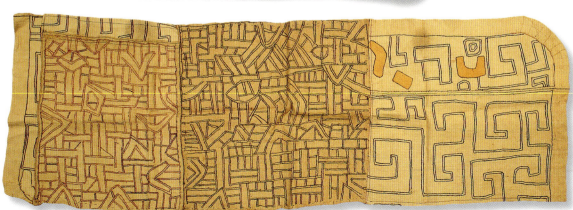

22" x 5'8"

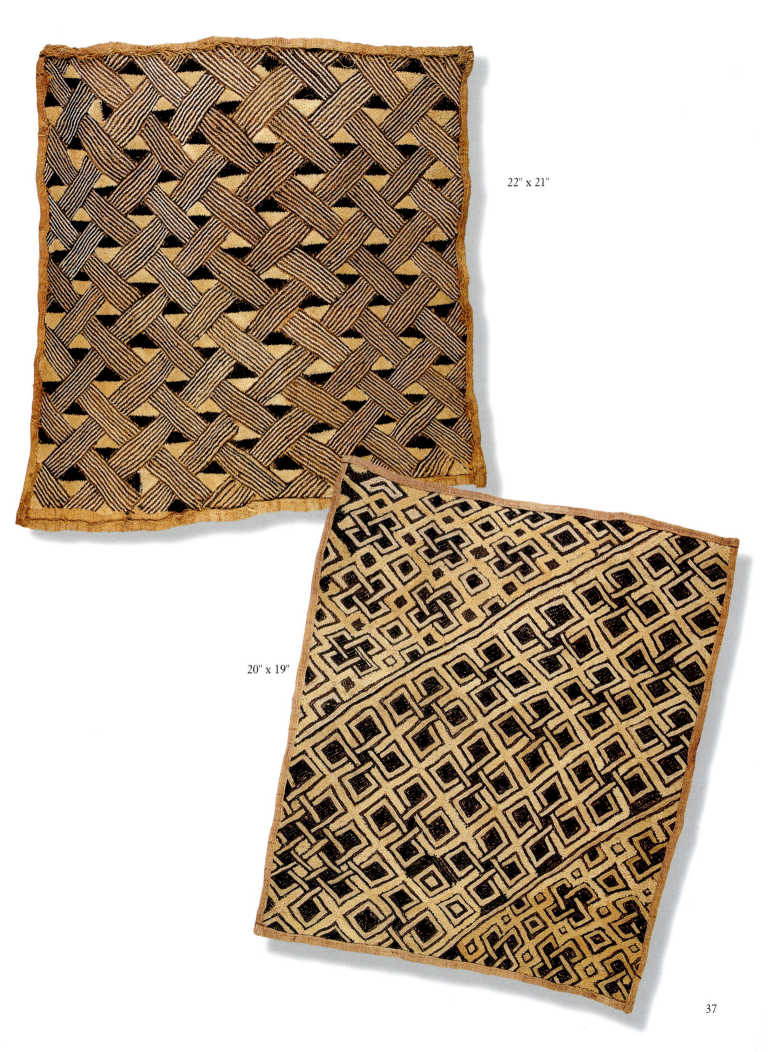

22" x 21"

20" x 19"

37

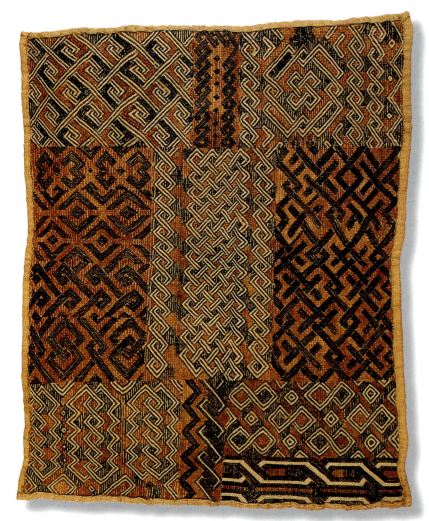

21" x 17"

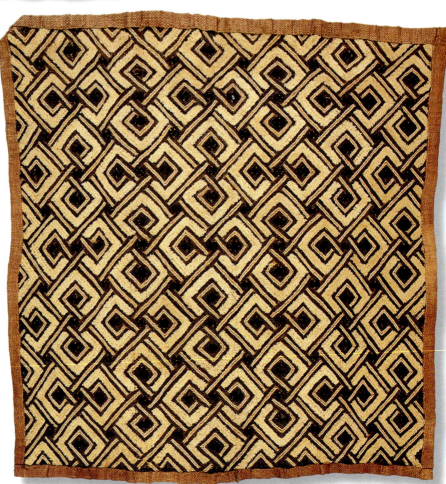

19" x 20"

38

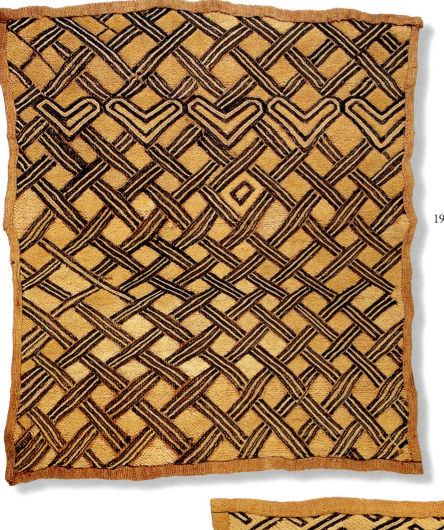

19" x 16"

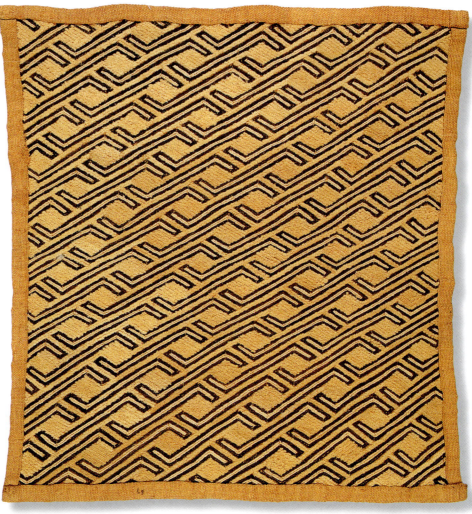

20" x 20"

39

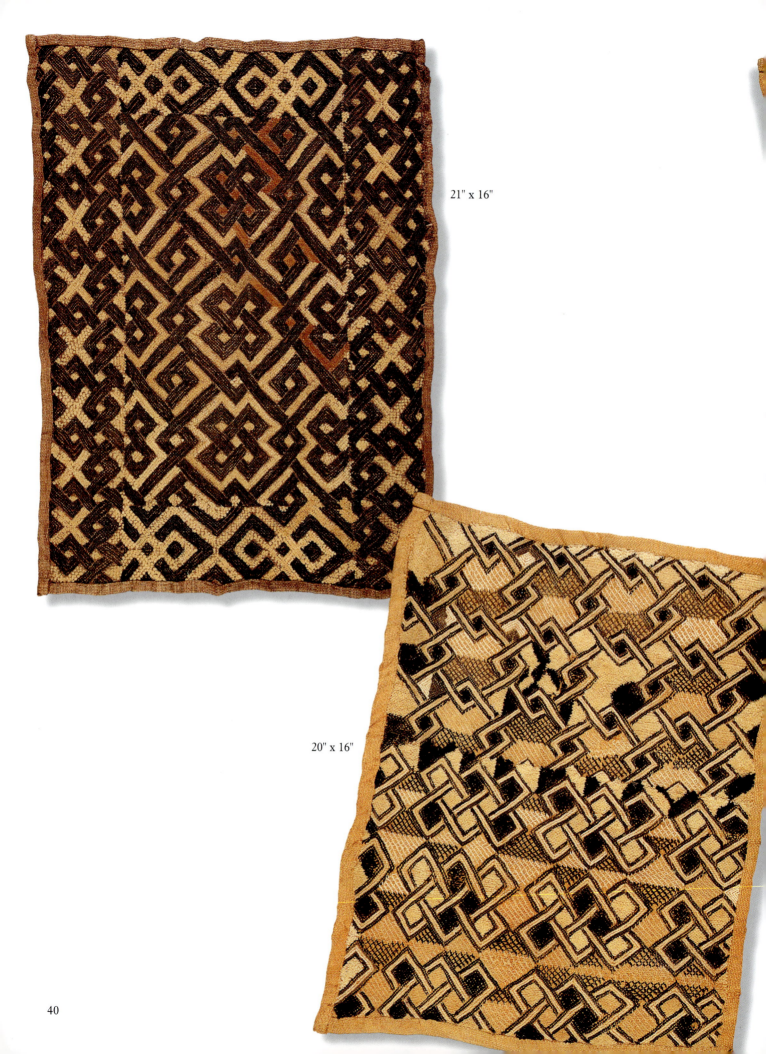

21" x 16"

20" x 16"

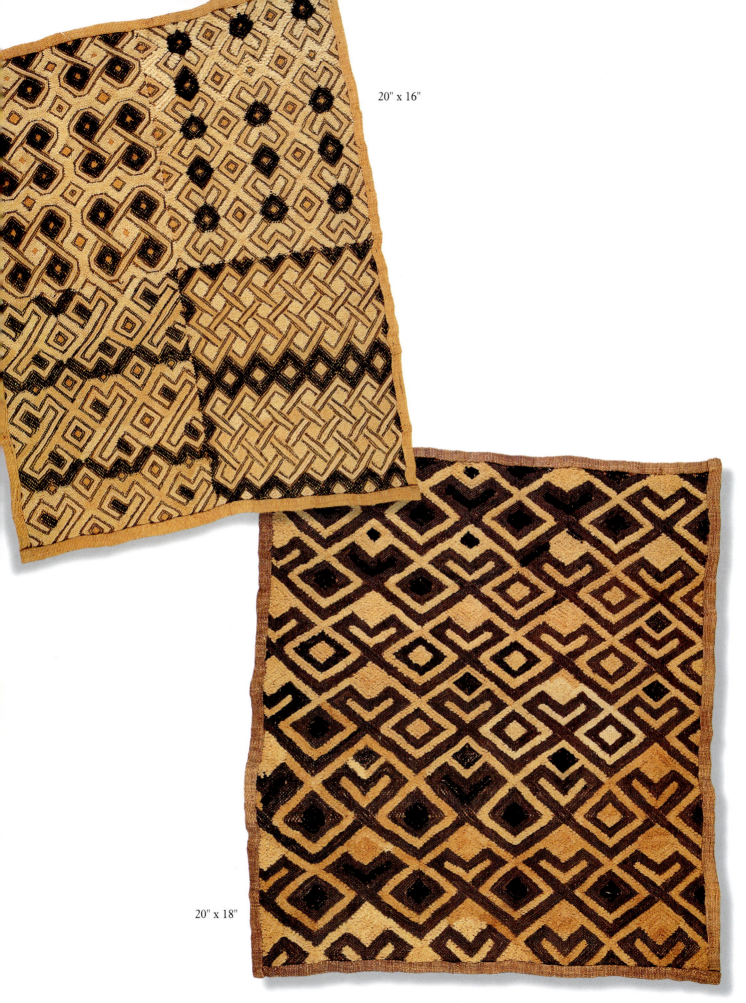

20" x 16"

20" x 18"

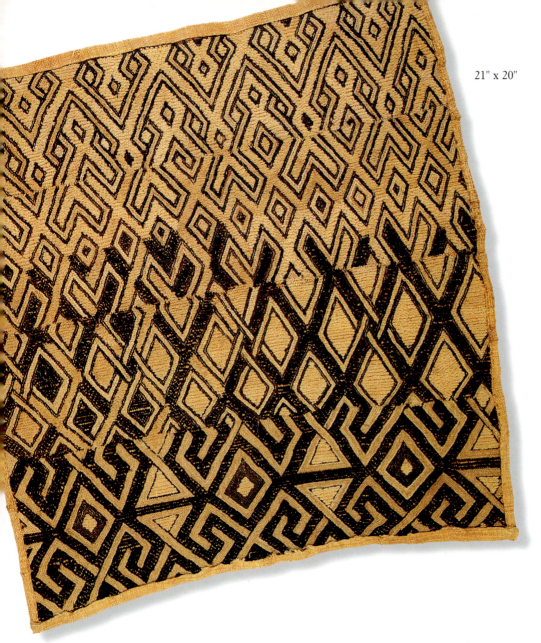

21" x 20"

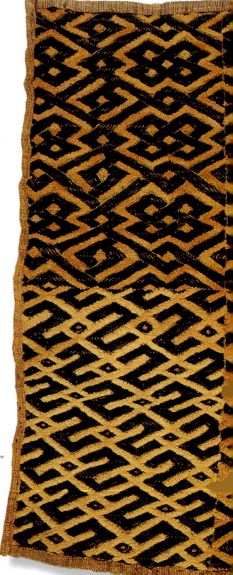

23" x 18"

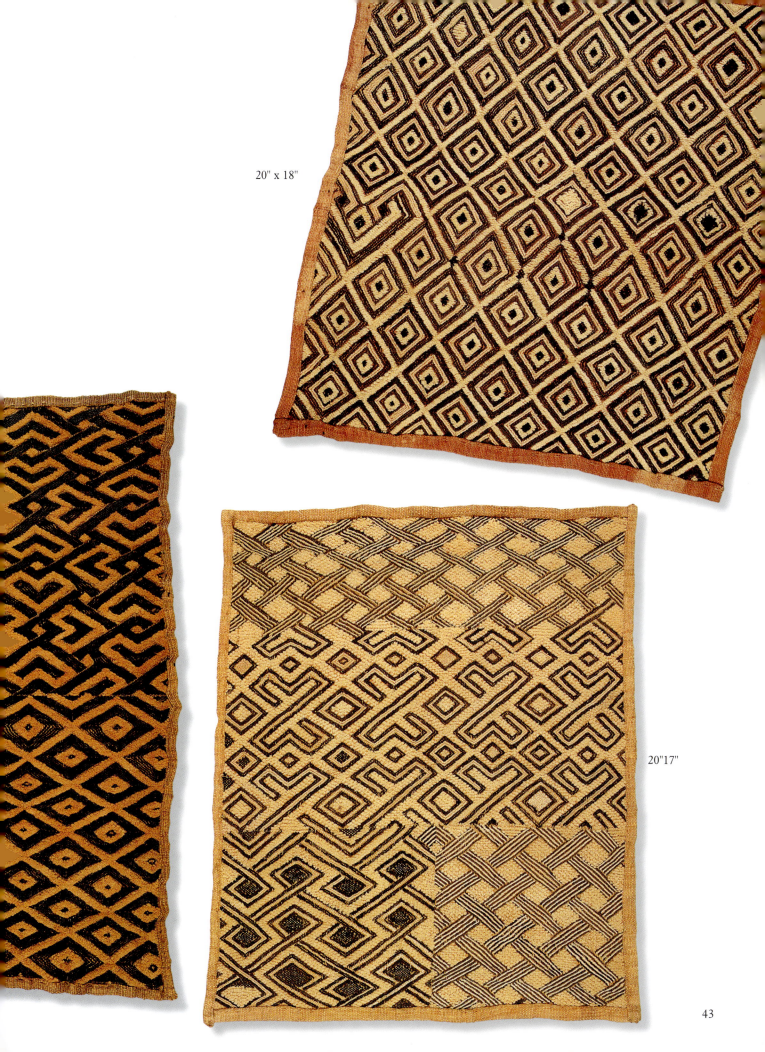

20" x 18"

20"17"

43

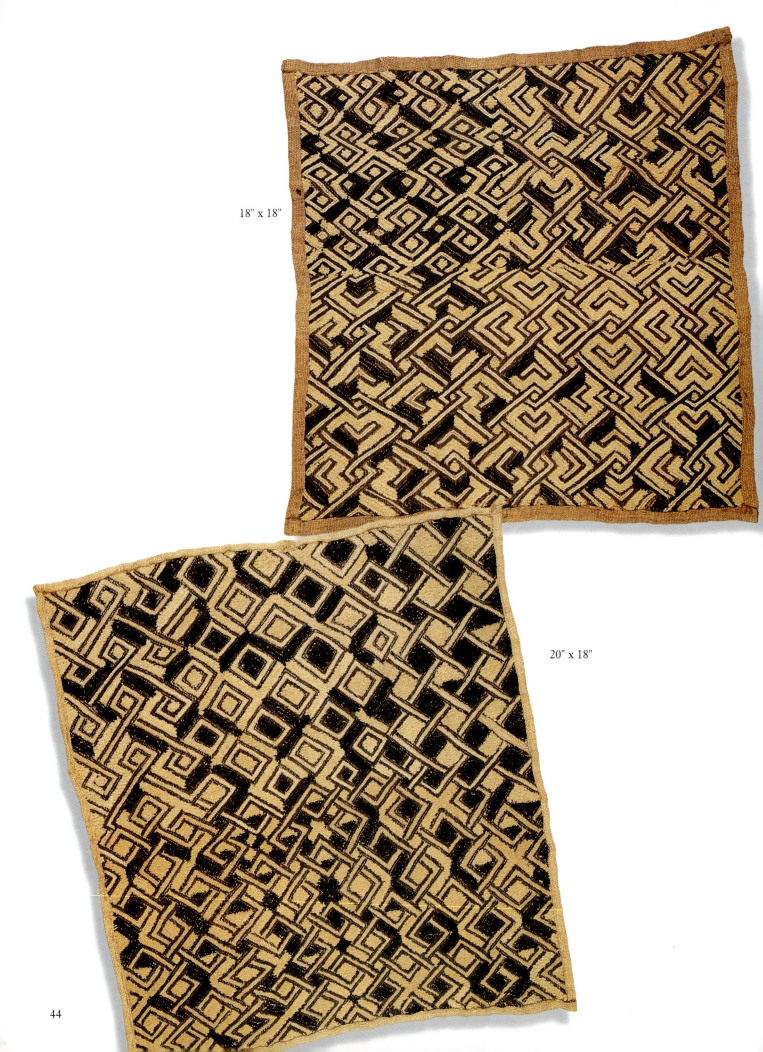

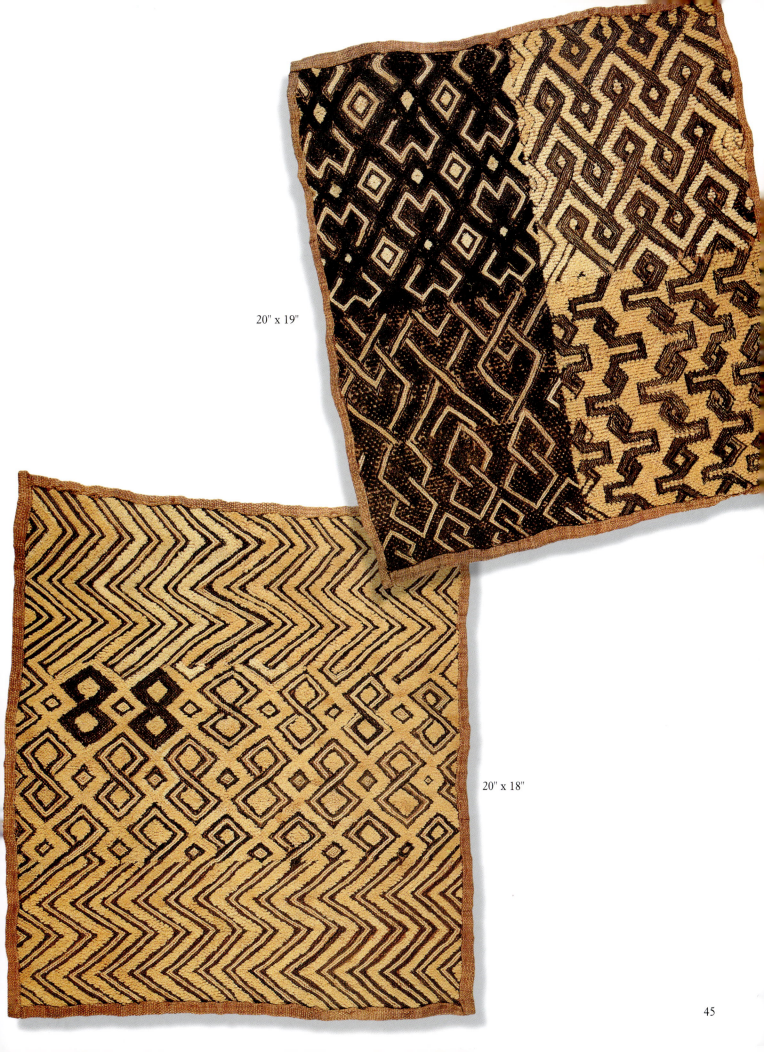

20" x 19"

20" x 18"

45

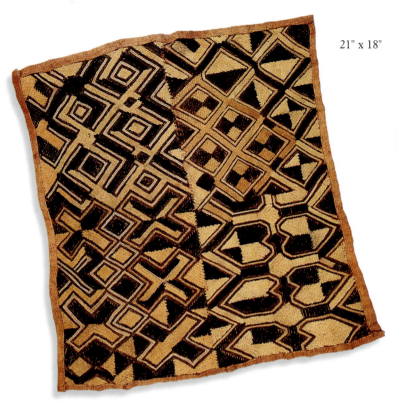

21" x 18"

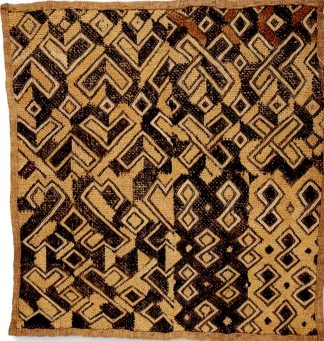

20" x 19"

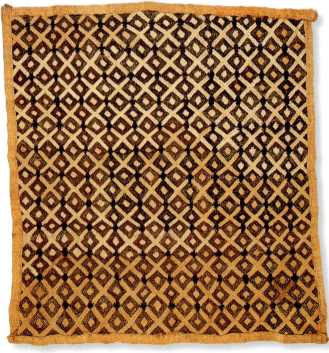

20" x 19"

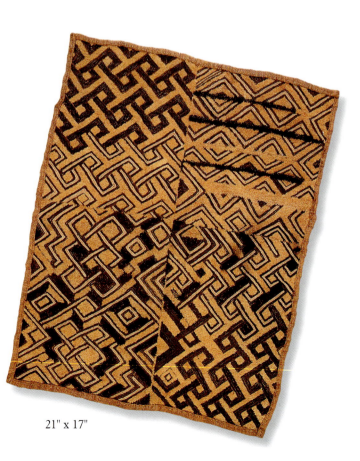

21" x 17"

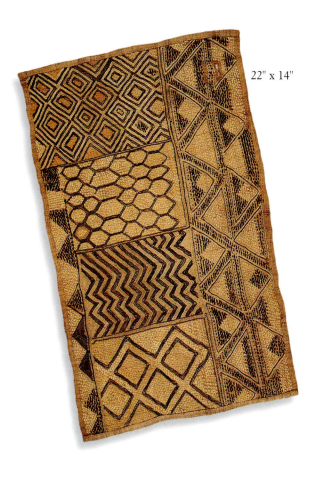

22" x 14"

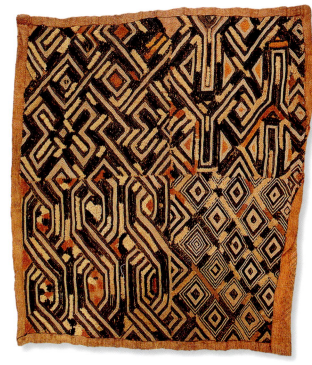

19" x 19"

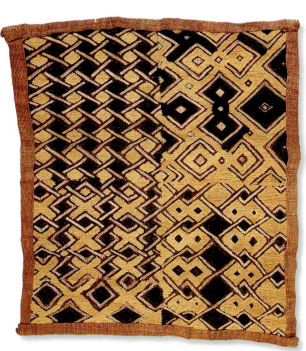

18" x 17"

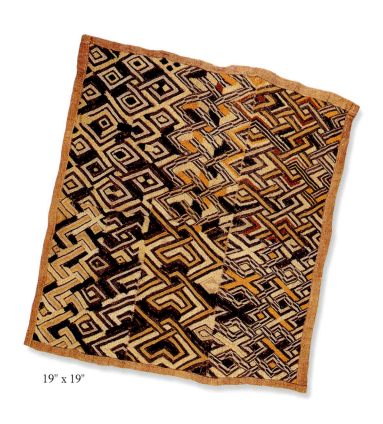

19" x 19"

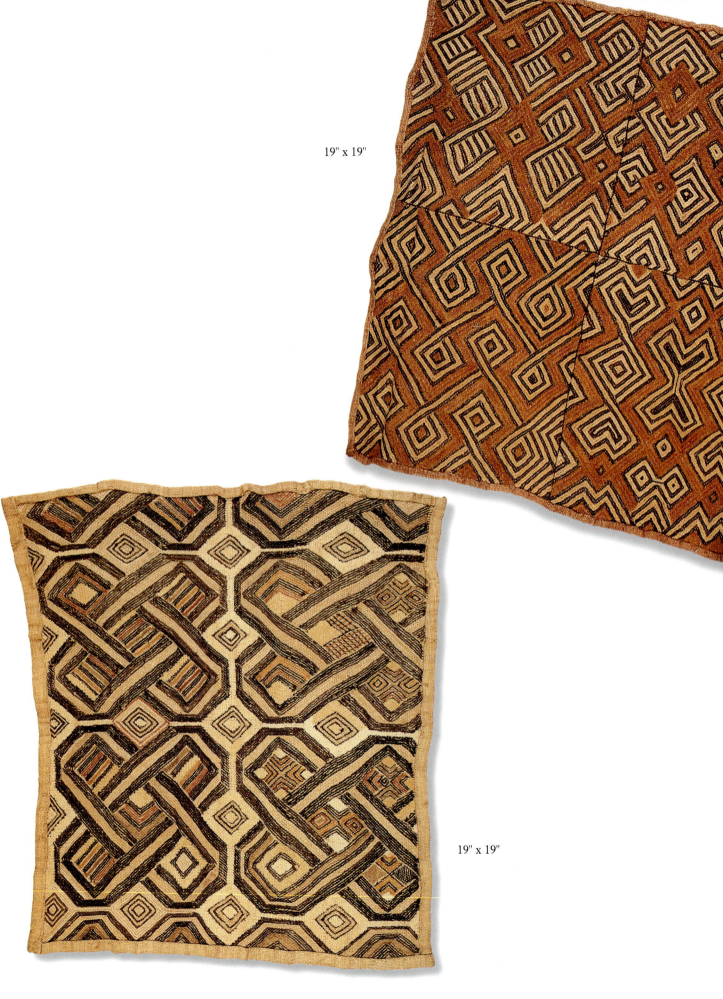

19" x 19"

19" x 19"

48

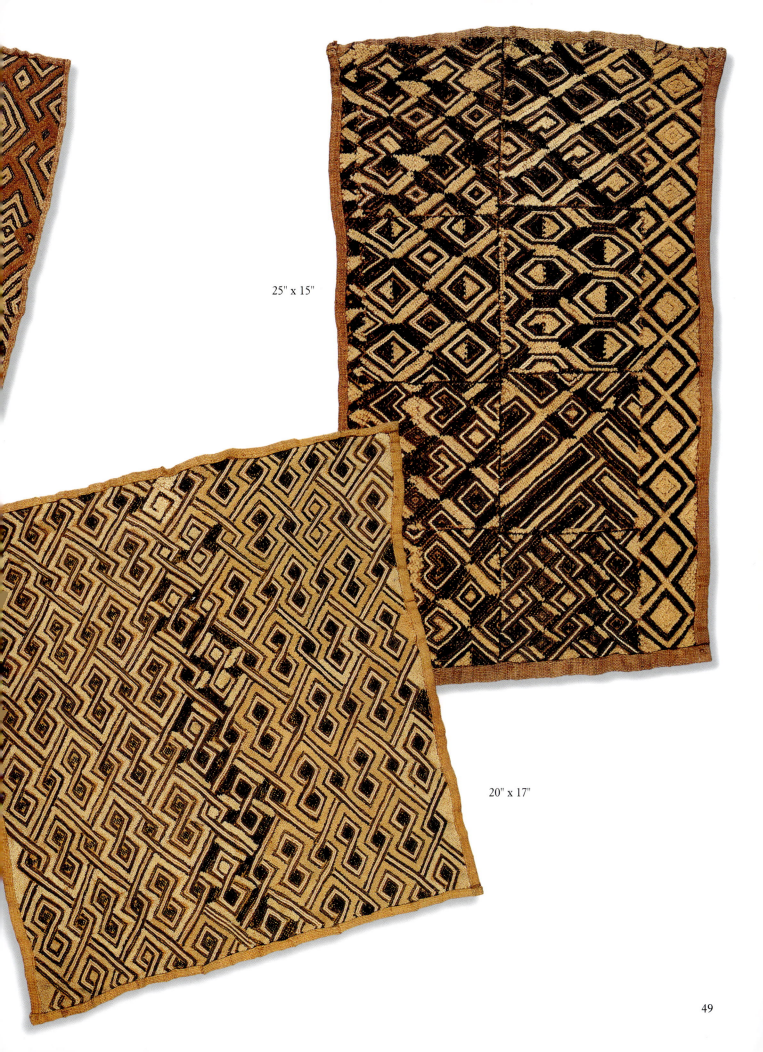

25" x 15"

20" x 17"

49

19" x 17"

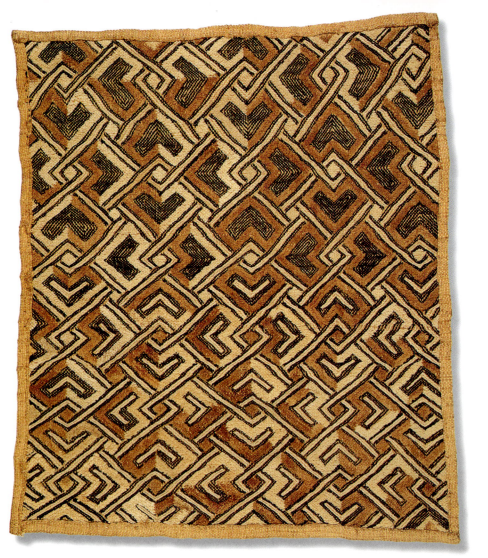

20" x 17"

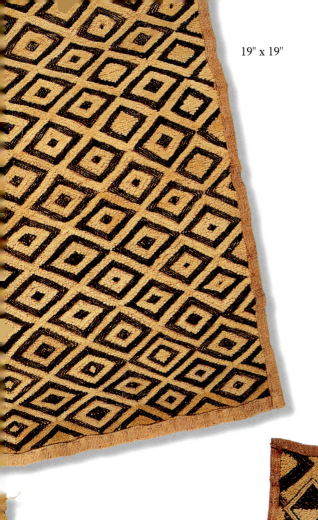

19" x 19"

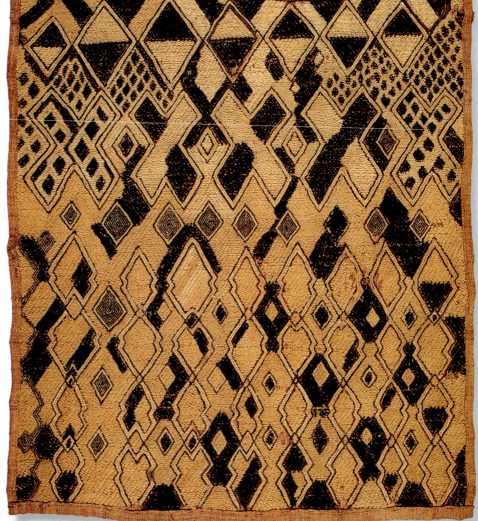

19" x 19"

51

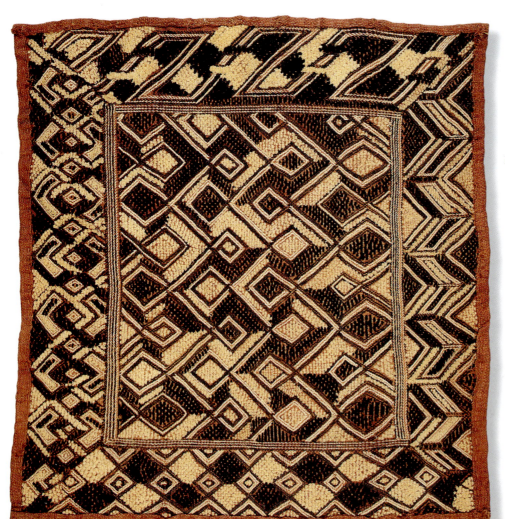

19" x 19"

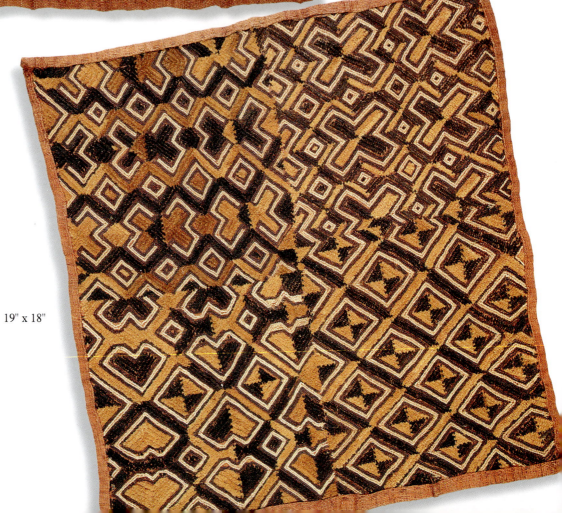

19" x 18"

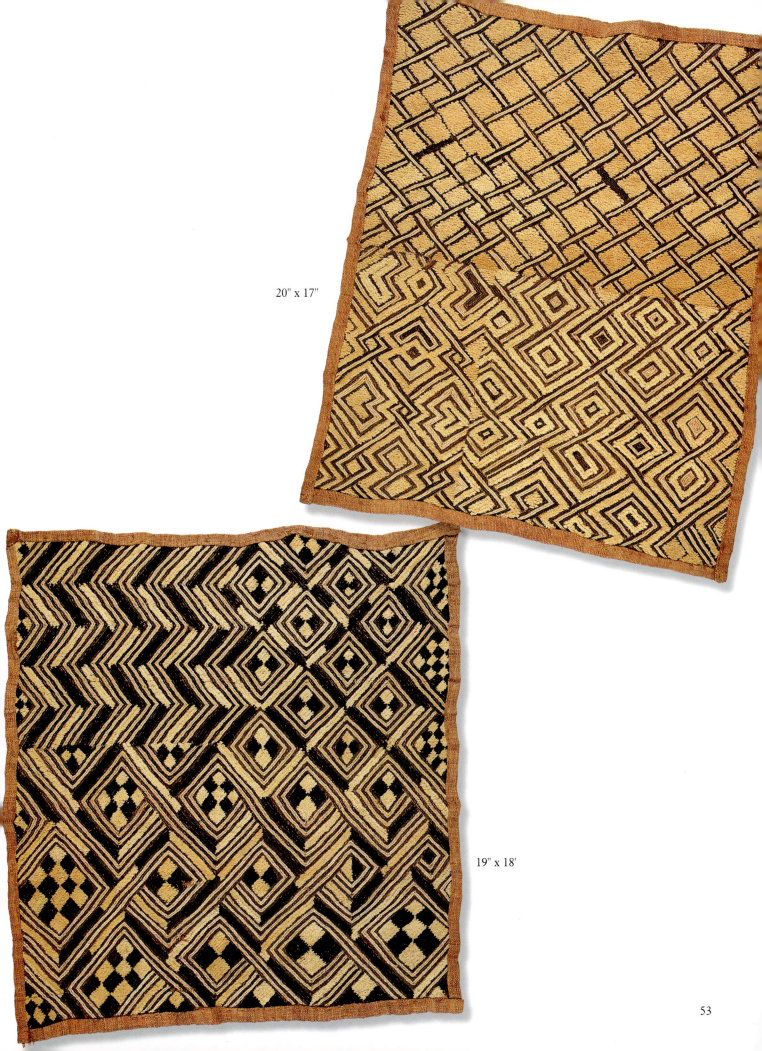

20" x 17"

19" x 18'

53

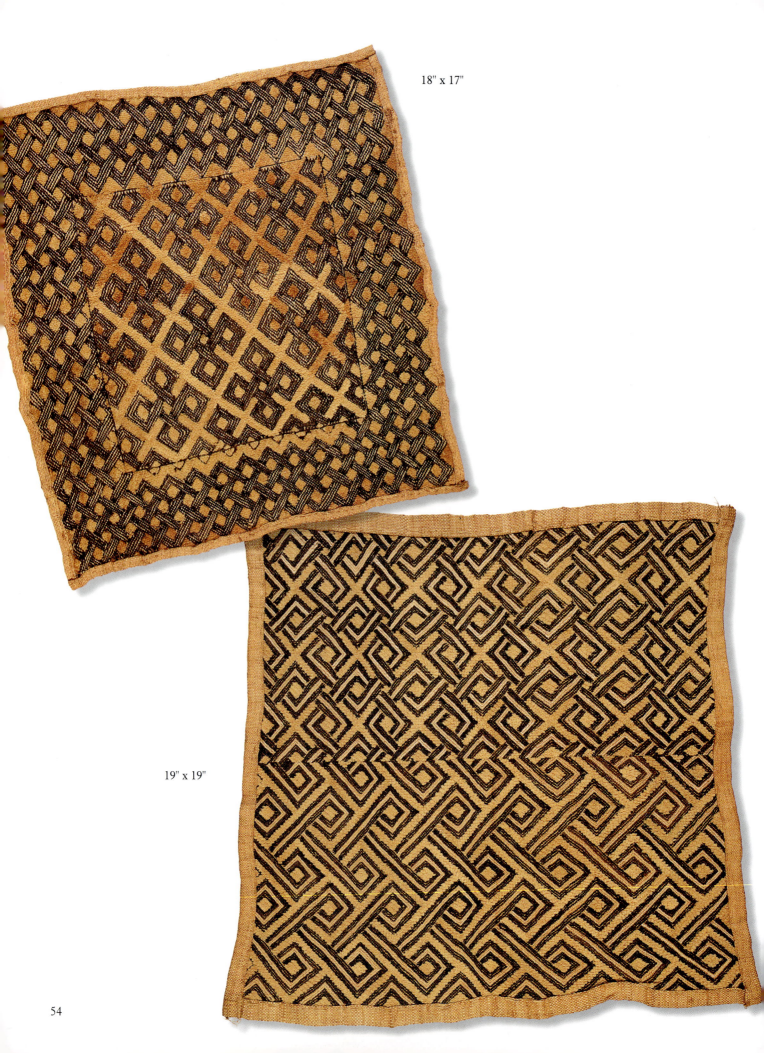

18" x 17"

19" x 19"

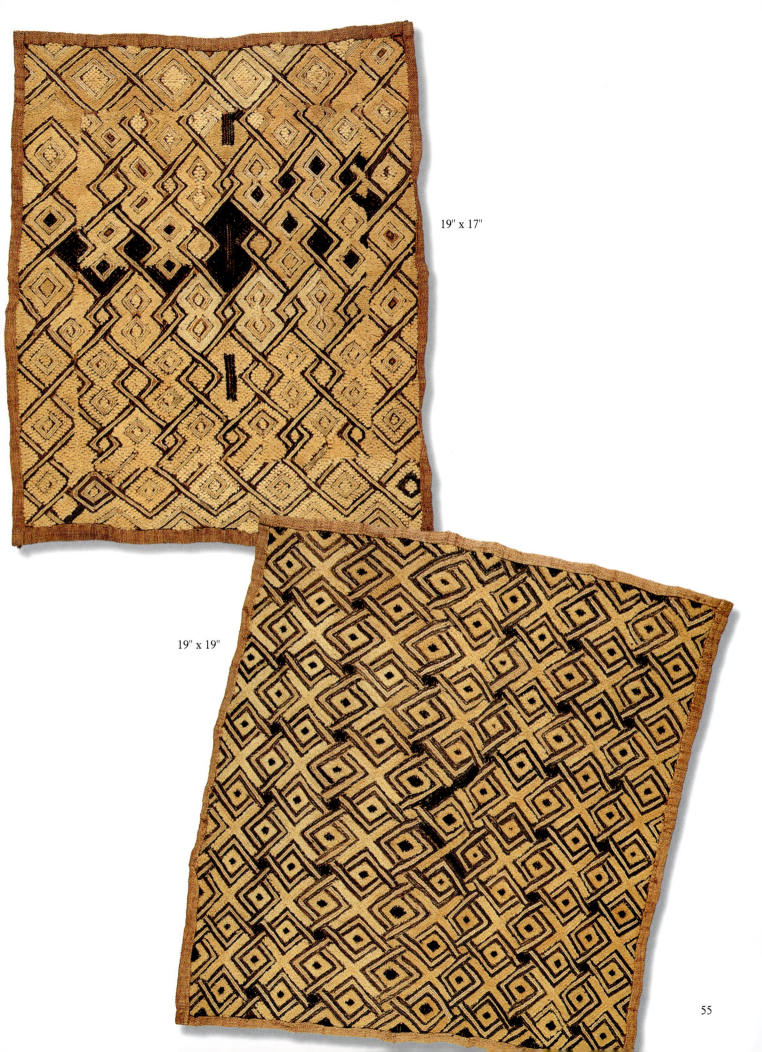

19" x 17"

19" x 19"

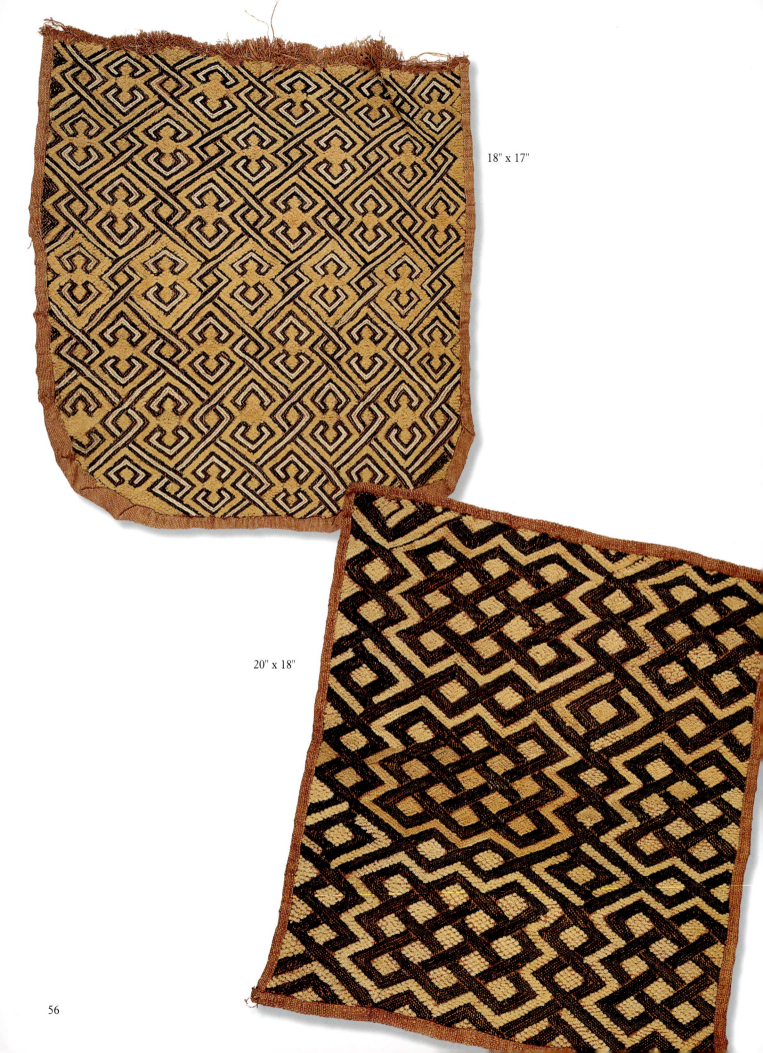

18" x 17"

20" x 18"

56

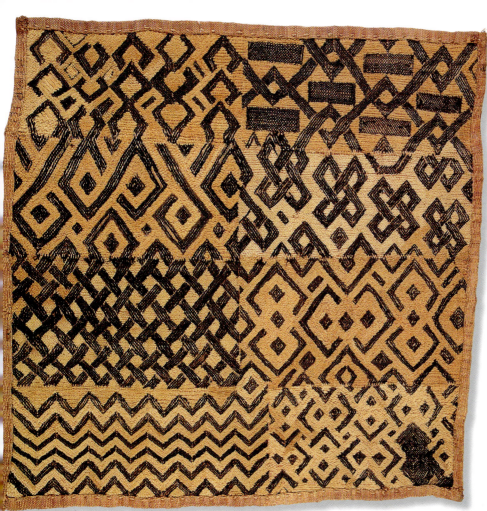

20" x 19"

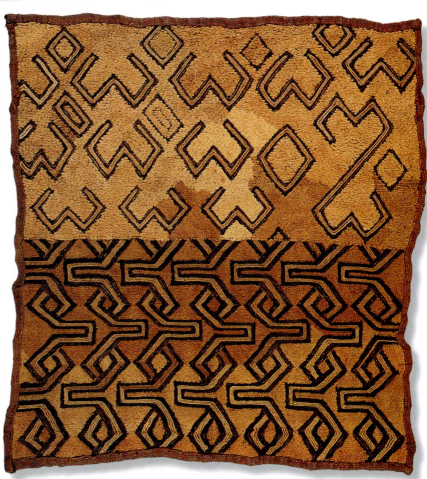

17" x 16"

57

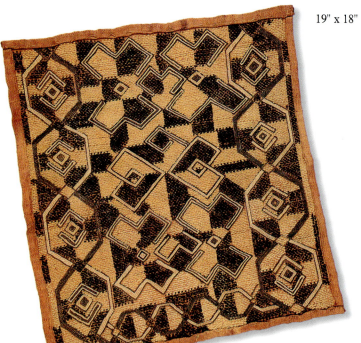

19" x 18"

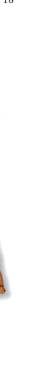

19" x 19"

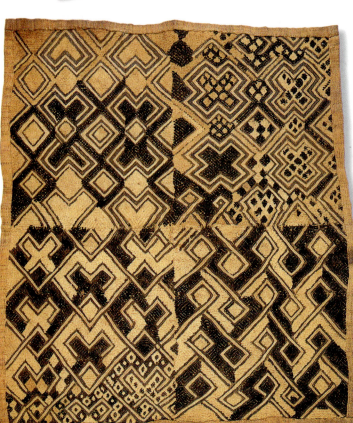

25" x 22"

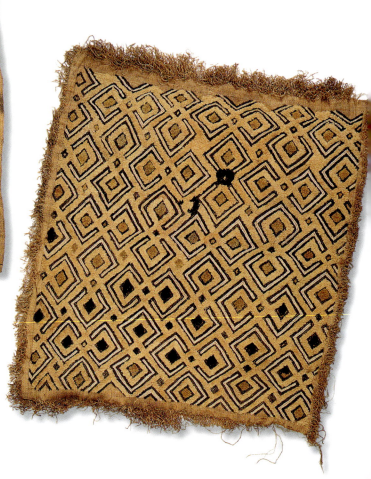

23" x 23"

24" x 21"

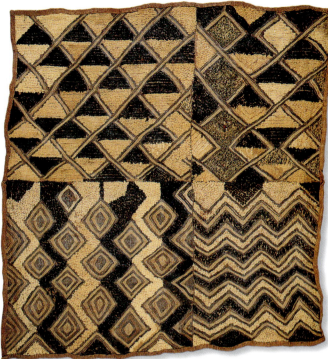

24" x 23"

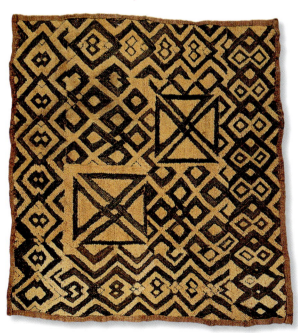

21" x 20"

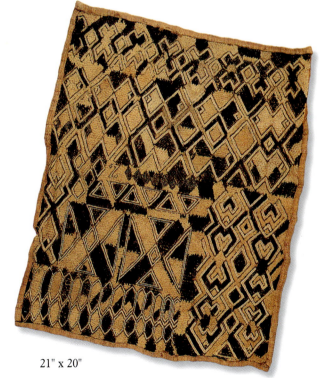

21" x 20"

59

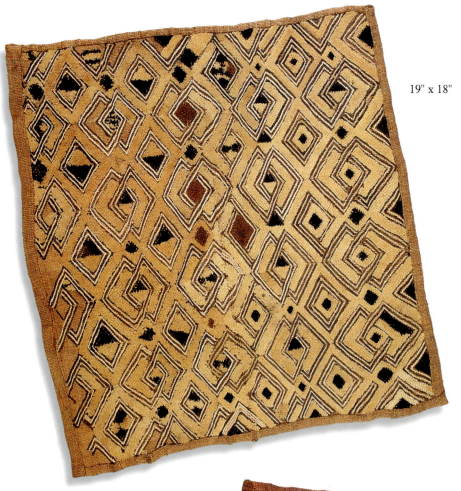

19" x 18"

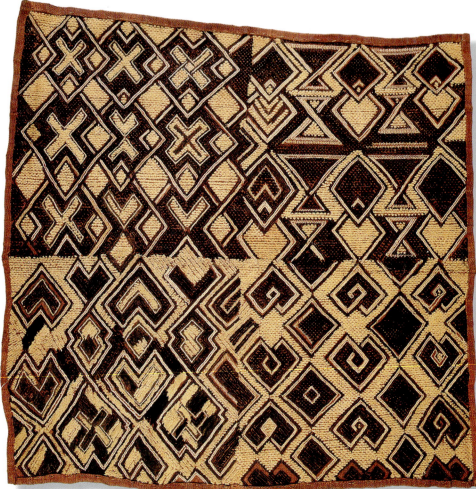

23" x 22"

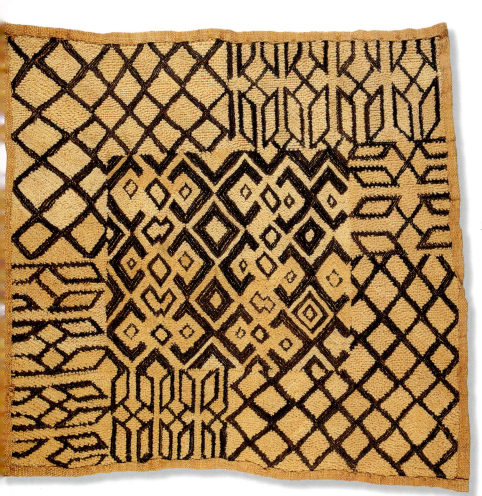

22" x 20"

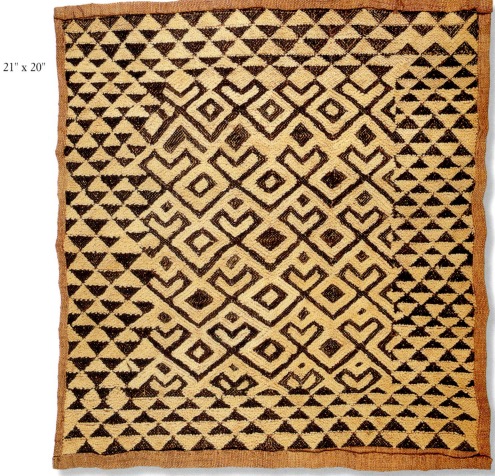

21" x 20"

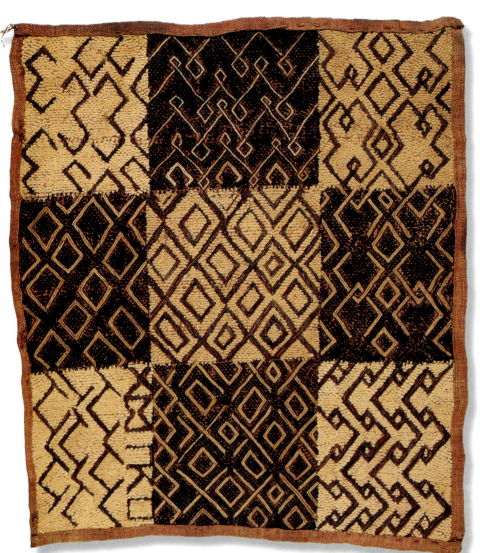

23" x 22"

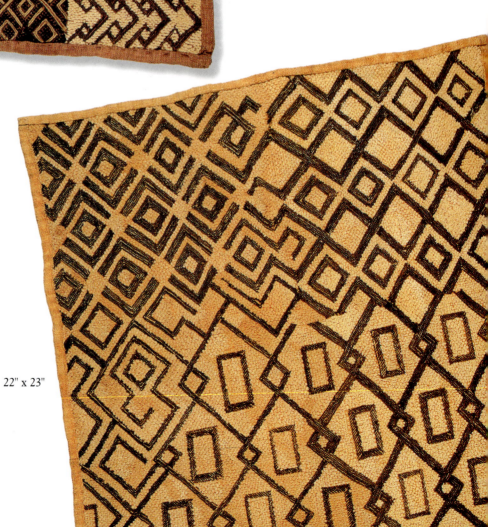

22" x 23"

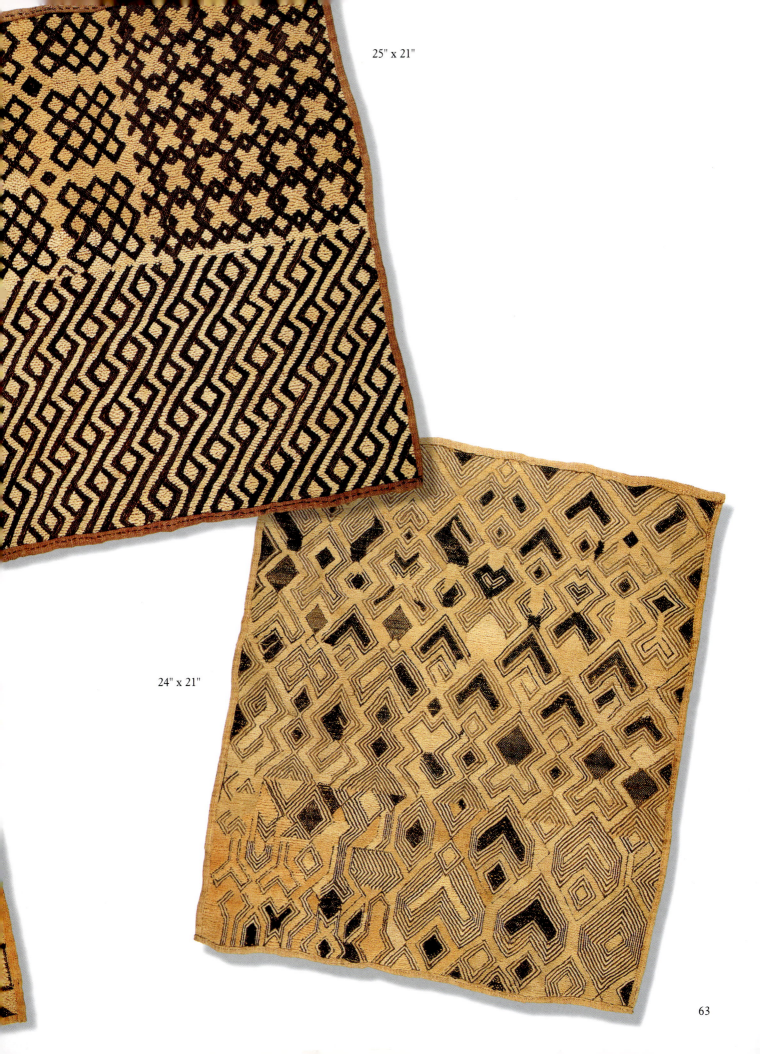

25" x 21"

24" x 21"

63

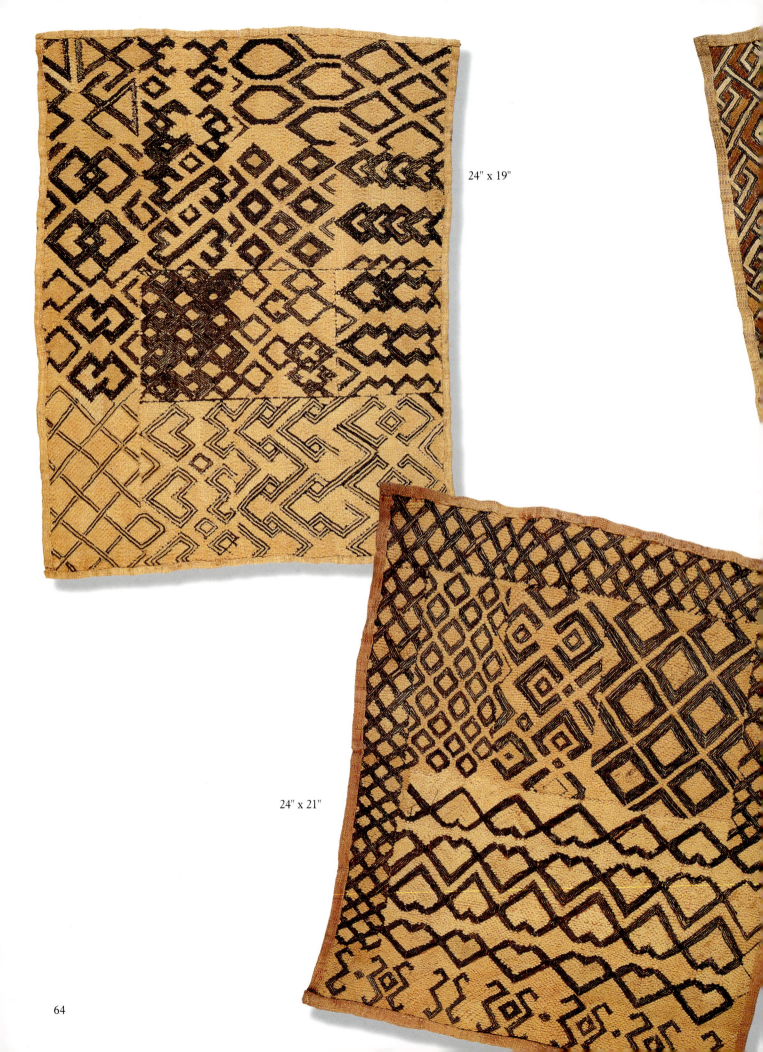

24" x 19"

24" x 21"

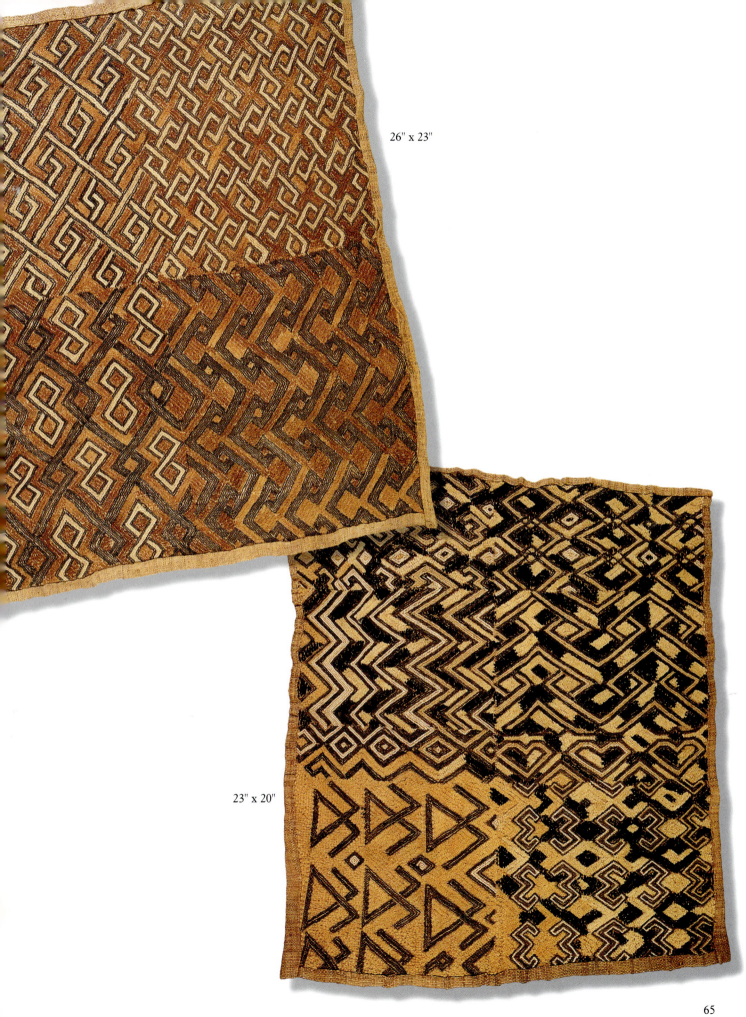

26" x 23"

23" x 20"

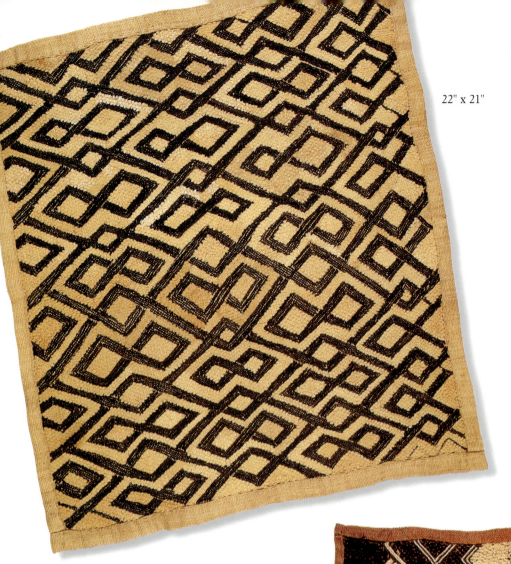

22" x 21"

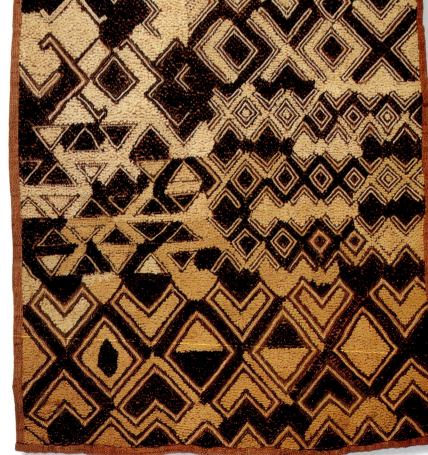

22" x 21"

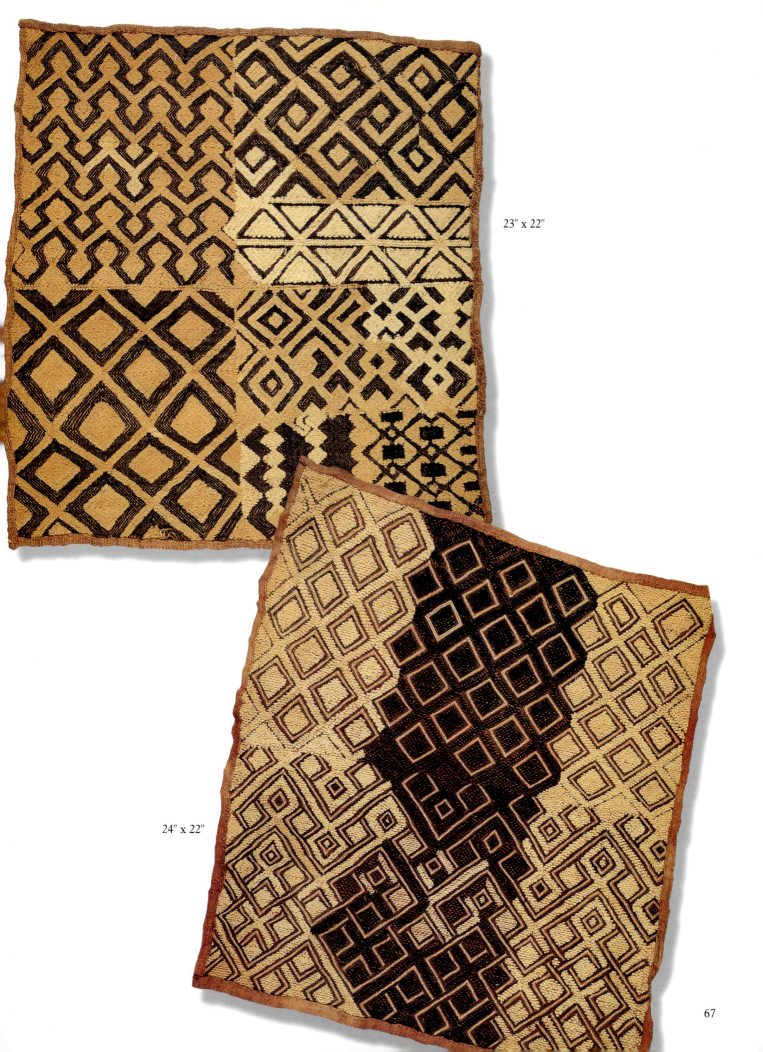

23" x 22"

24" x 22"

67

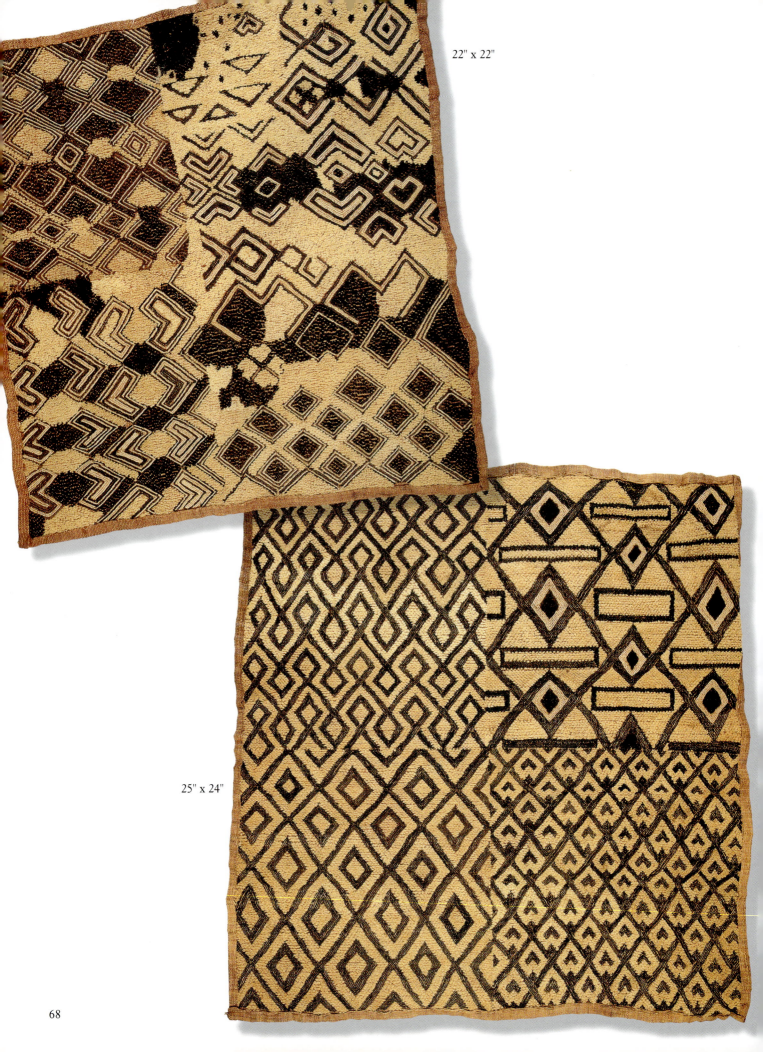

22" x 22"

25" x 24"

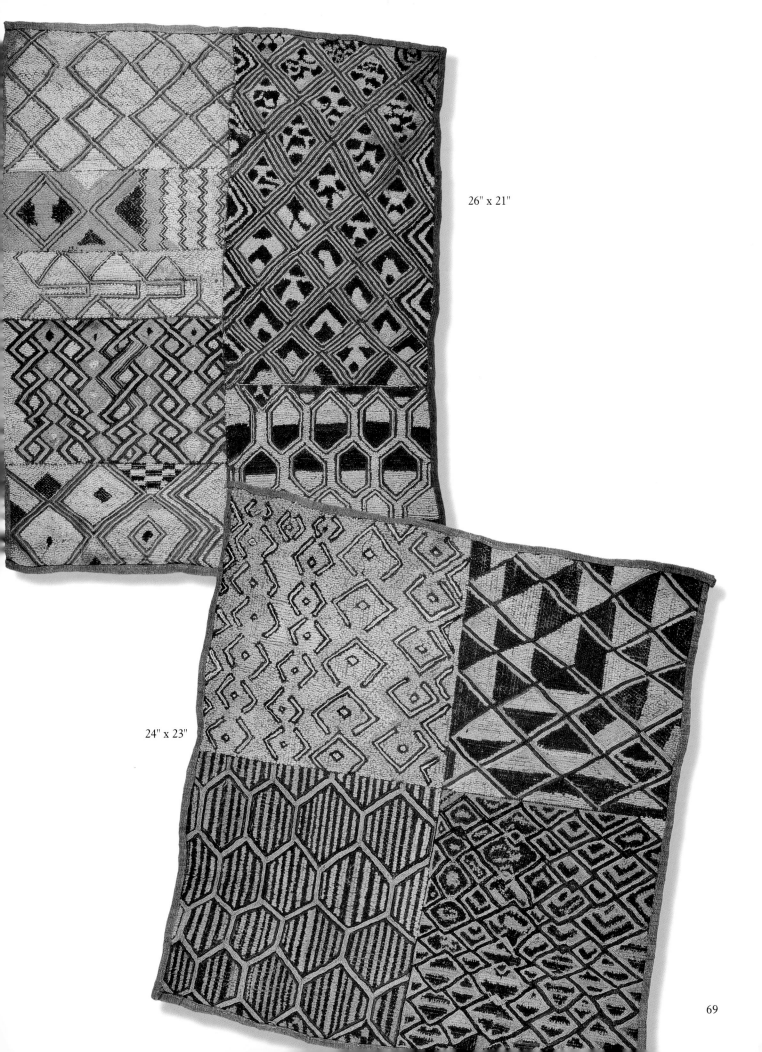

26" x 21"

24" x 23"

69

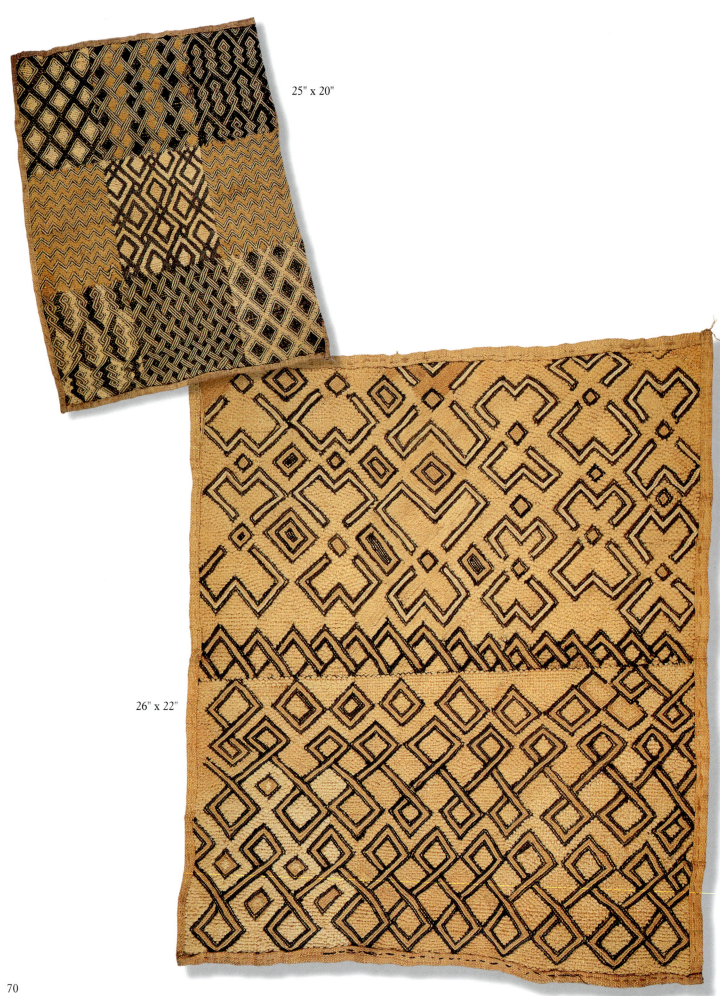

25" x 20"

26" x 22"

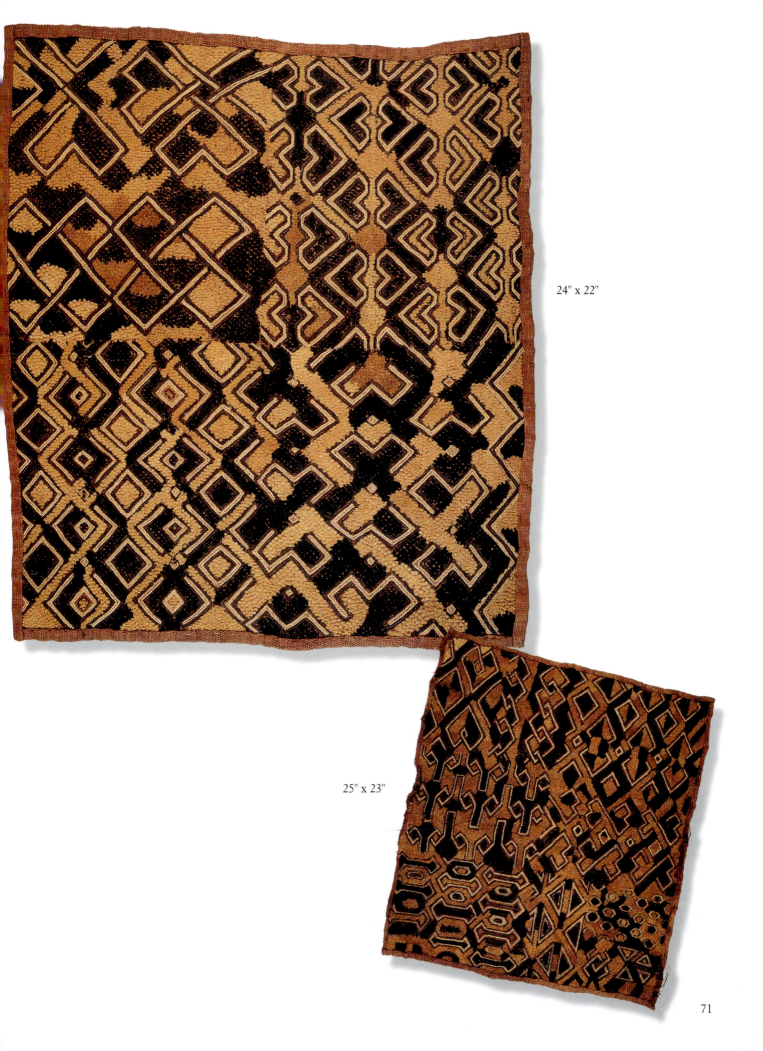

24" x 22"

25" x 23"

71

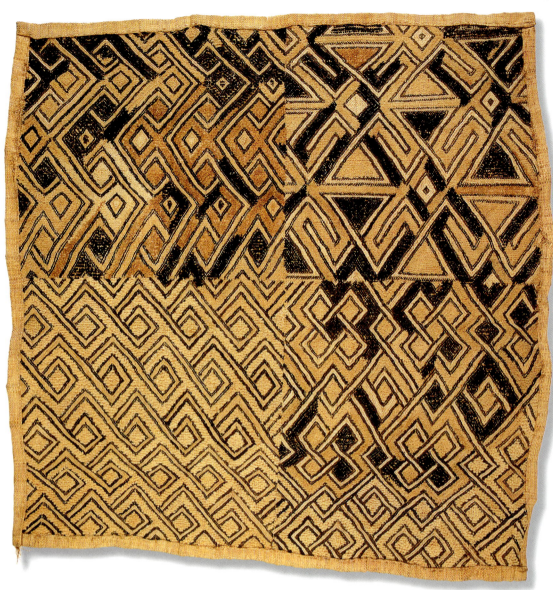

24" x 25"

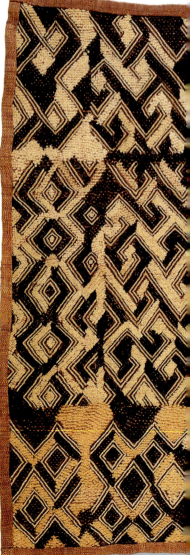

25" x 23"

72

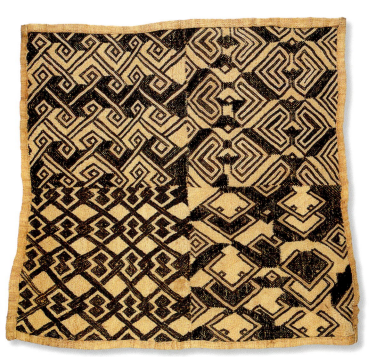

23" x 23"

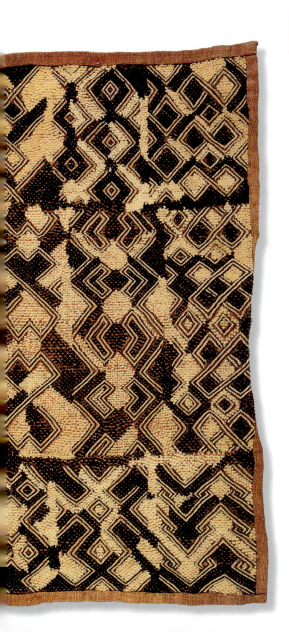

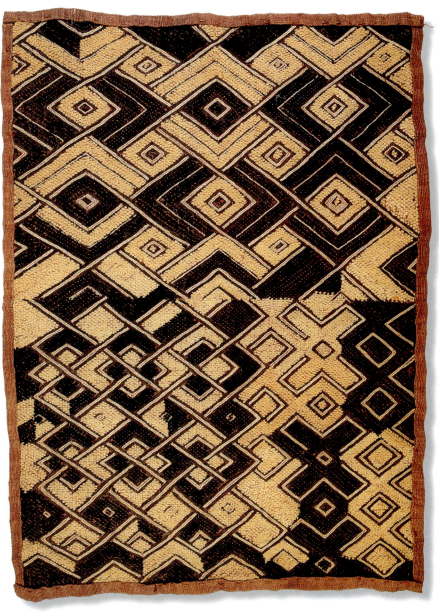

27" x 20"

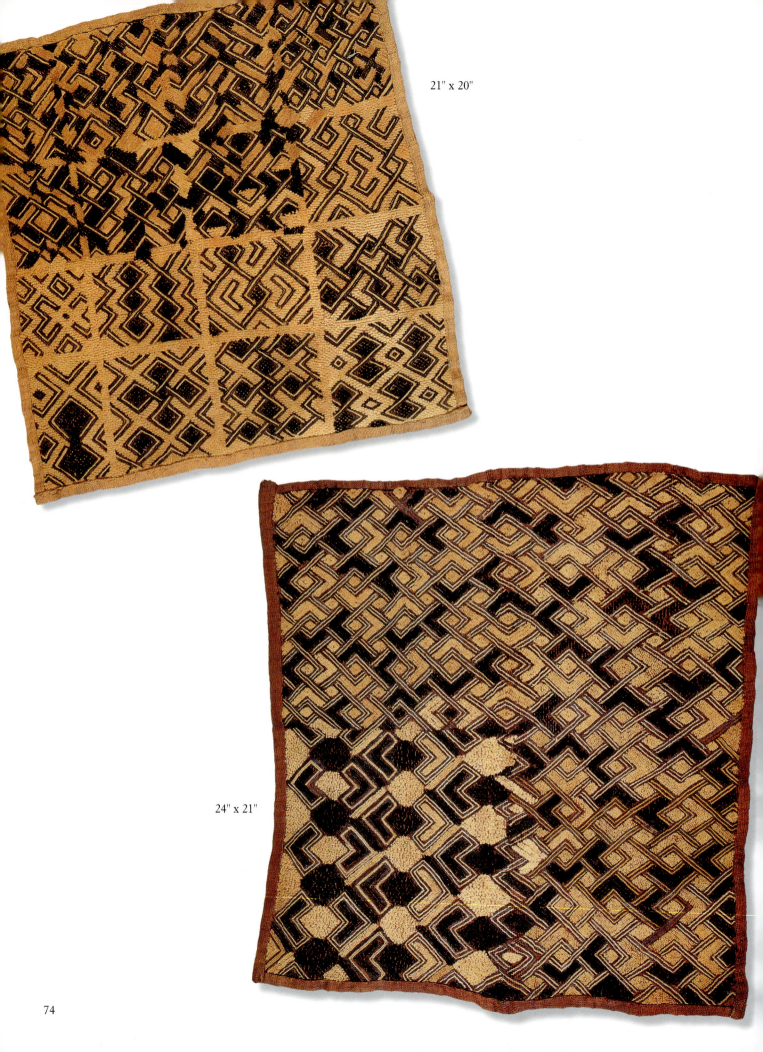

21" x 20"

24" x 21"

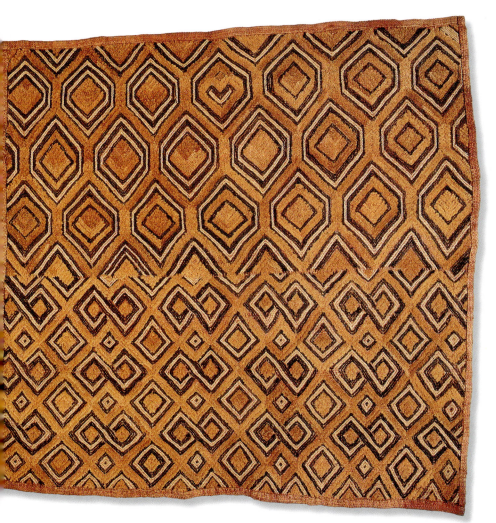

23" x 21"

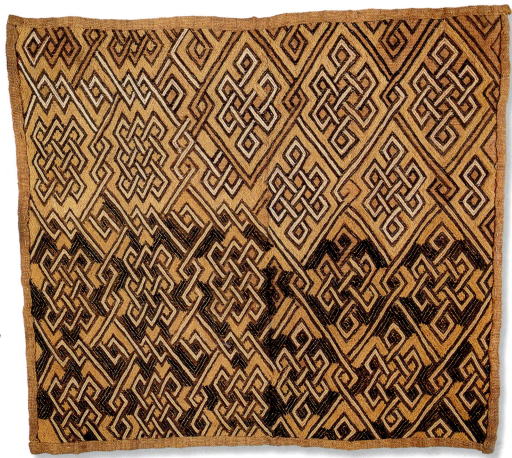

23" x 19"

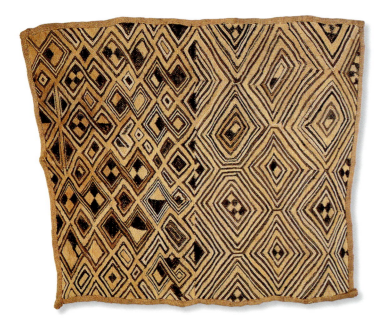

24" x 20"

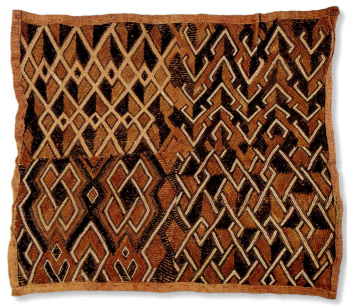

22" x 19"

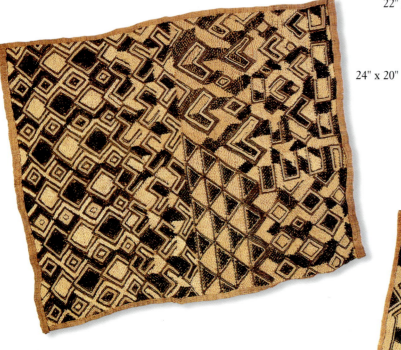

24" x 20"

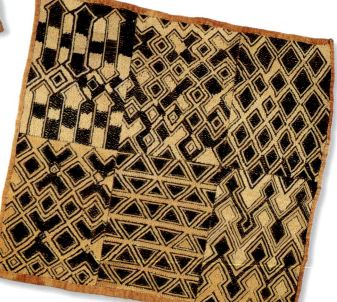

22" x 20"

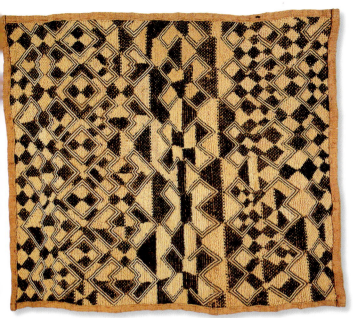

23" x 21"

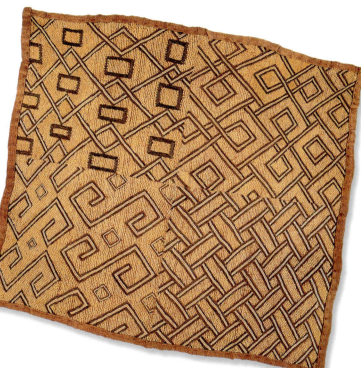

24" x 22"

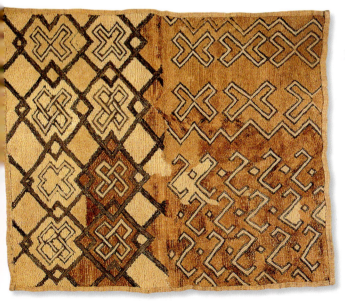

23" x 19"

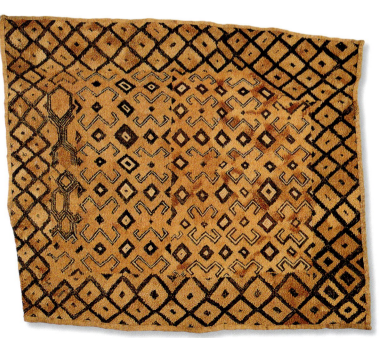

26"22"

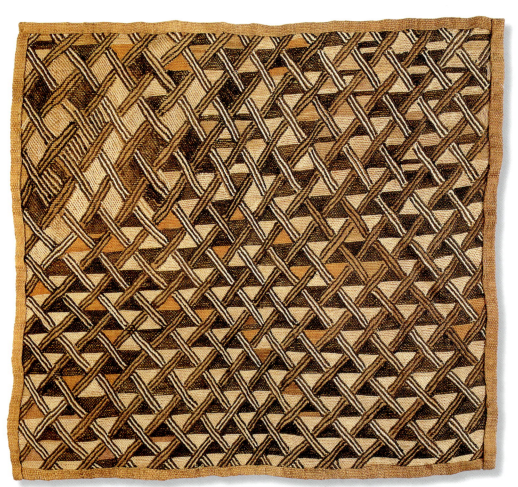

23" x 20"

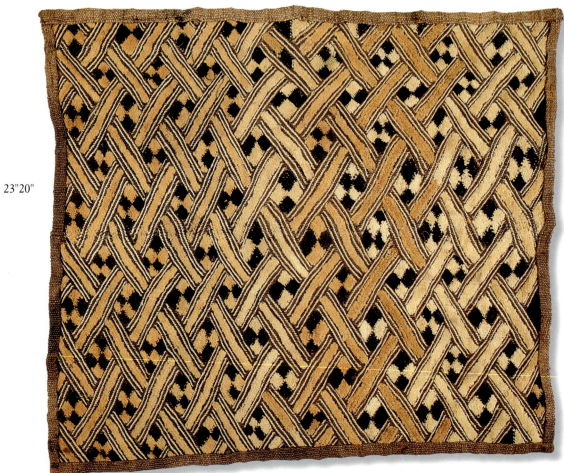

23" 20"

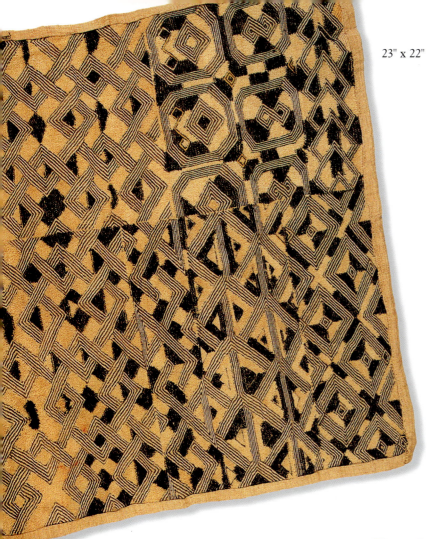
23" x 22"

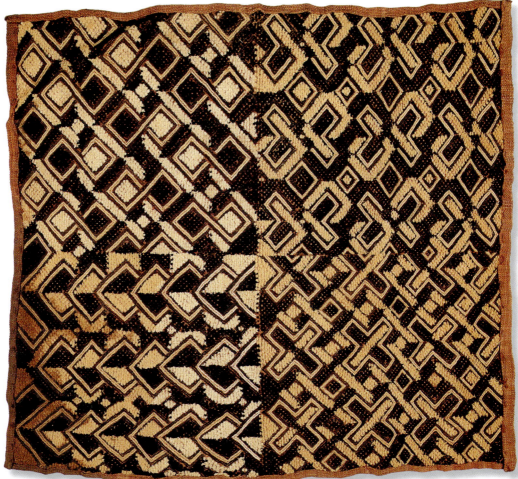
23" x 22"

79

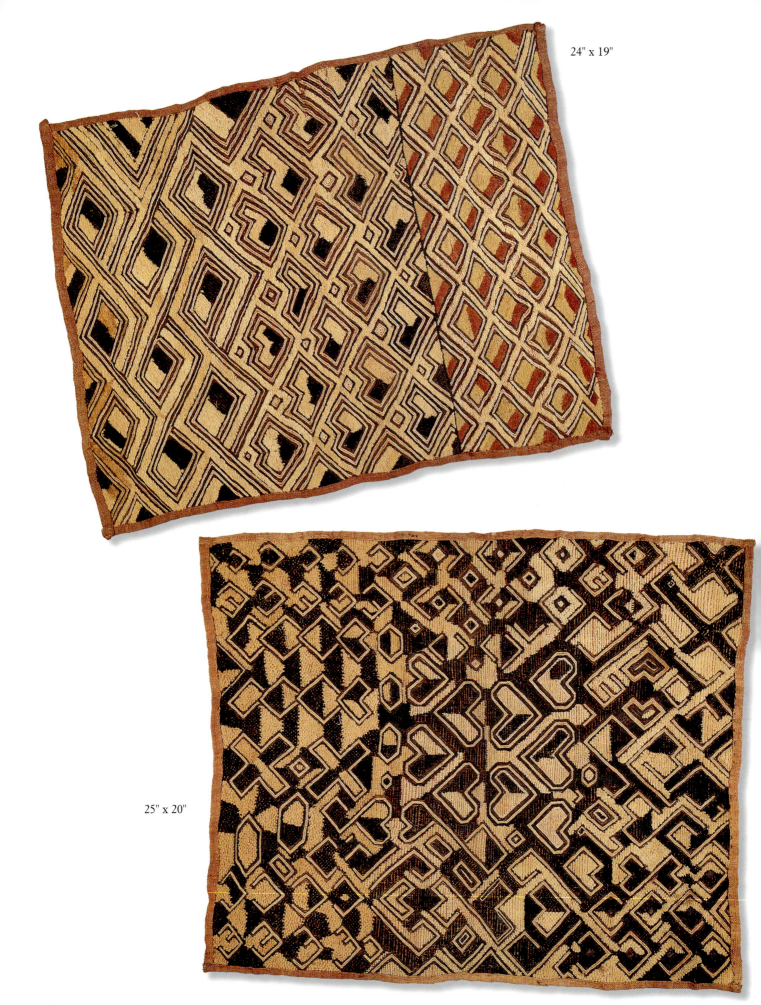

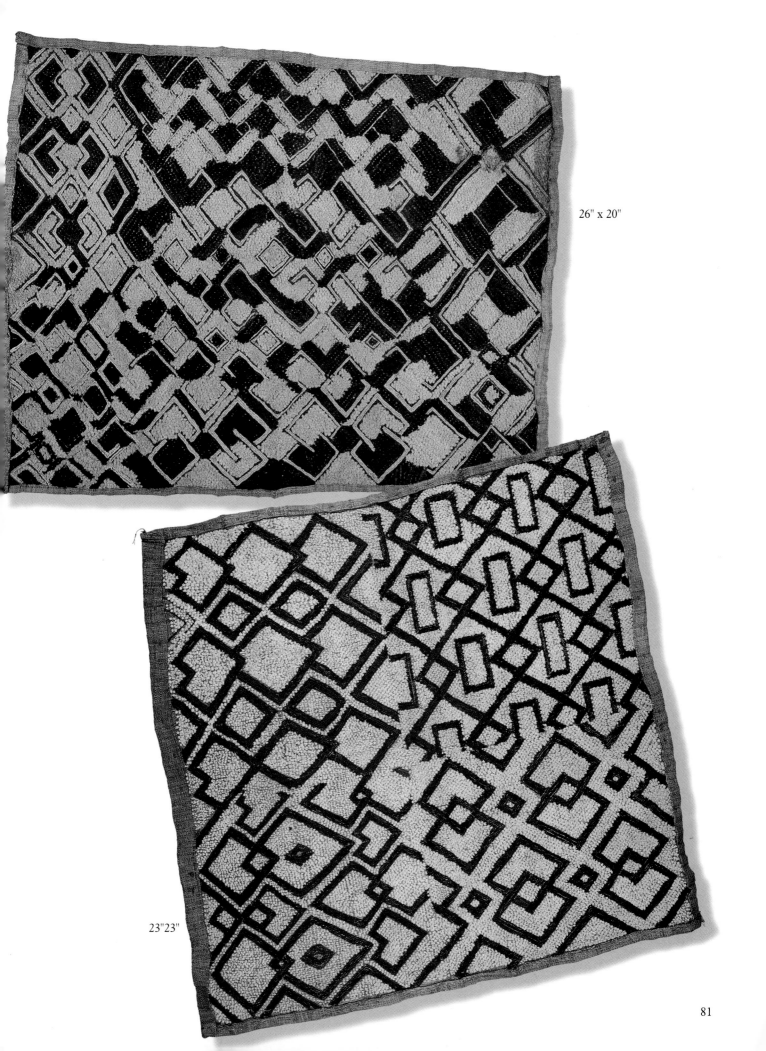

26" x 20"

23" x 23"

81

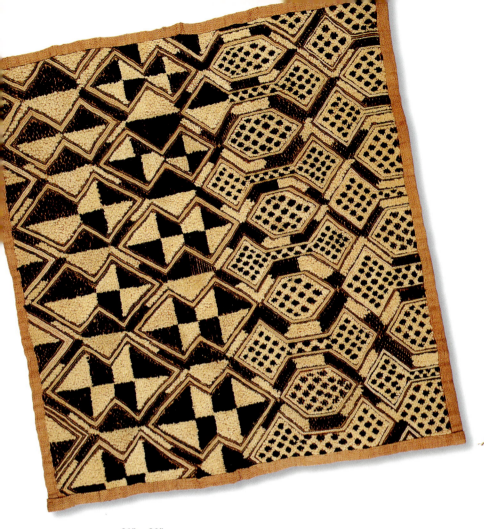

21" x 20"

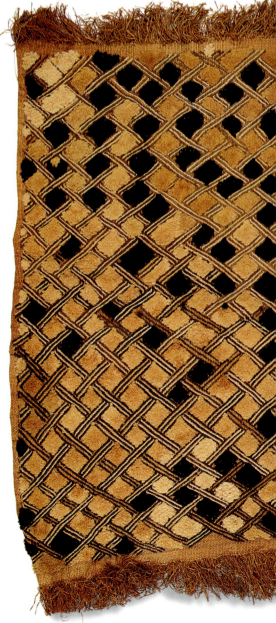

23" x 19"

82

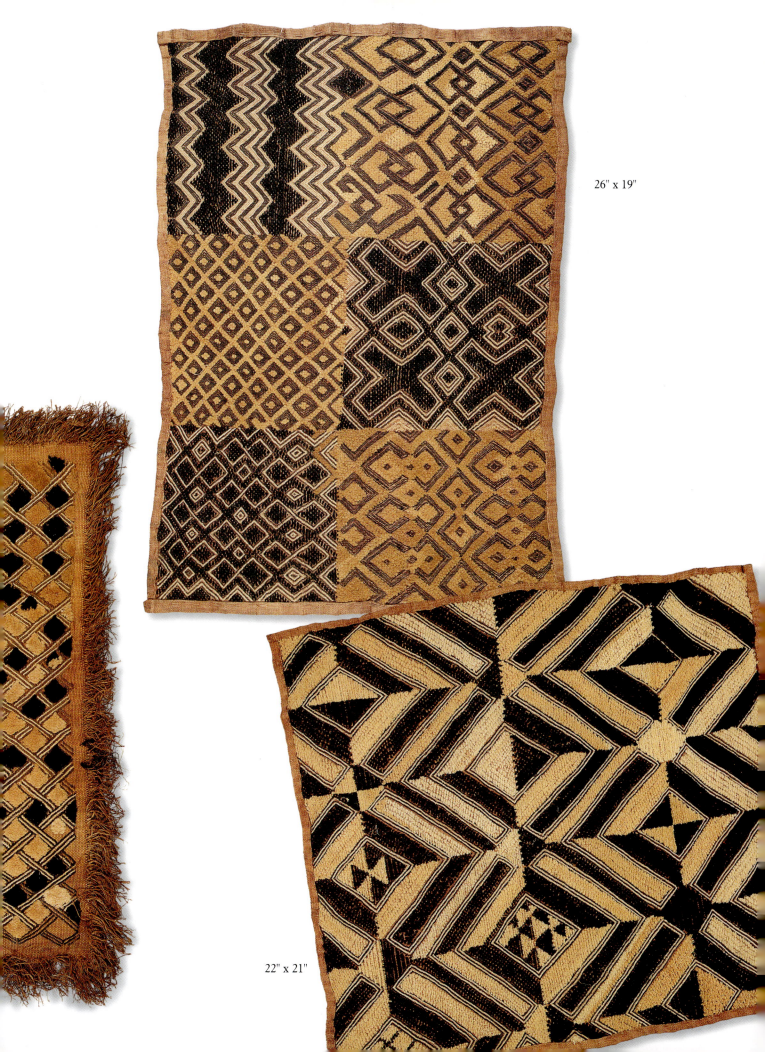

26" x 19"

22" x 21"

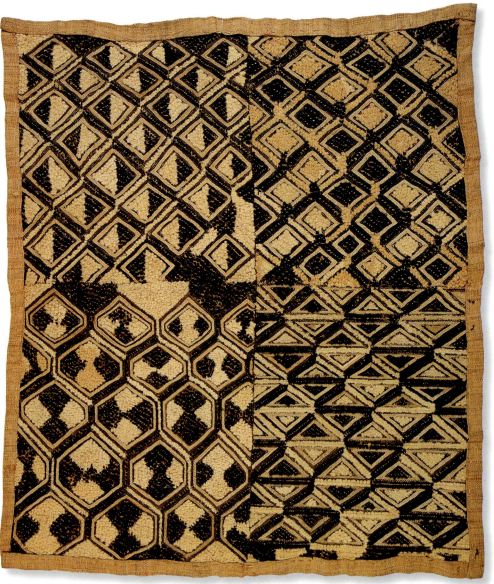

25" x 23"

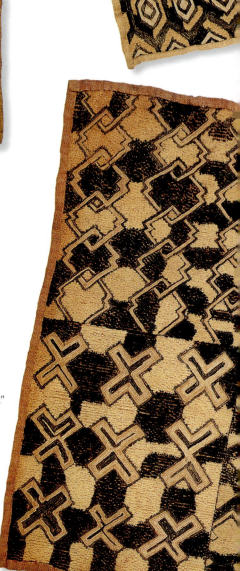

25" x 22"

84

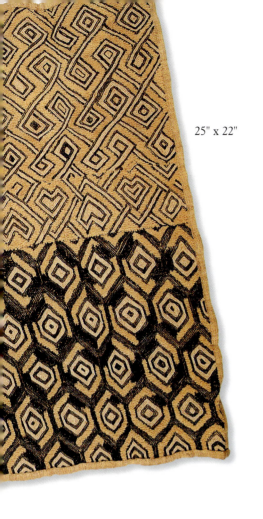
25" x 22"

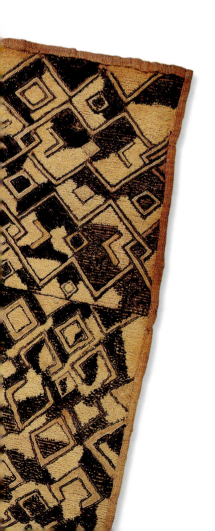

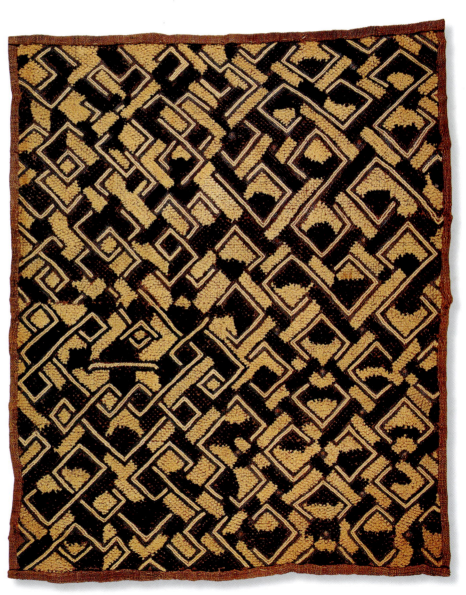
25" x 21"

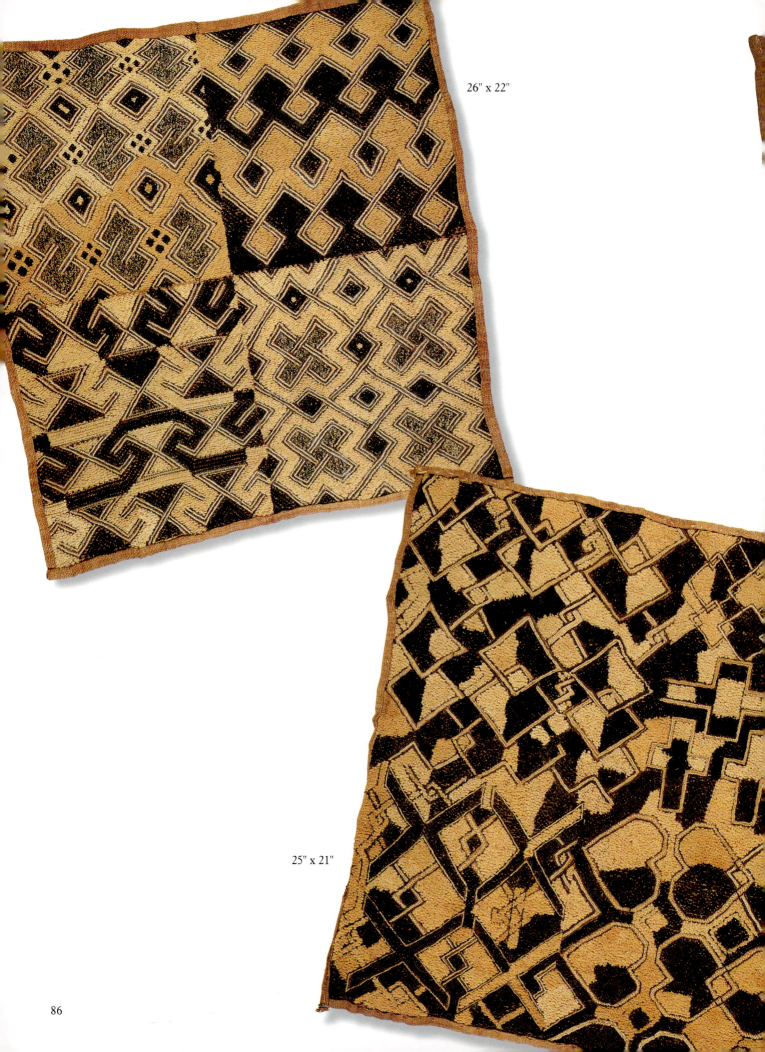

26" x 22"

25" x 21"

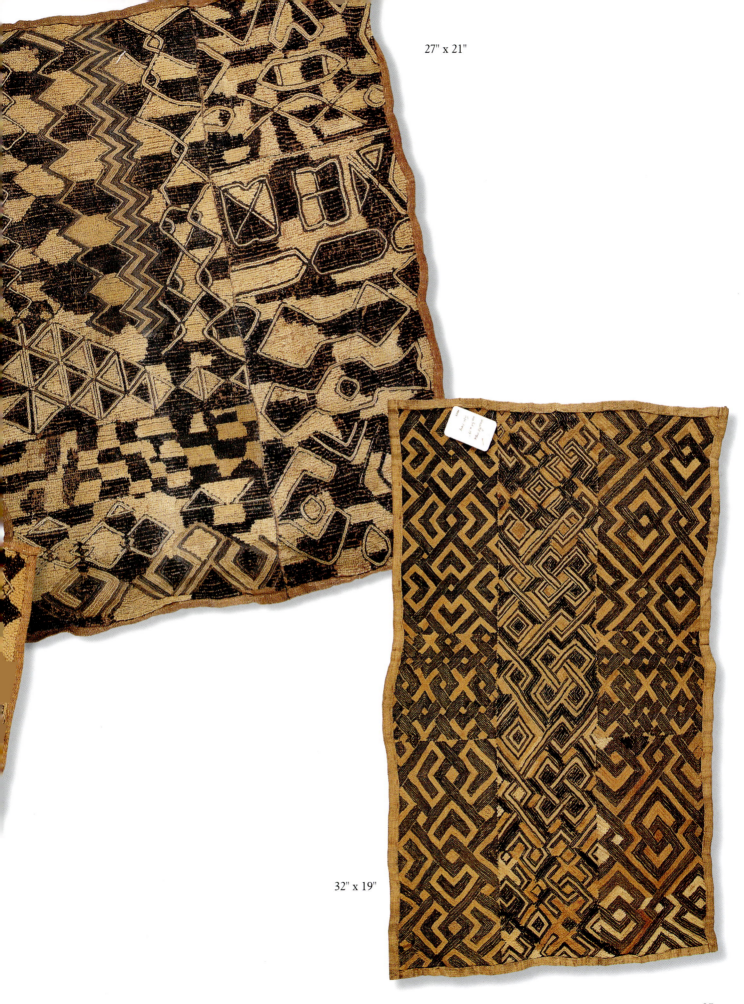

27" x 21"

32" x 19"

87

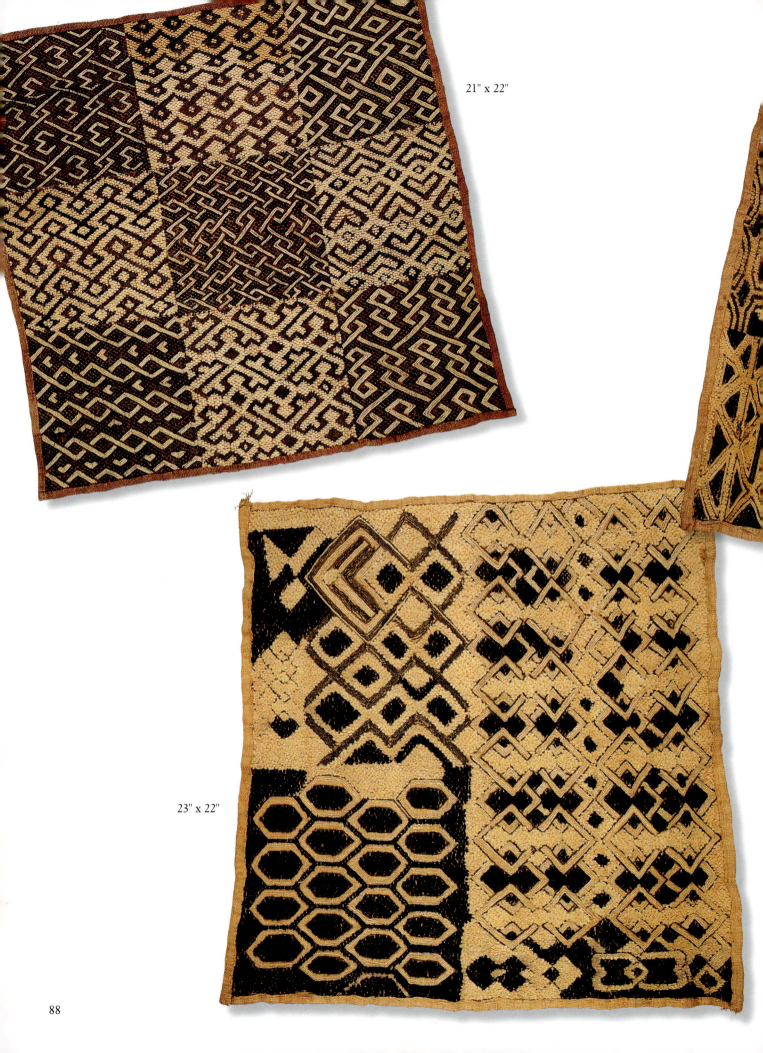

21" x 22"

23" x 22"

88

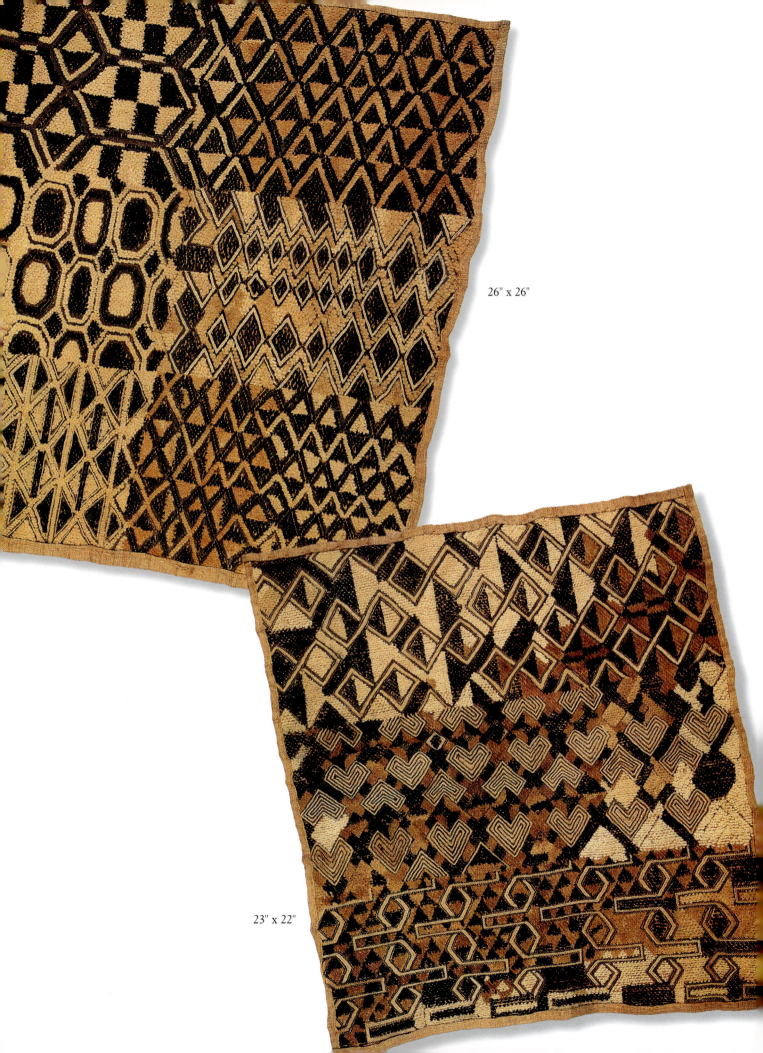

26" x 26"

23" x 22"

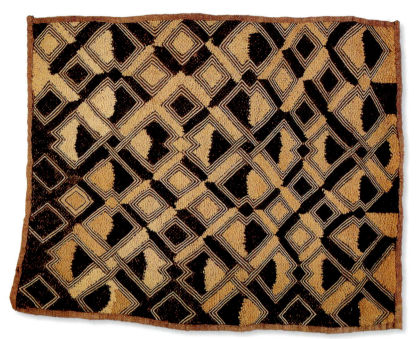

27" x 22"

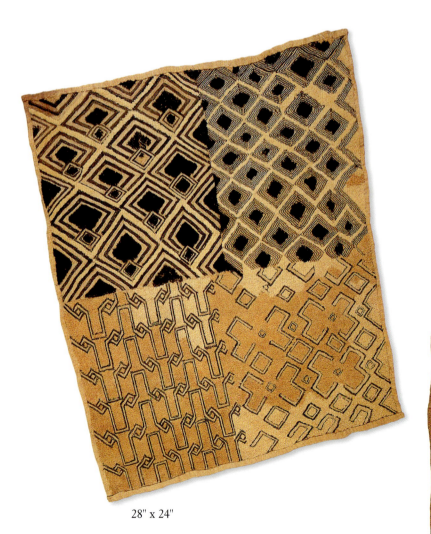

26" x 23"

28" x 24"

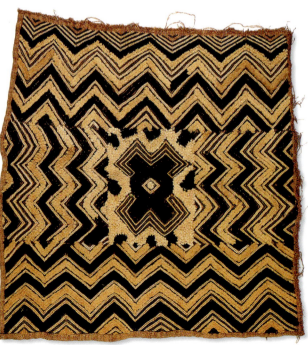

21½" x 21½"

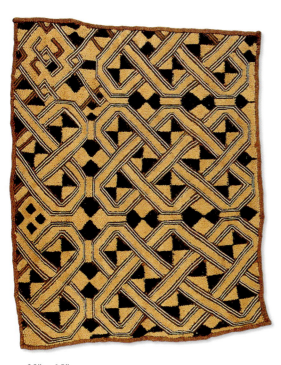

22" x 18"

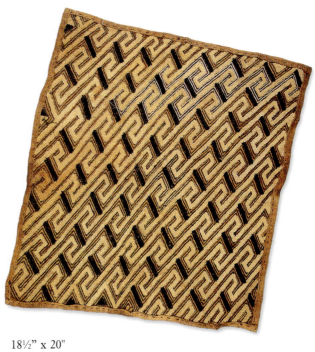

18½" x 20"

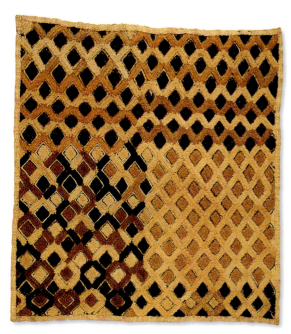

19" x 20"

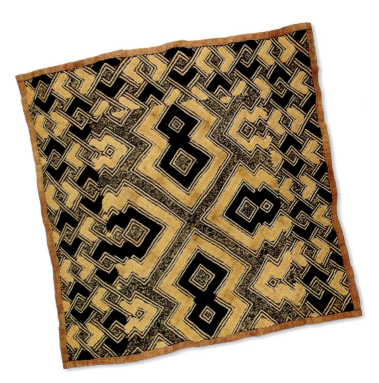

21" x 21 ½"

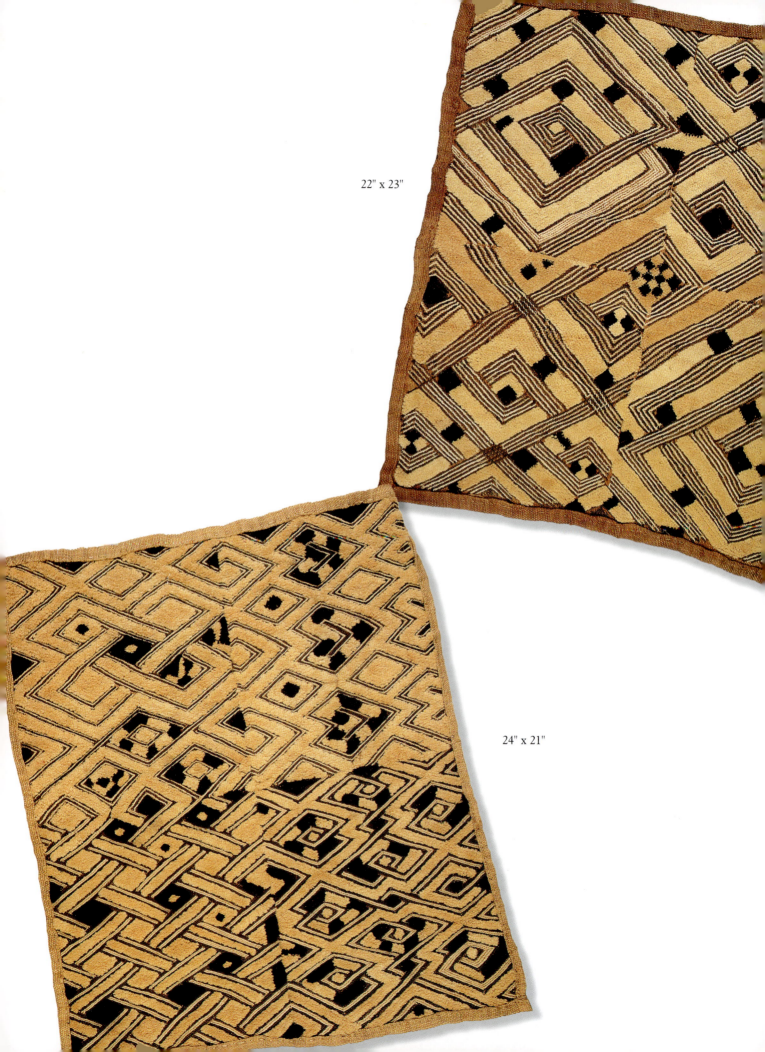

22" x 23"

24" x 21"

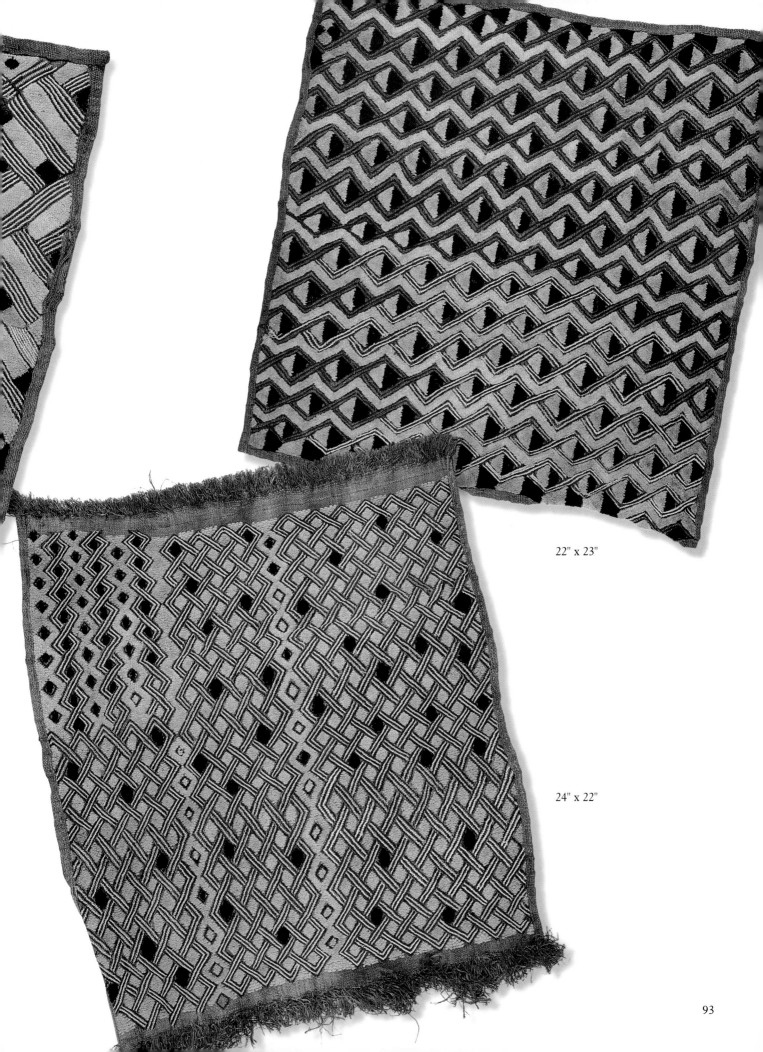

22" x 23"

24" x 22"

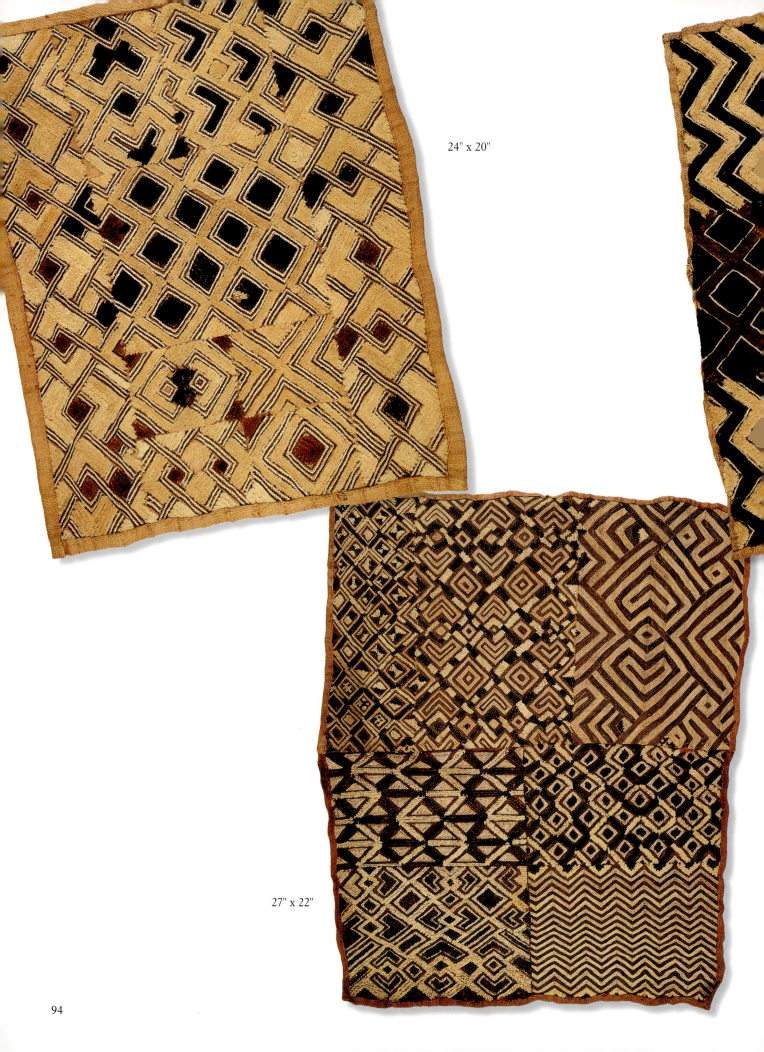

24" x 20"

27" x 22"

94

23" x 23"

23" x 22"

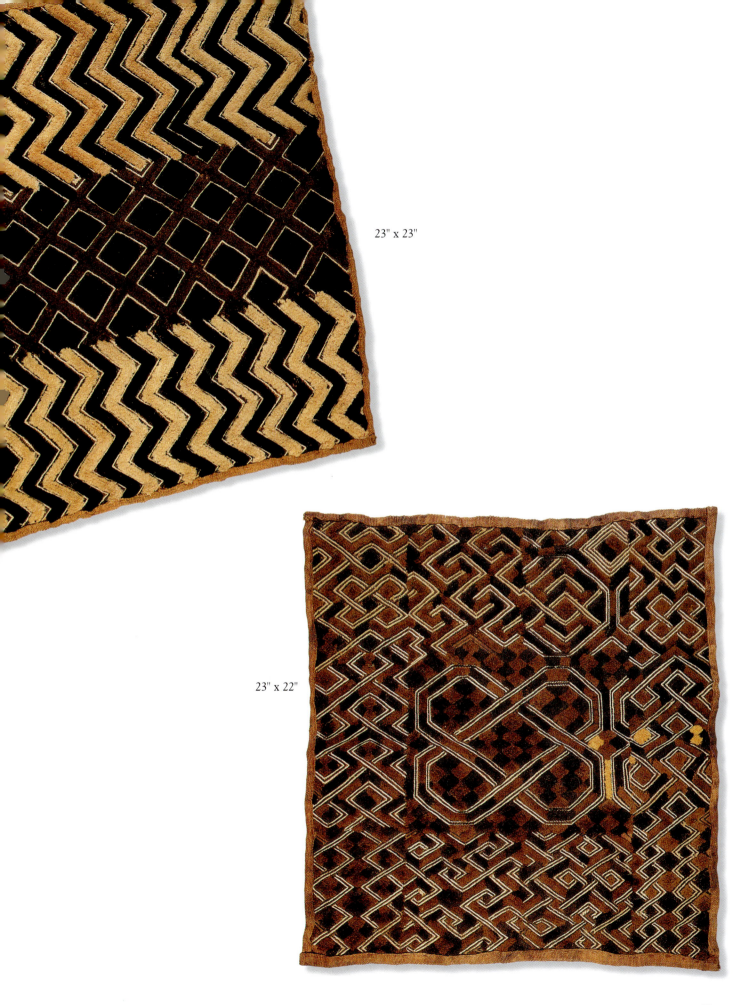

95

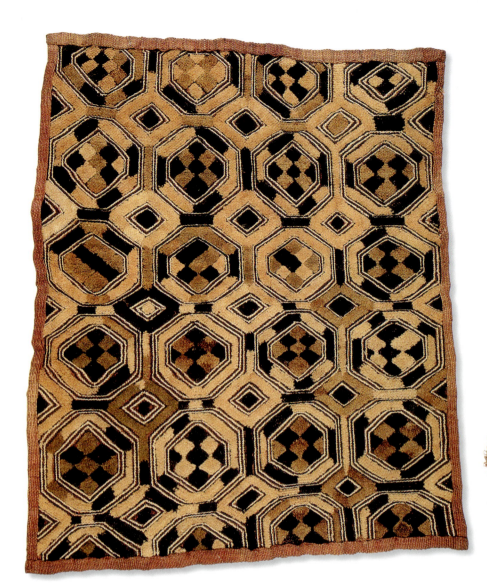

24" x 20"

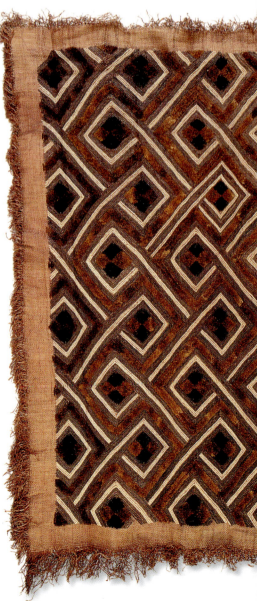

28" x 22"

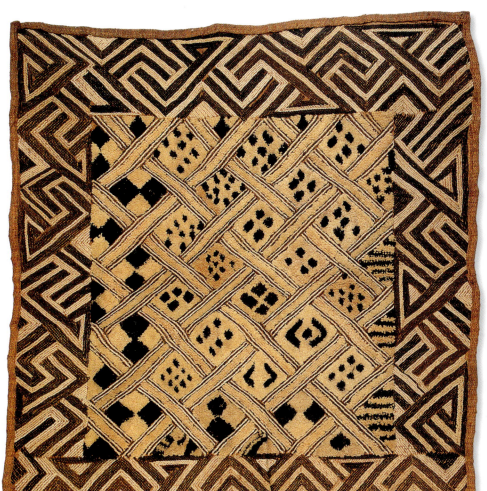

23" x 22"

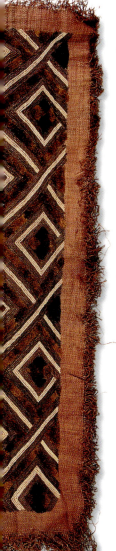

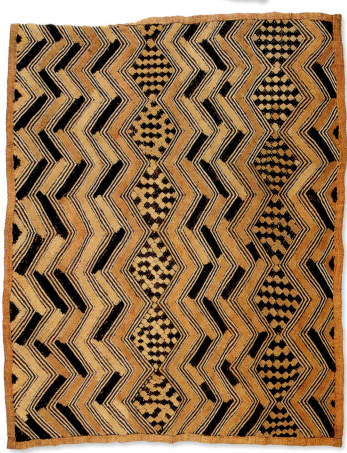

25" x 20"

97

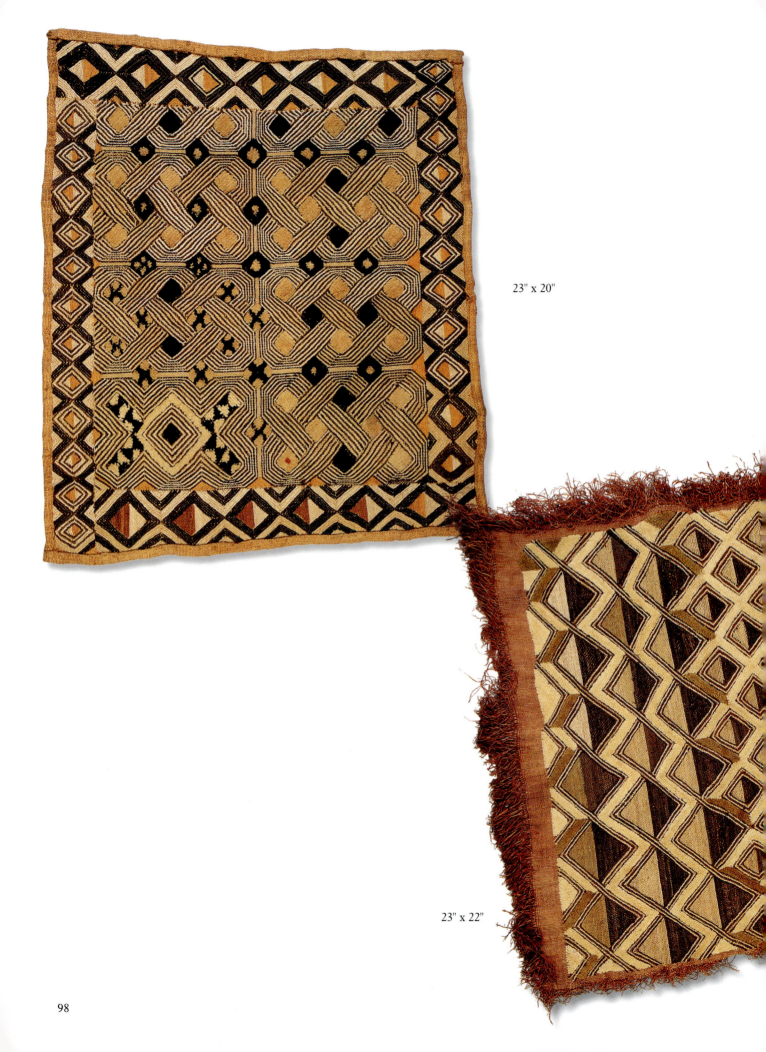

23" x 20"

23" x 22"

98

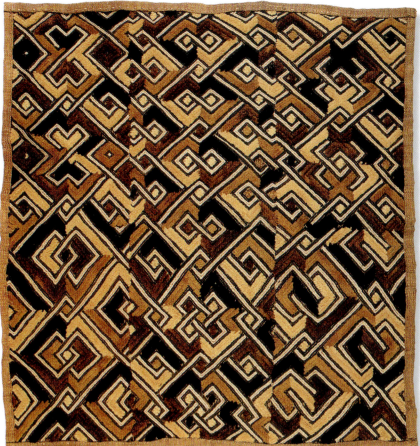
22" x 22"

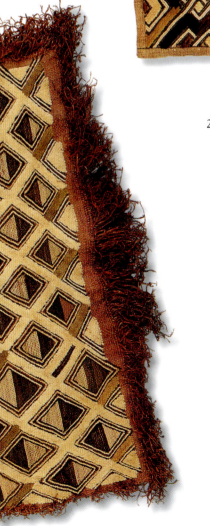

24" x 21"

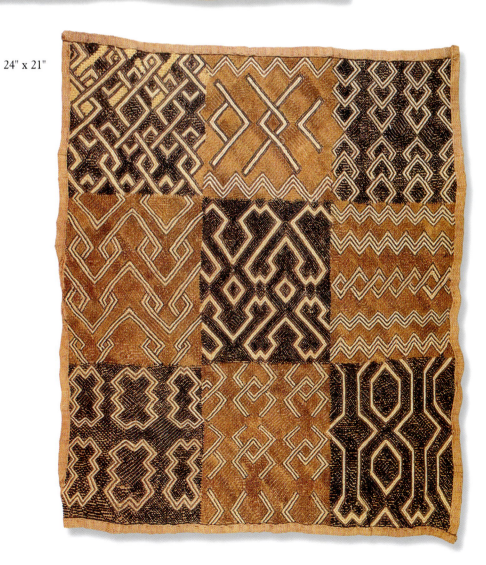

99

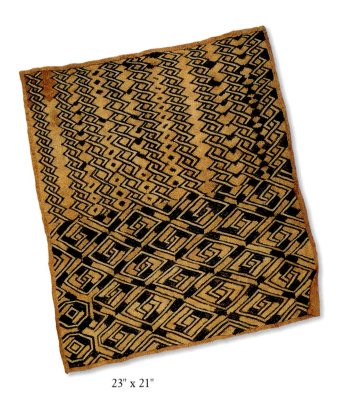

23" x 21"

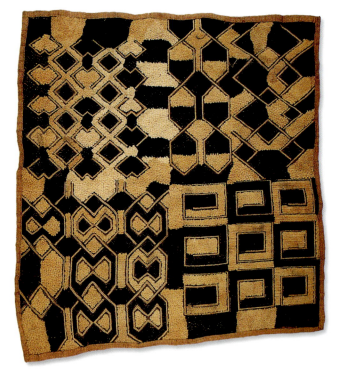

25" x 26"

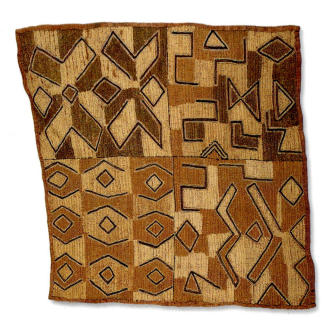

23" x 23"

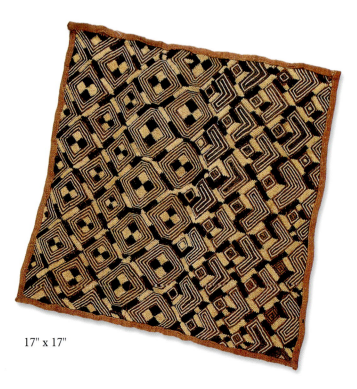

17" x 17"

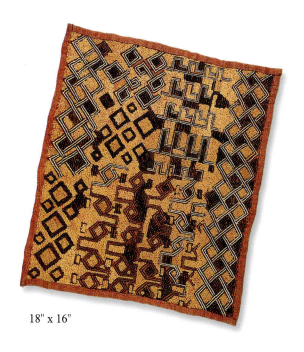

18" x 16"

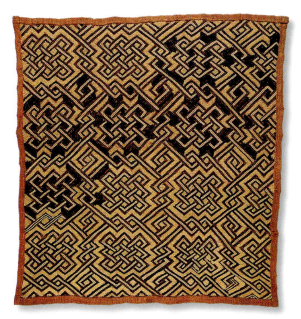

19" x 18"

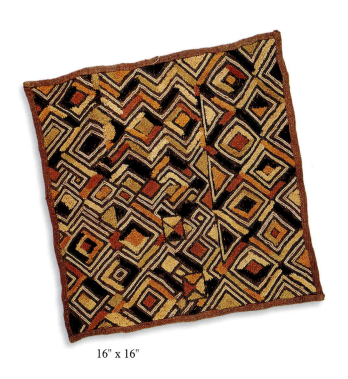

16" x 16"

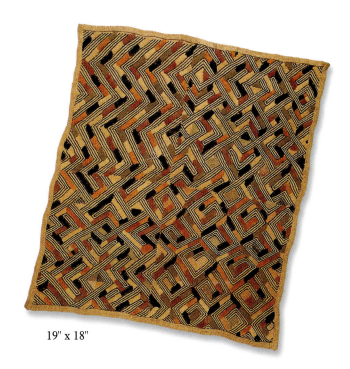

19" x 18"

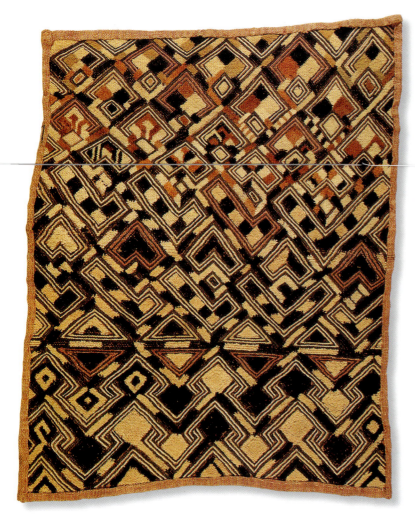

20" x 17"

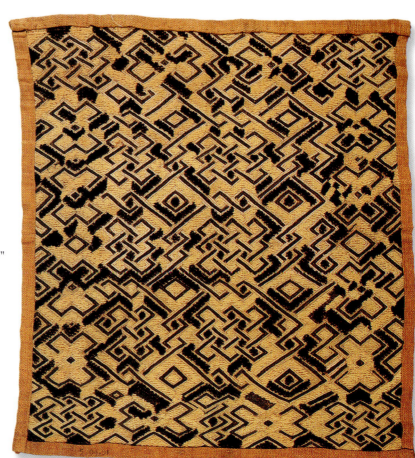

19" x 17"

102

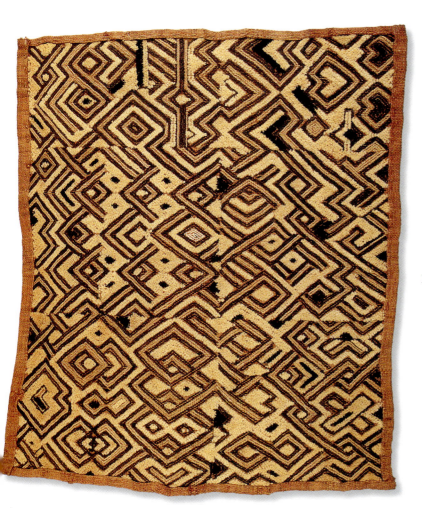

19" x 17"

18" x 17"

103

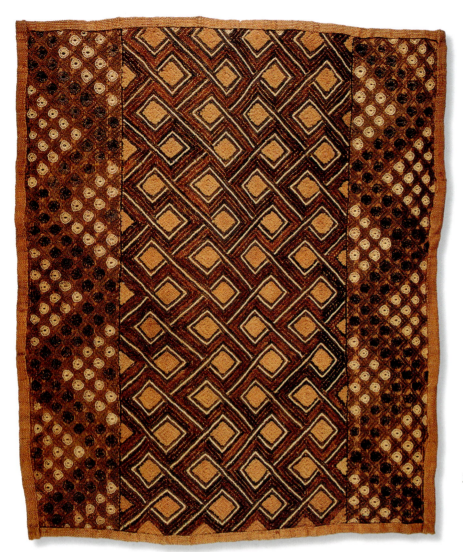

20" x 17"

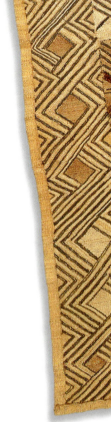

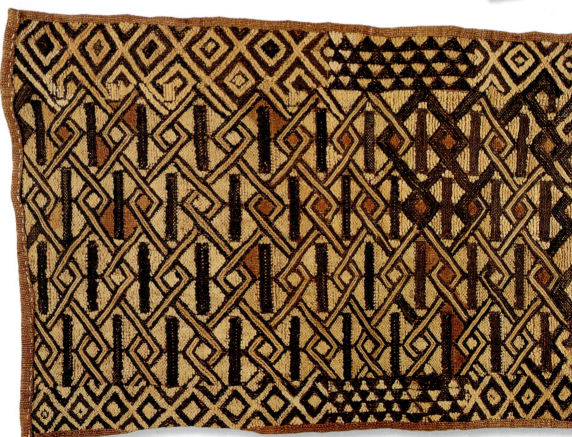

26" x 15"

104

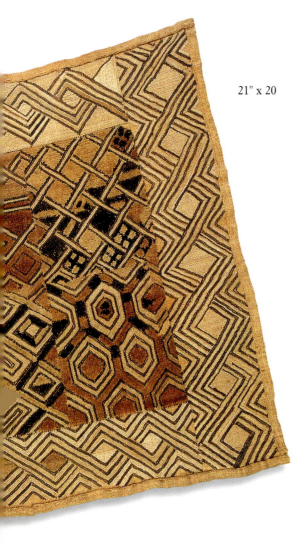
21" x 20"

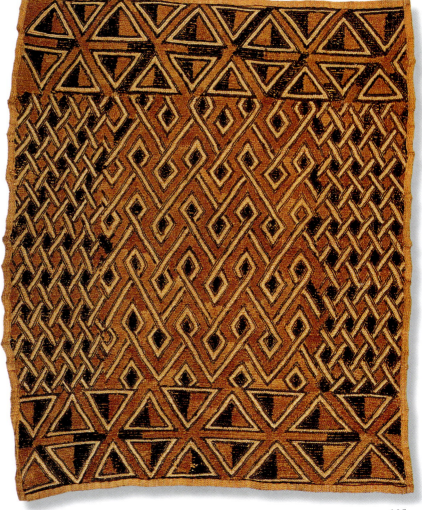
24" x 20"

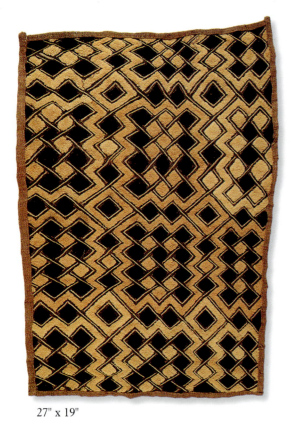

27" x 19"

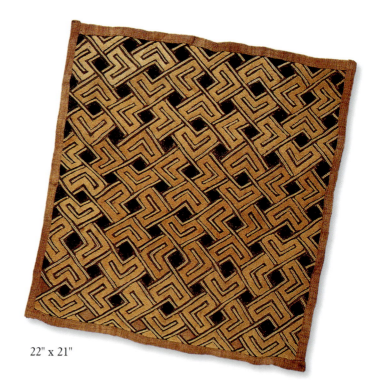

22" x 21"

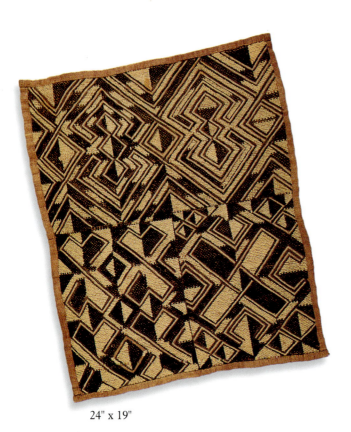

24" x 19"

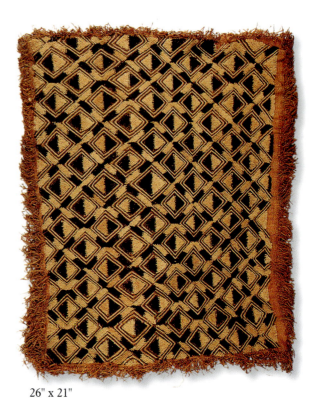

26" x 21"

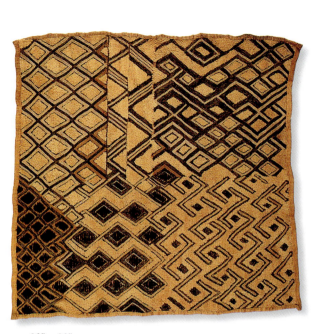

23" x 22"

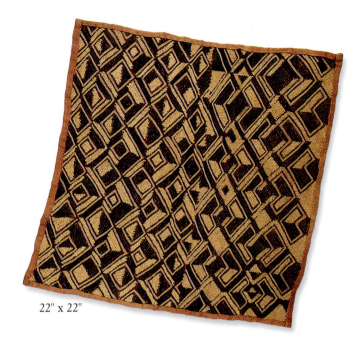

22" x 22"

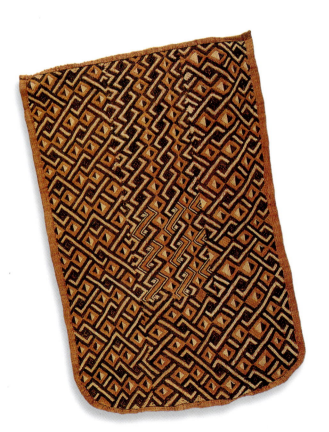

29" x 19"

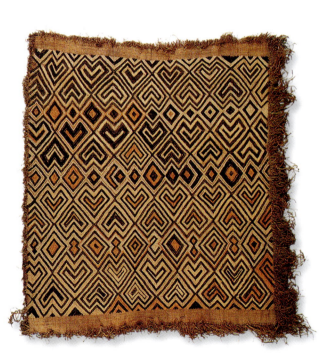

22" x 23"

107

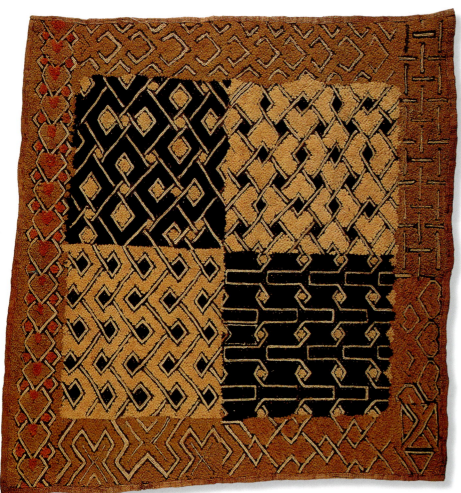

23" x 22"

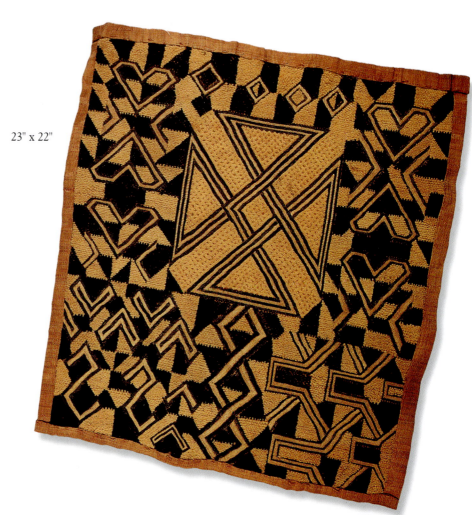

23" x 22"

108

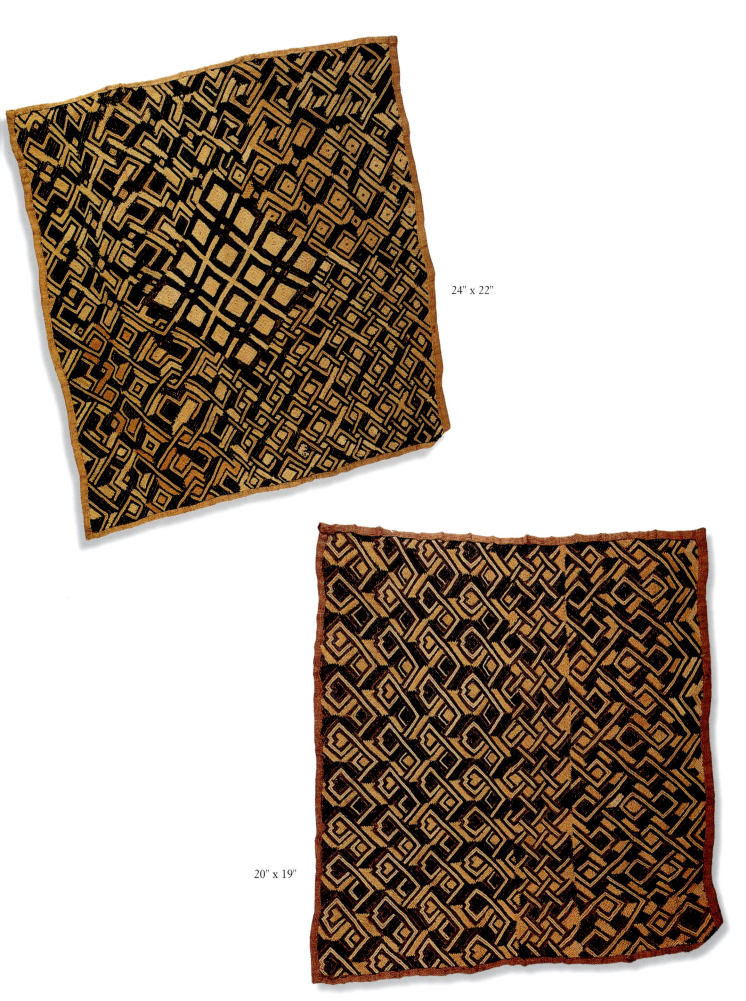

24" x 22"

20" x 19"

109

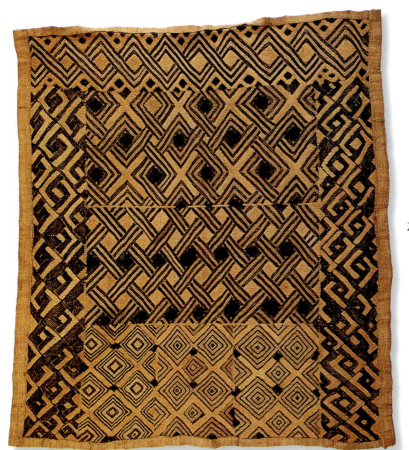

22" x 21"

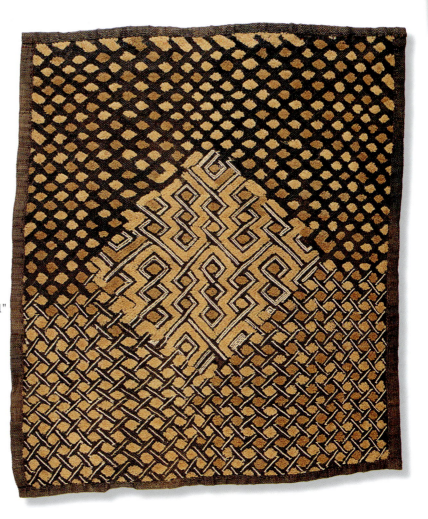

23" x 21"

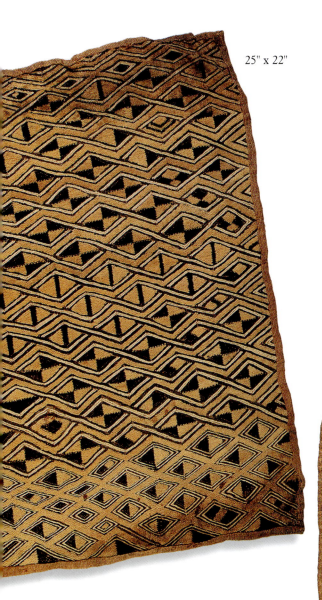
25" x 22"

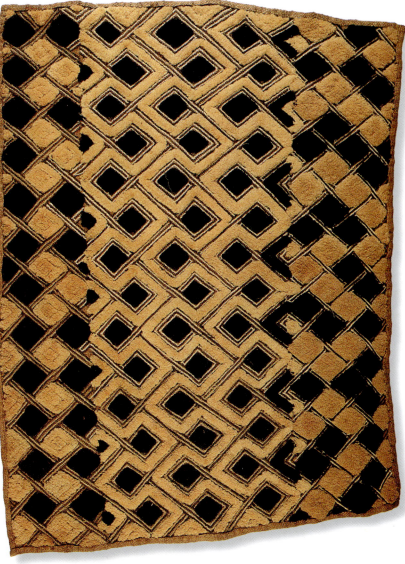
29" x 22"

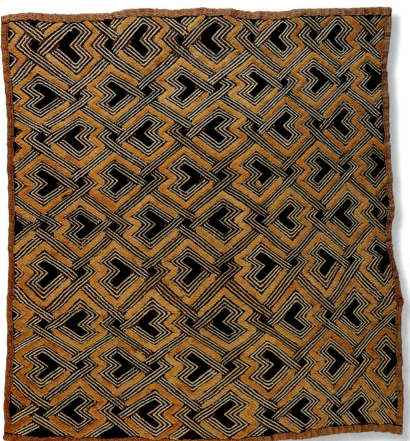

23" x 21"

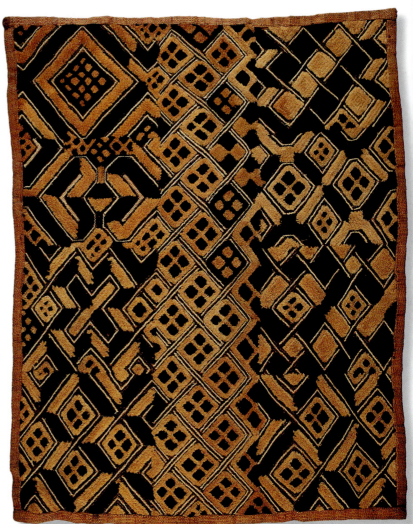

26" x 21"

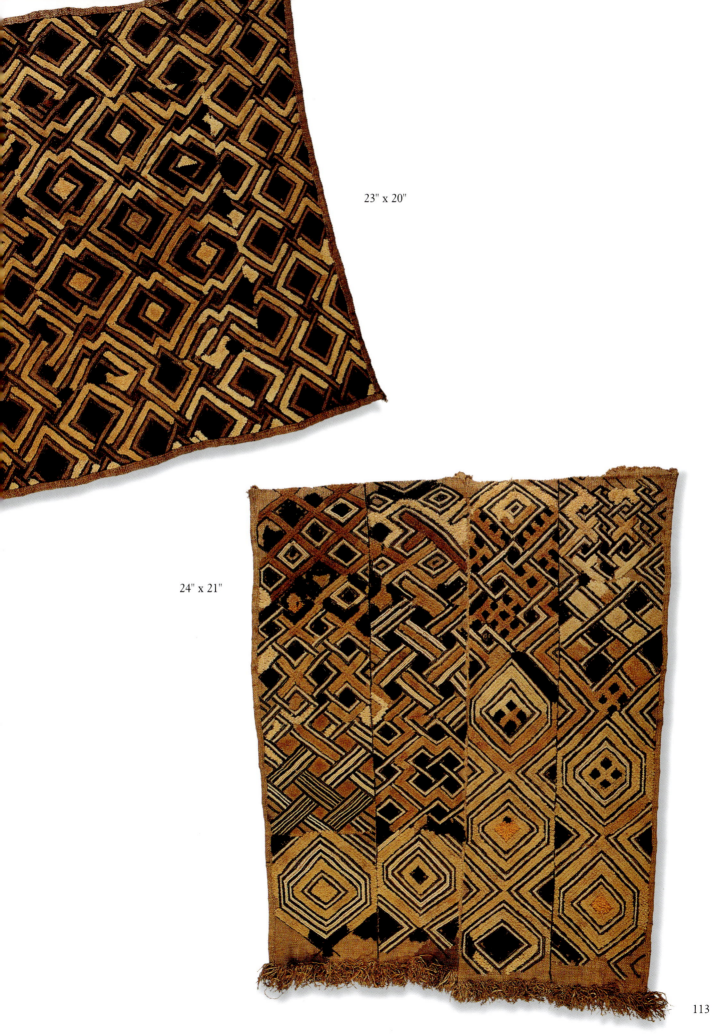

23" x 20"

24" x 21"

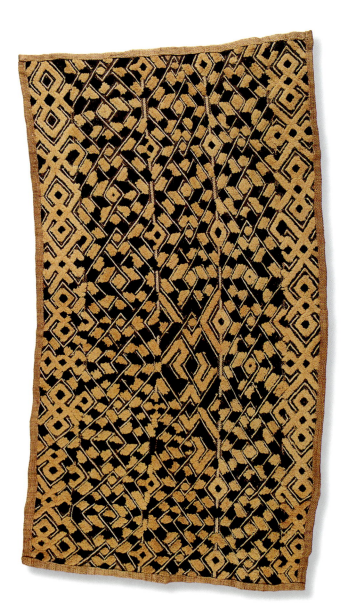

31" x 18"

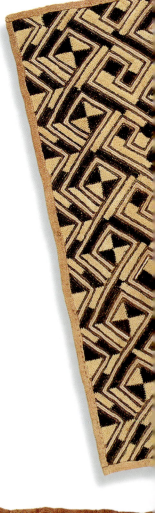

21½" x 22"

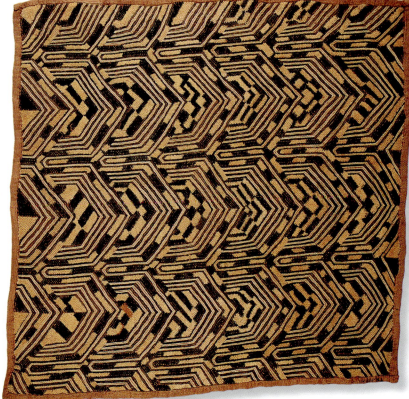

114

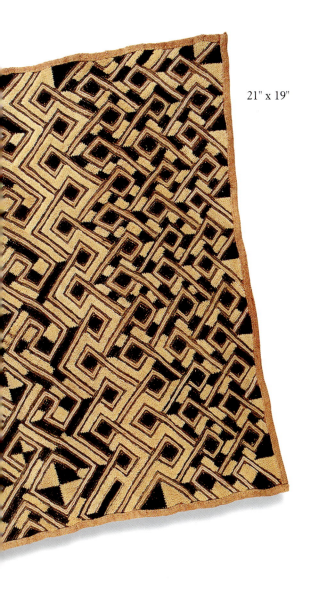

21" x 19"

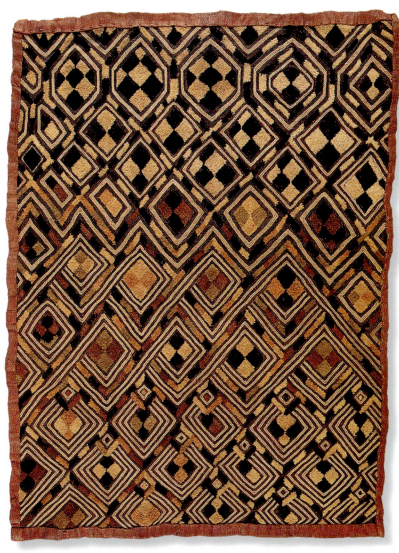

23" x 17½"

115

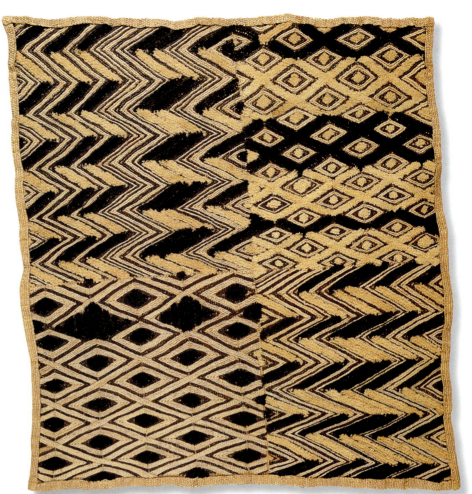

21½" x 20½"

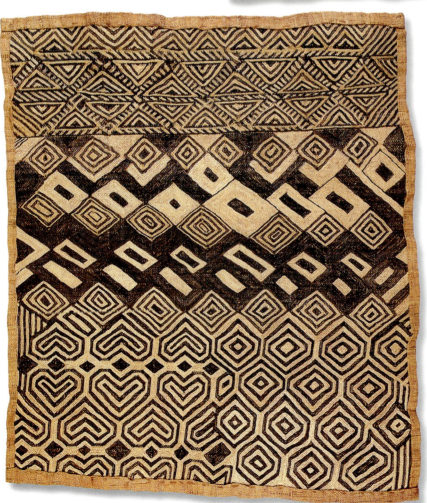

21" x 19"

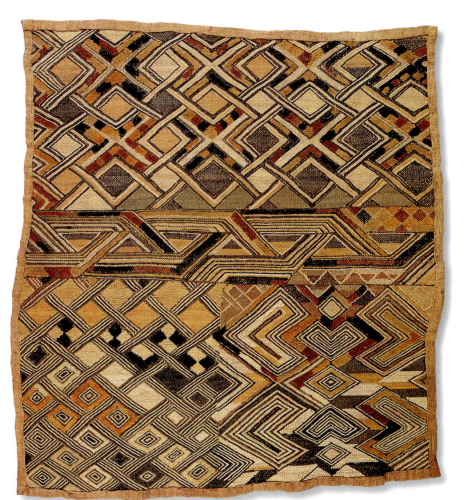

21" x 20"

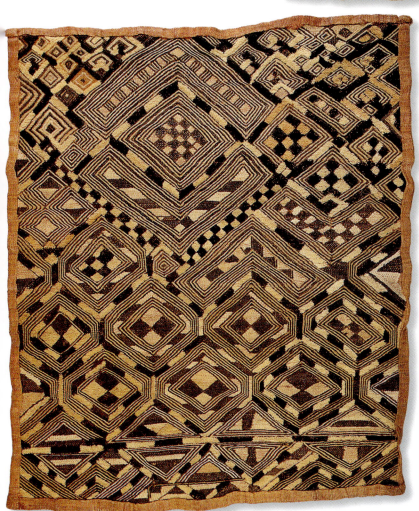

21" x 18"

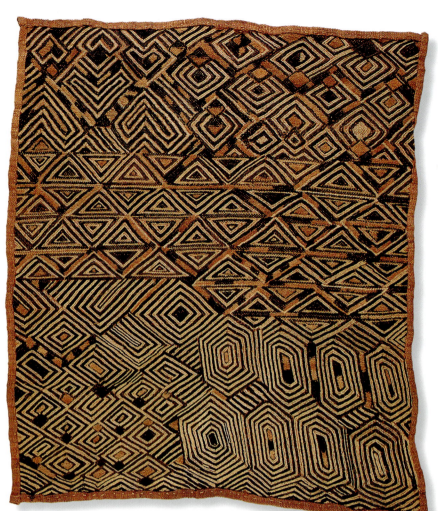

22" x 19"

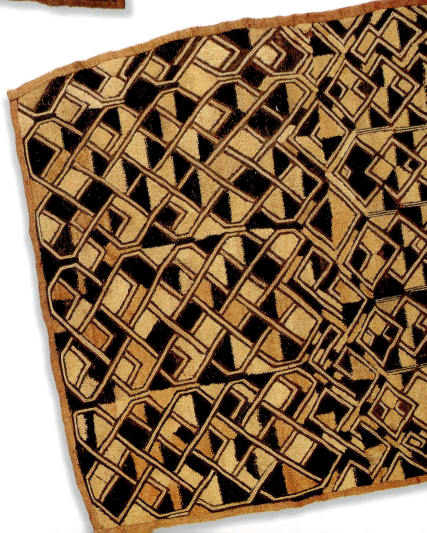

22½" x 19"

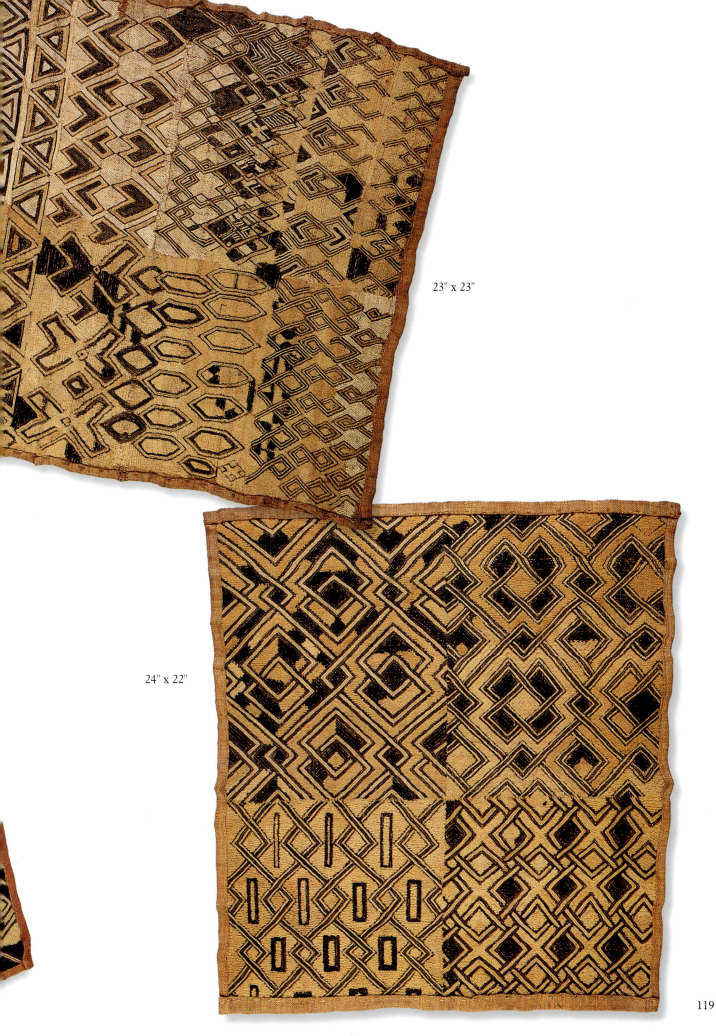

23" x 23"

24" x 22"

119

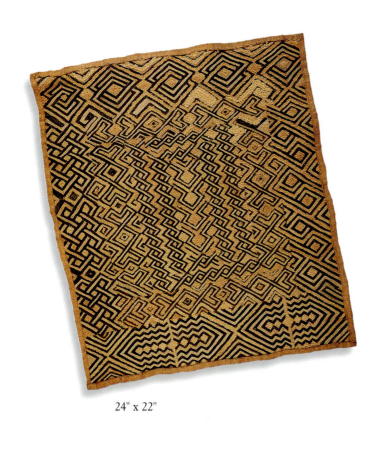

24" x 22"

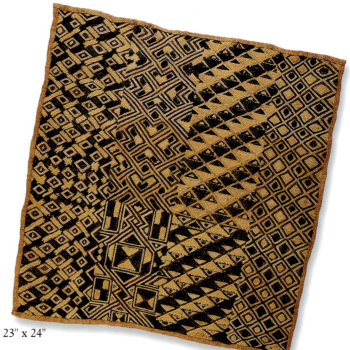

23" x 24"

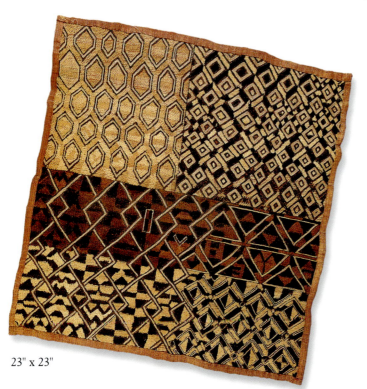

23" x 23"

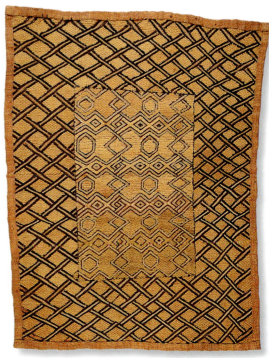

25" x 19"

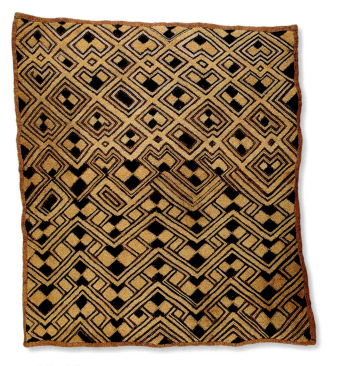

24" x 21"

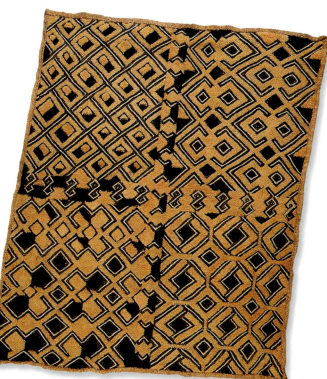

27" x 22"

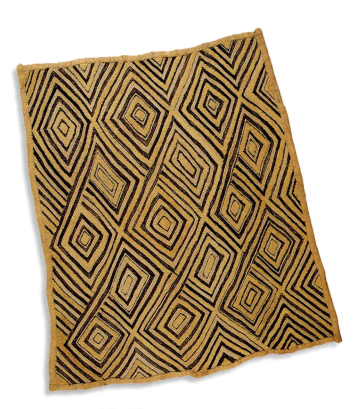

24" x 20"

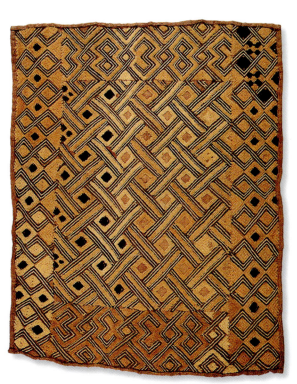

25" x 21"

121

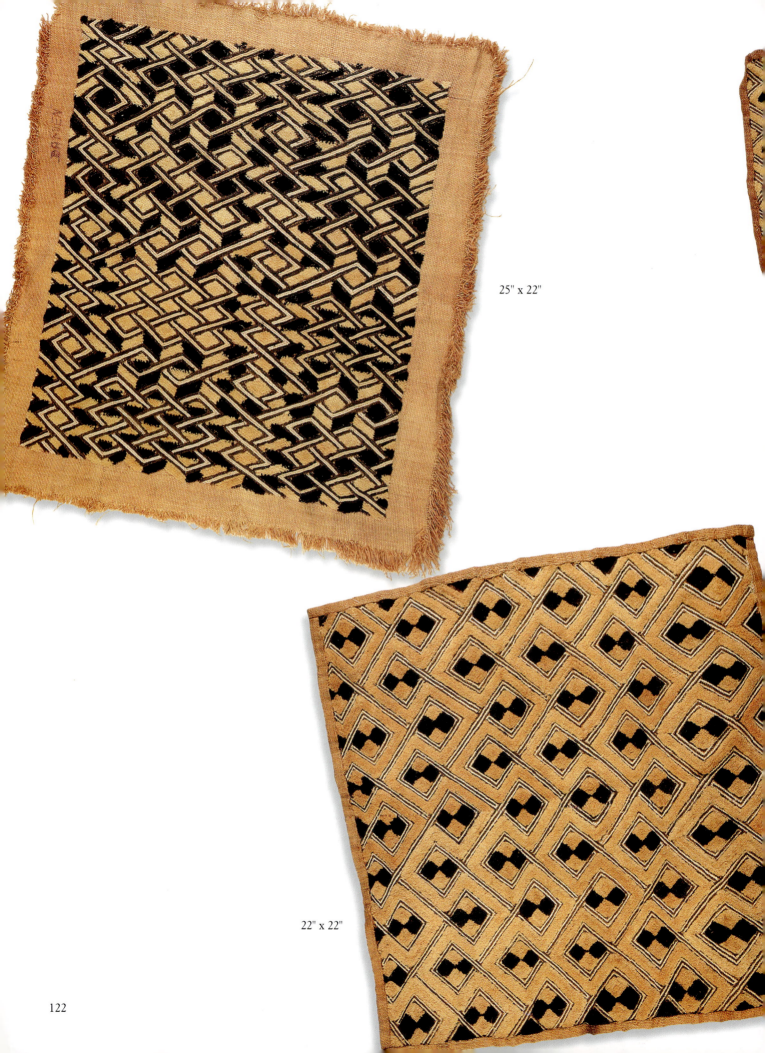

25" x 22"

22" x 22"

122

22" x 22"

24" x 22"

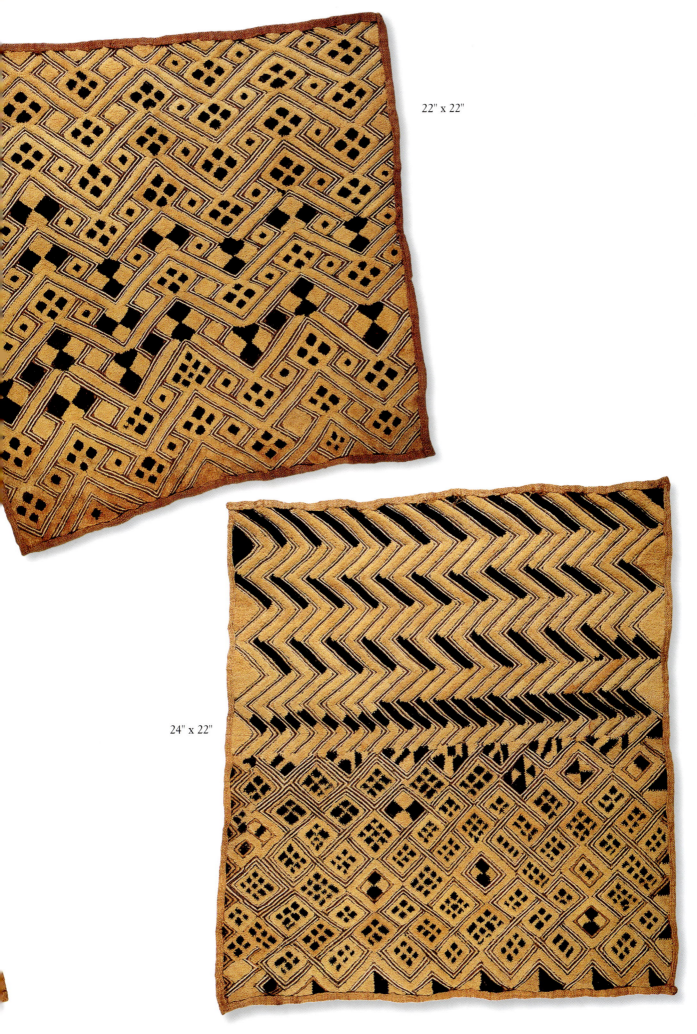

123

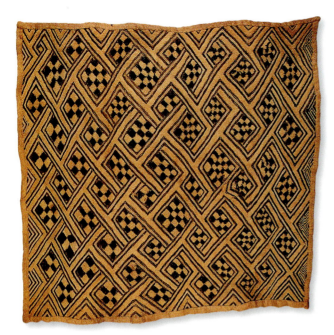

22" x 21"

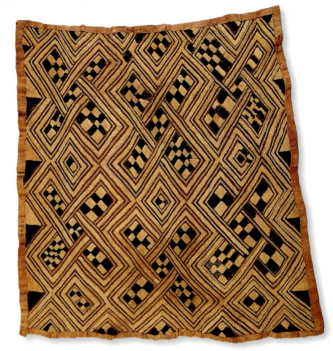

24" x 23"

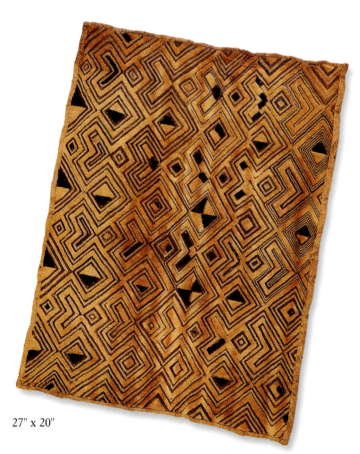

27" x 20"

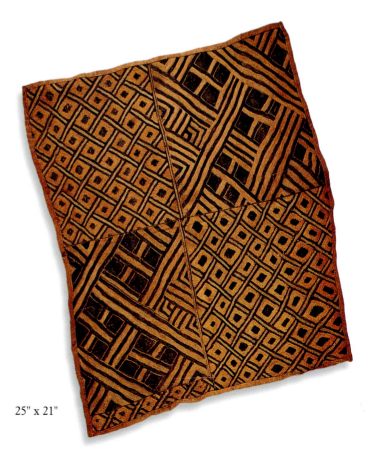

25" x 21"

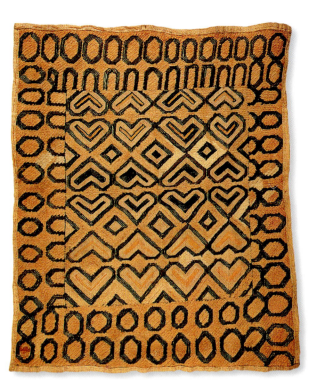

28" x 23"

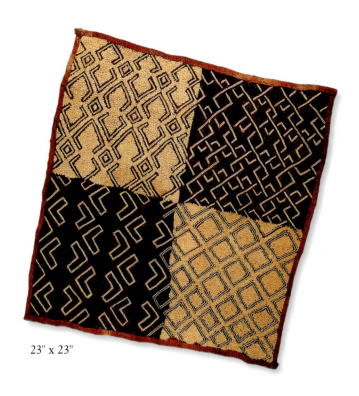

23" x 23"

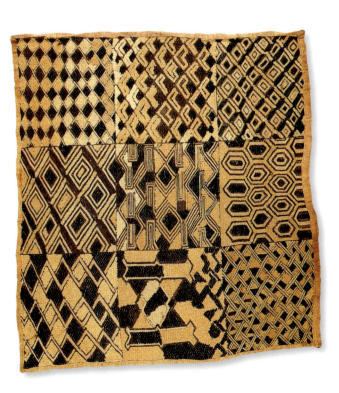

26" x 26"

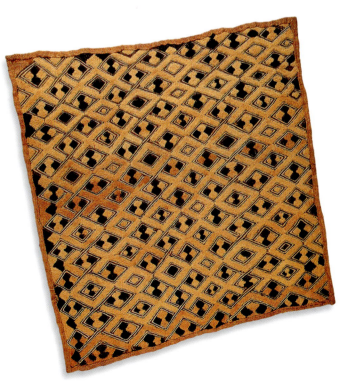

22" x 22"

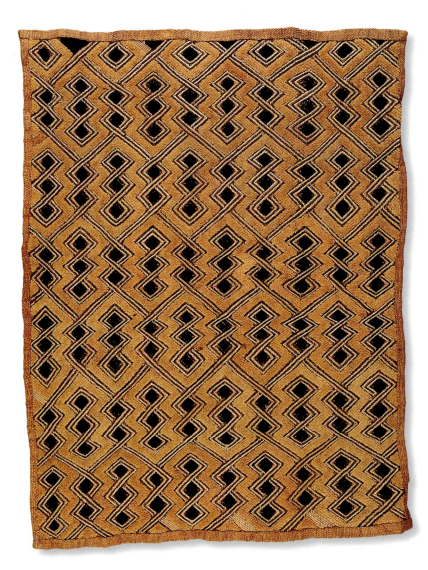

24" x 19"

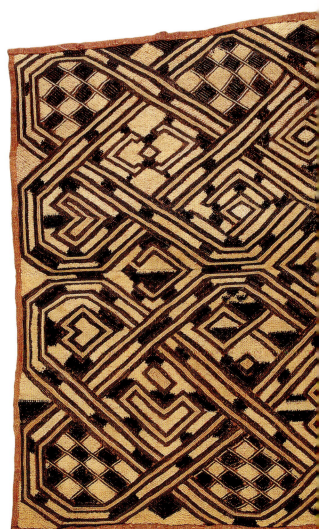

24" x 19½"

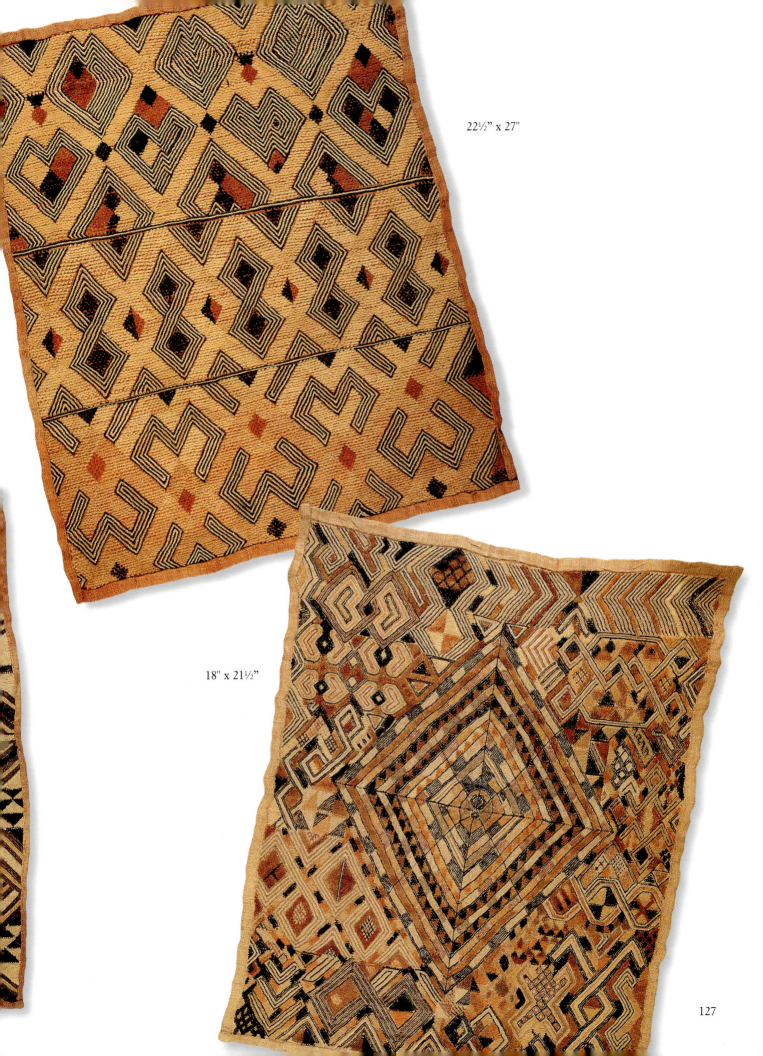

22½" x 27"

18" x 21½"

127

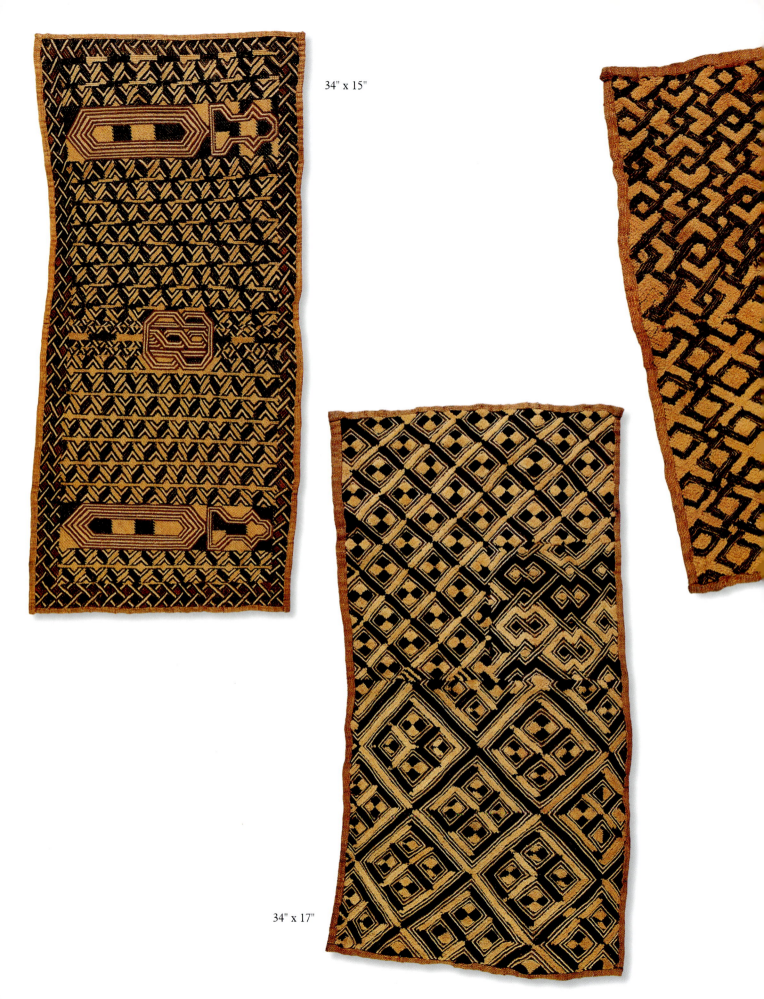

34" x 15"

34" x 17"

128

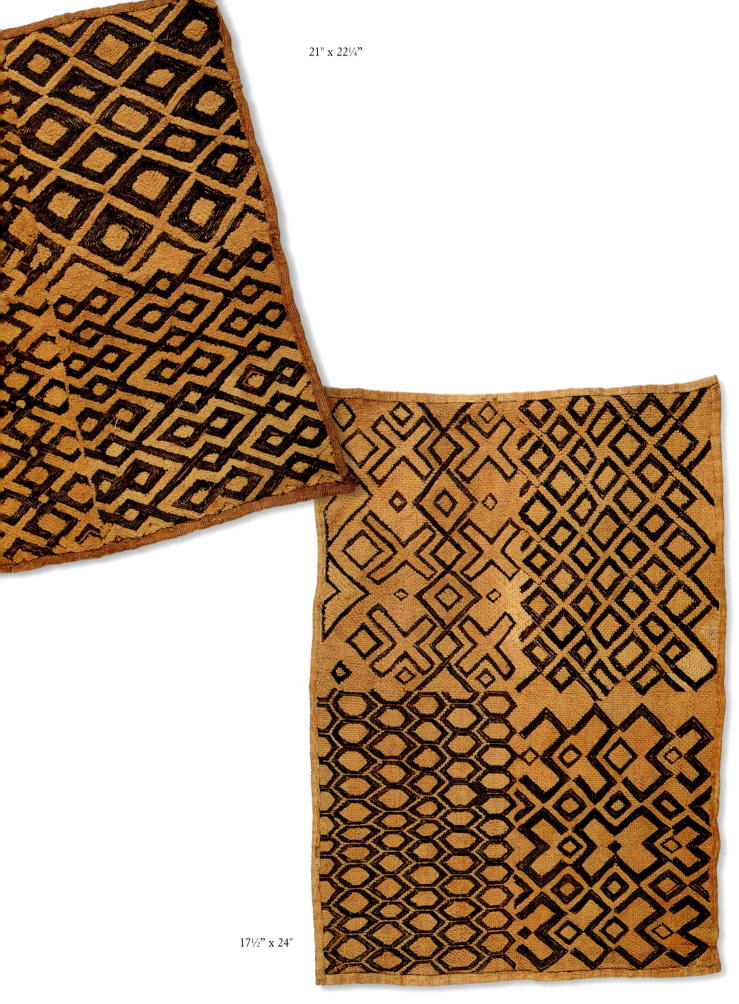

21" x 22¼"

17½" x 24"

129

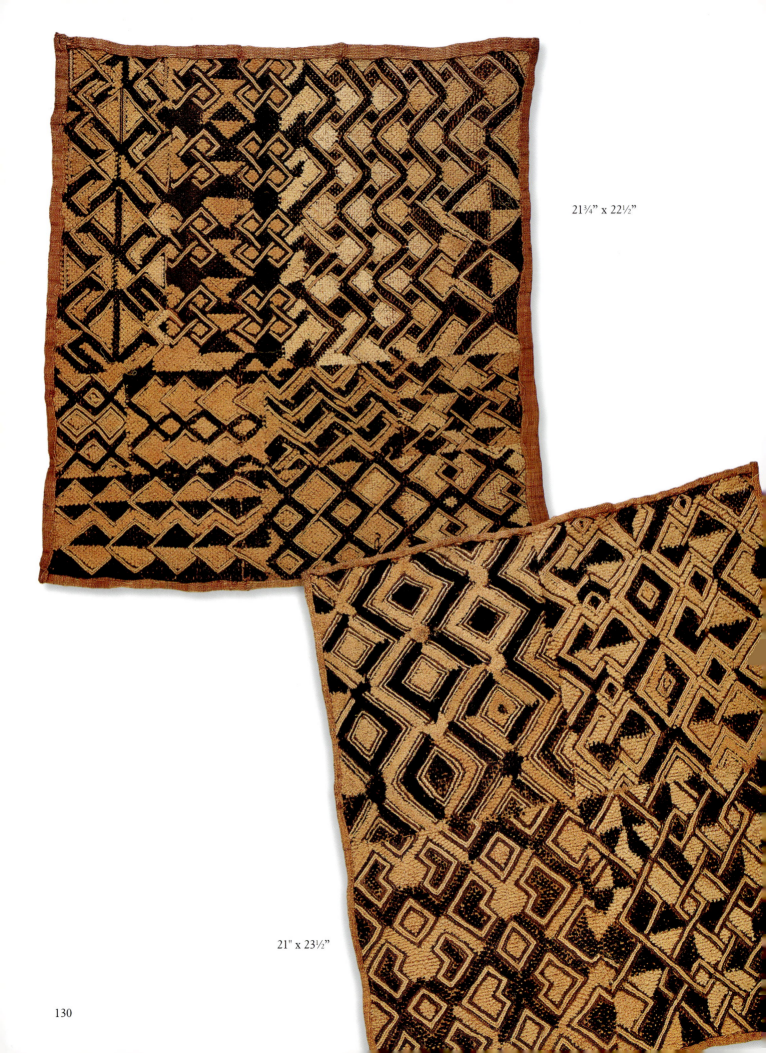

21¾" x 22½"

21" x 23½"

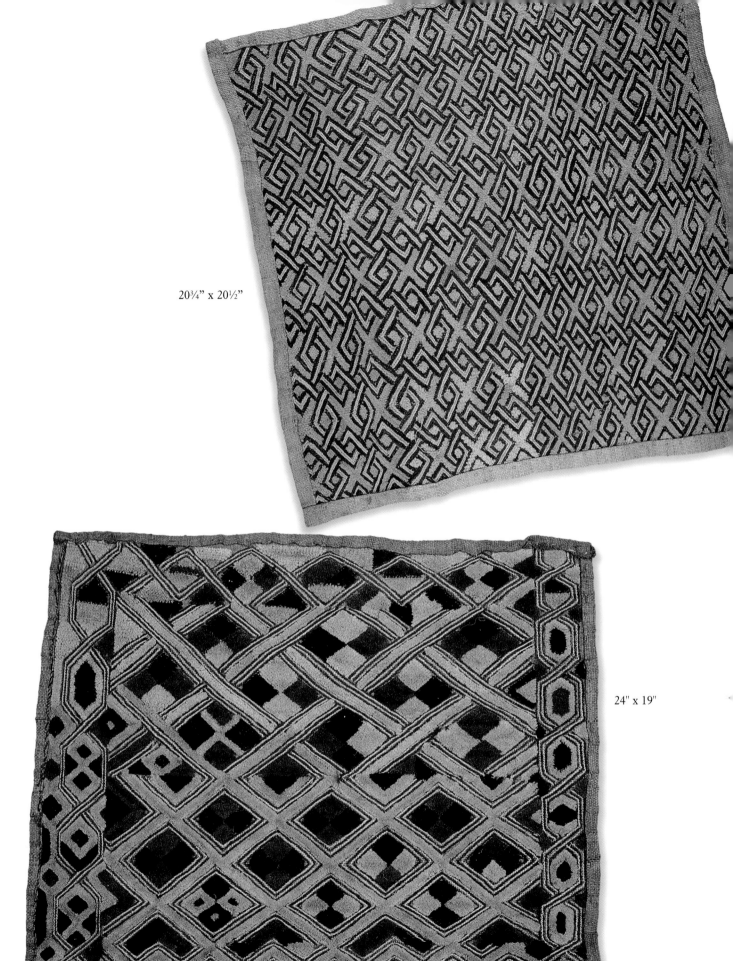

20¾" x 20½"

24" x 19"

131

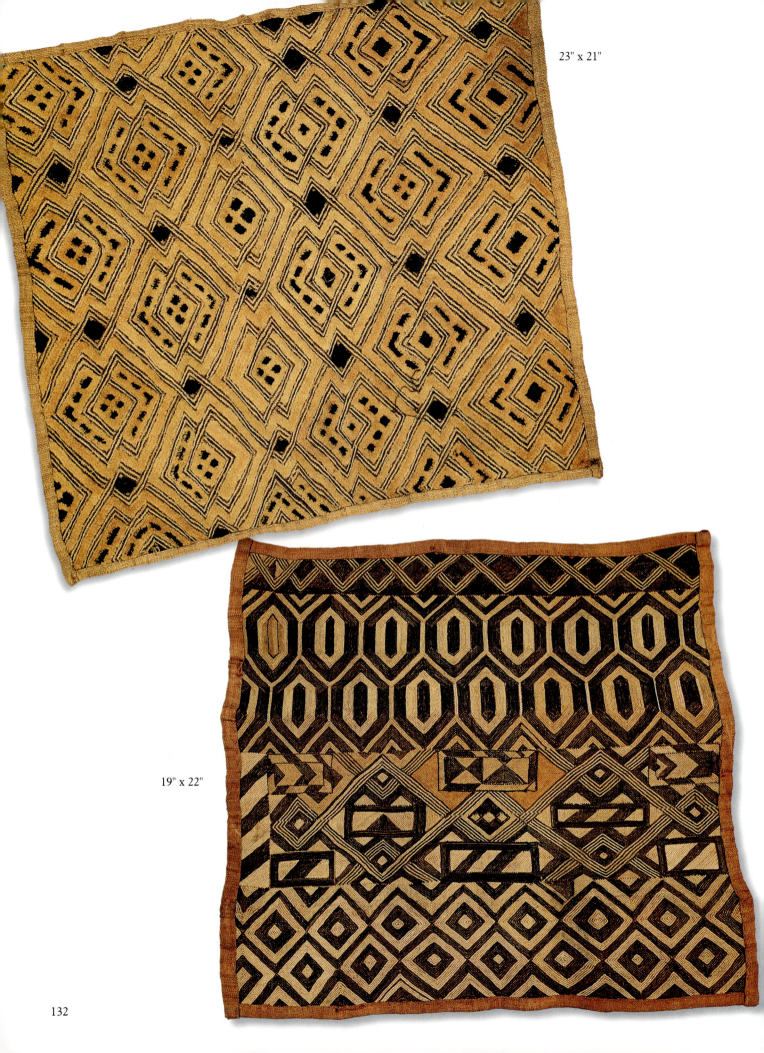

23" x 21"

19" x 22"

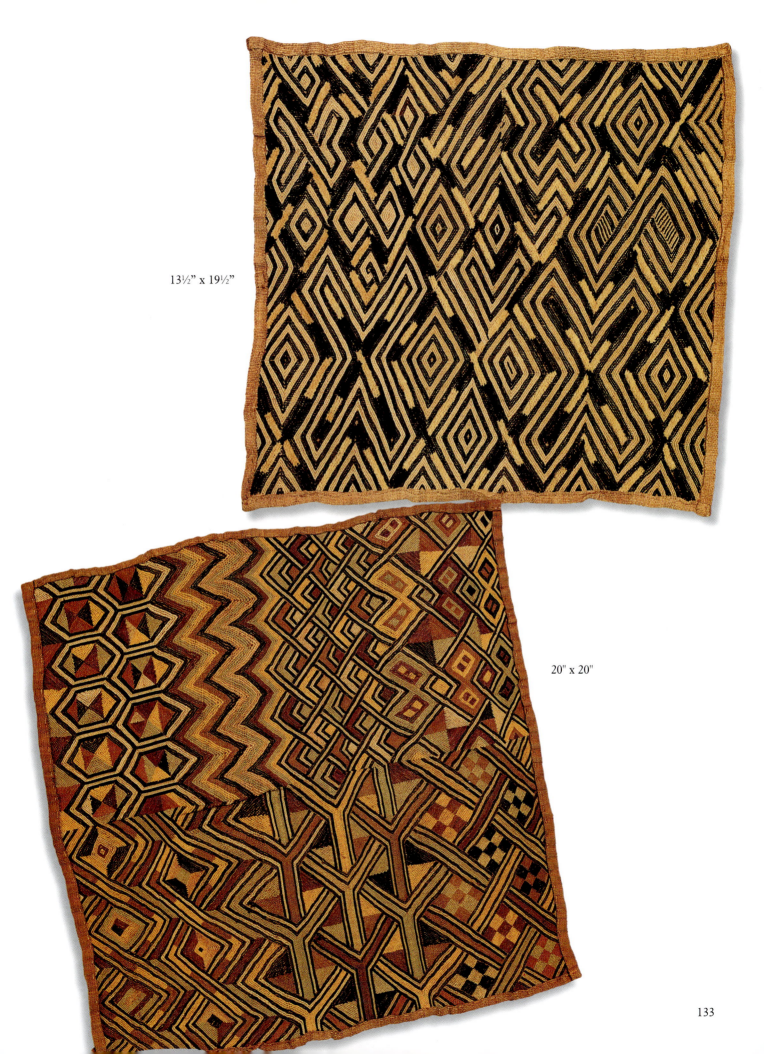

13½" x 19½"

20" x 20"

133

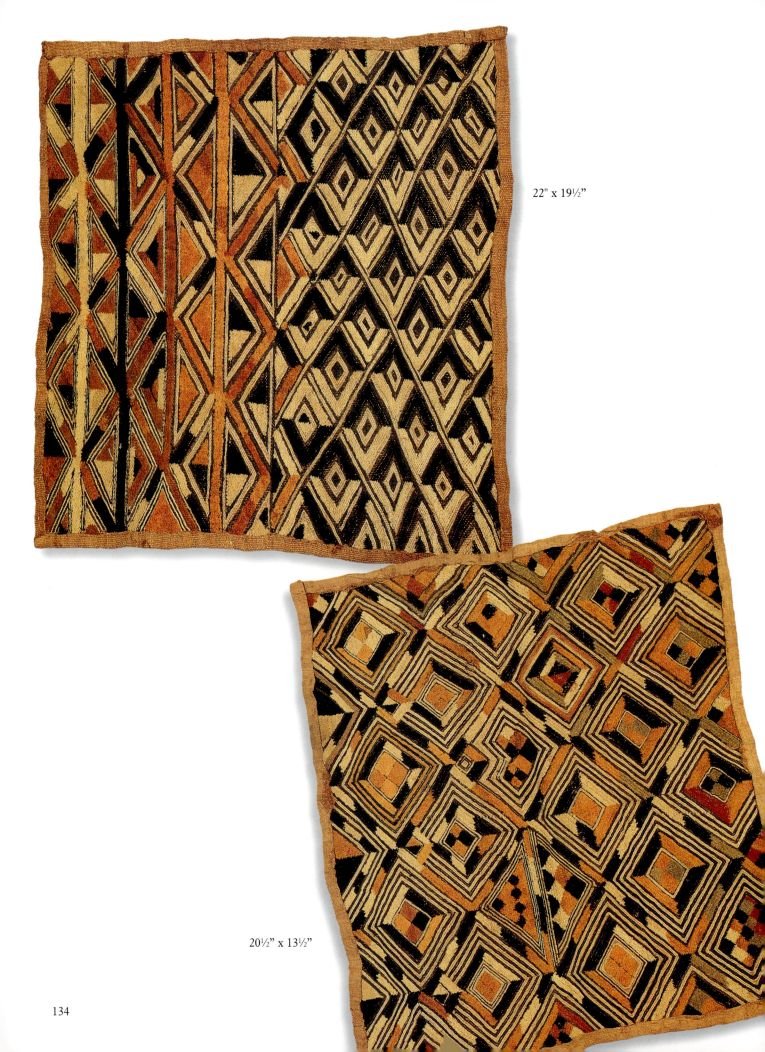

22" x 19½"

20½" x 13½"

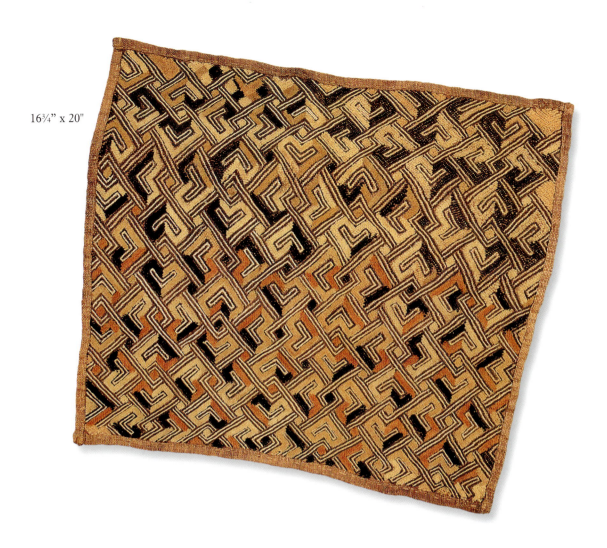
16¾" x 20"

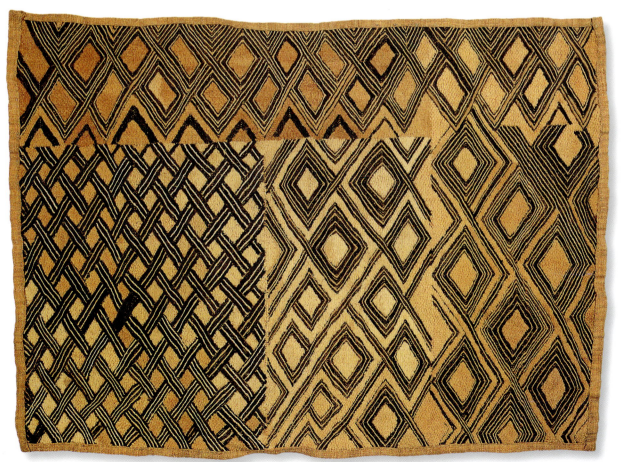
18" x 24½"

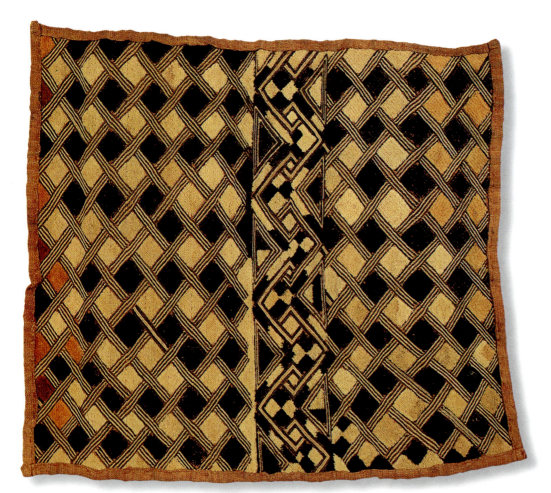

17" x 20"

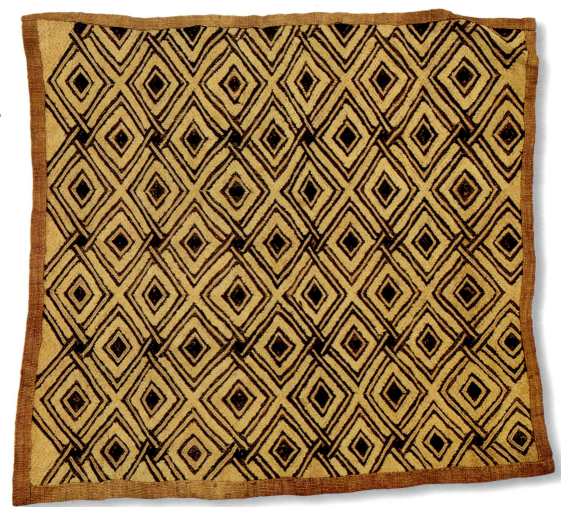

19" x 21"

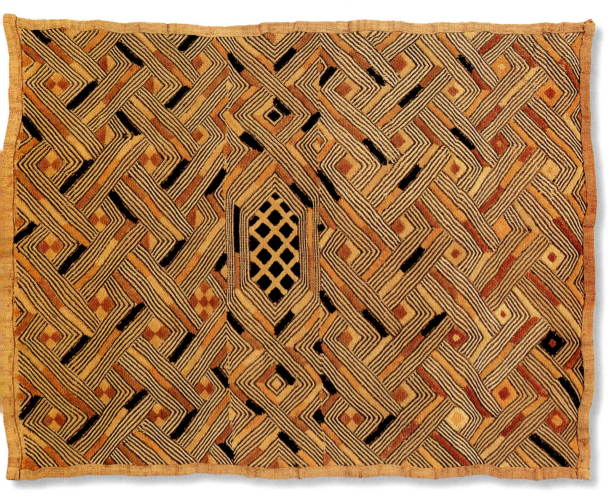

16" x 22"

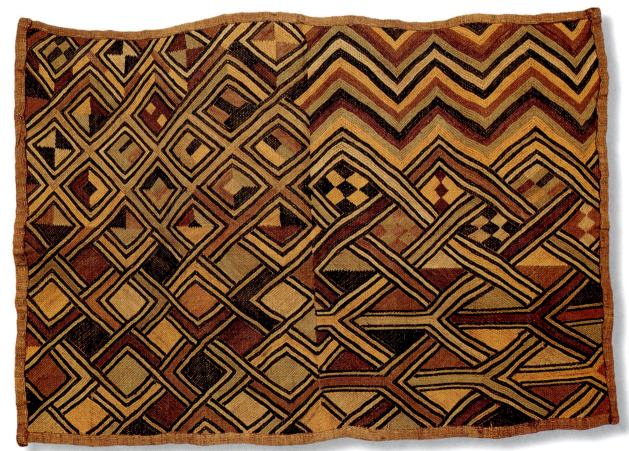

15" x 22"

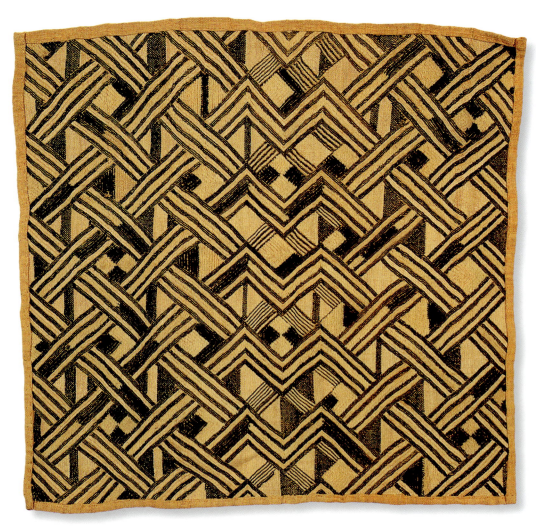

19" x 20¼"

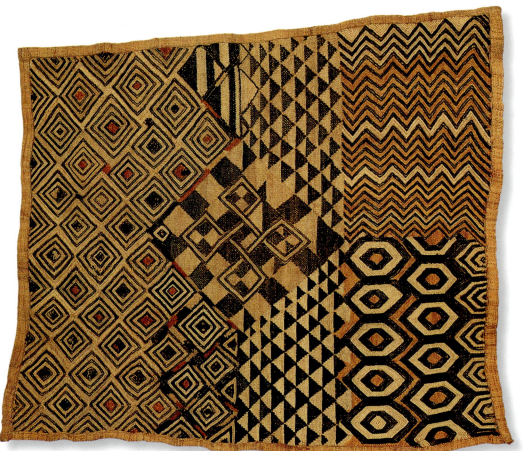

18" x 20"

138

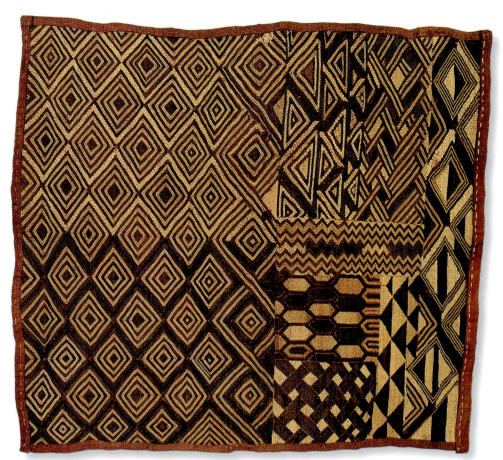

17" x 19¾"

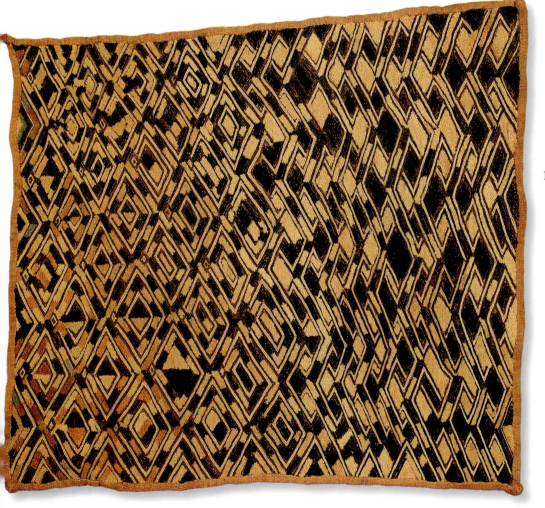

19½" x 21½"

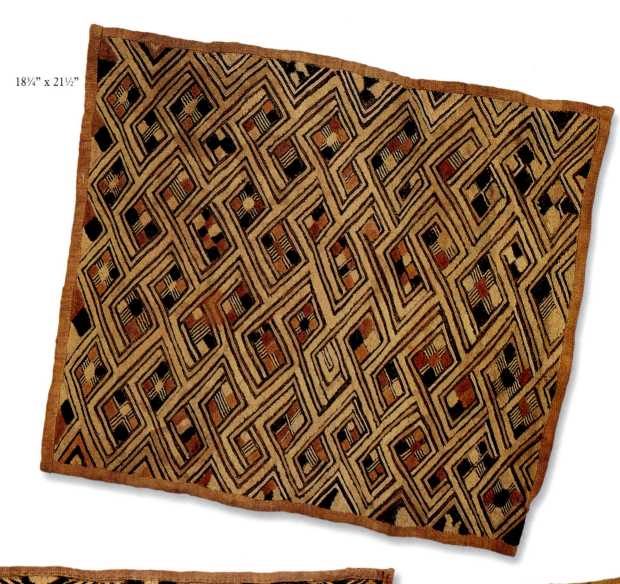

18¾" x 21½"

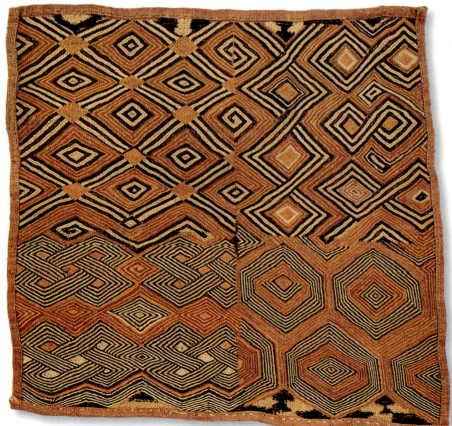

17½" x 13½"

140

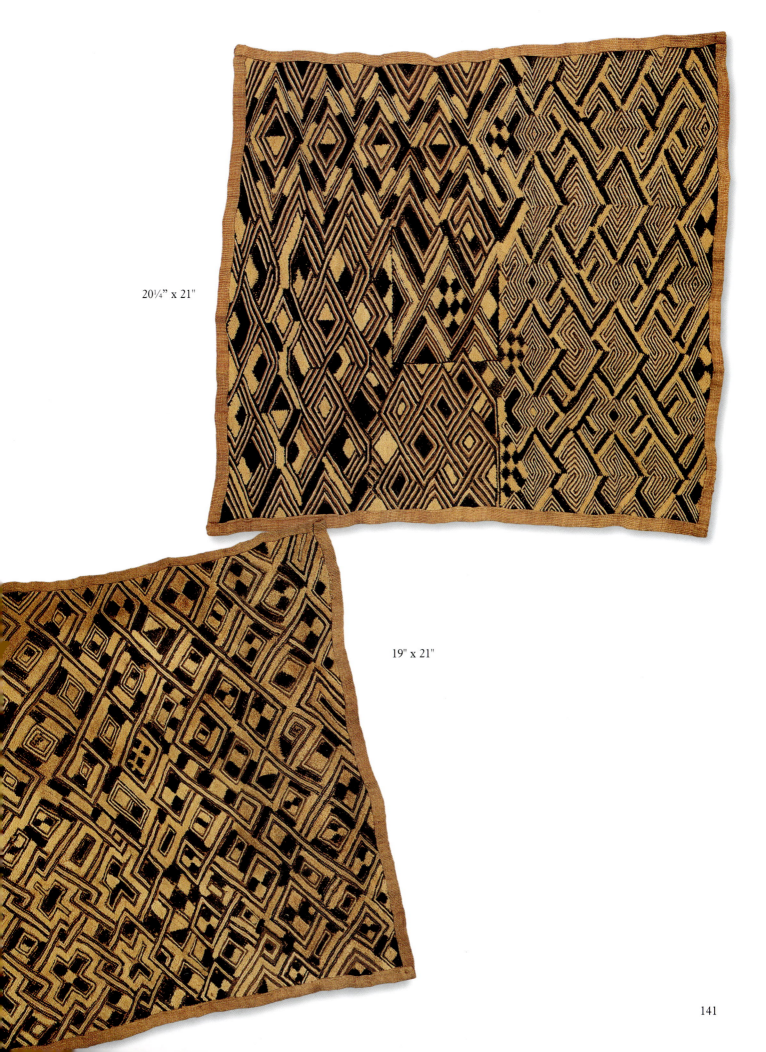

20¼" x 21"

19" x 21"

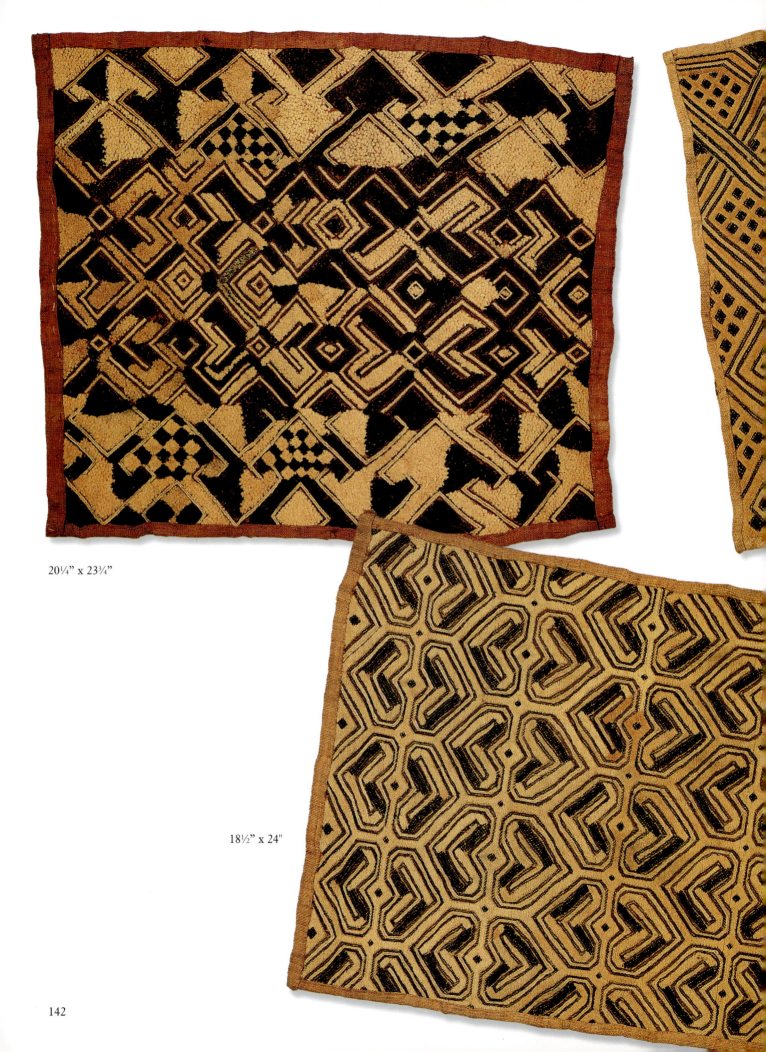

20¼" x 23¾"

18½" x 24"

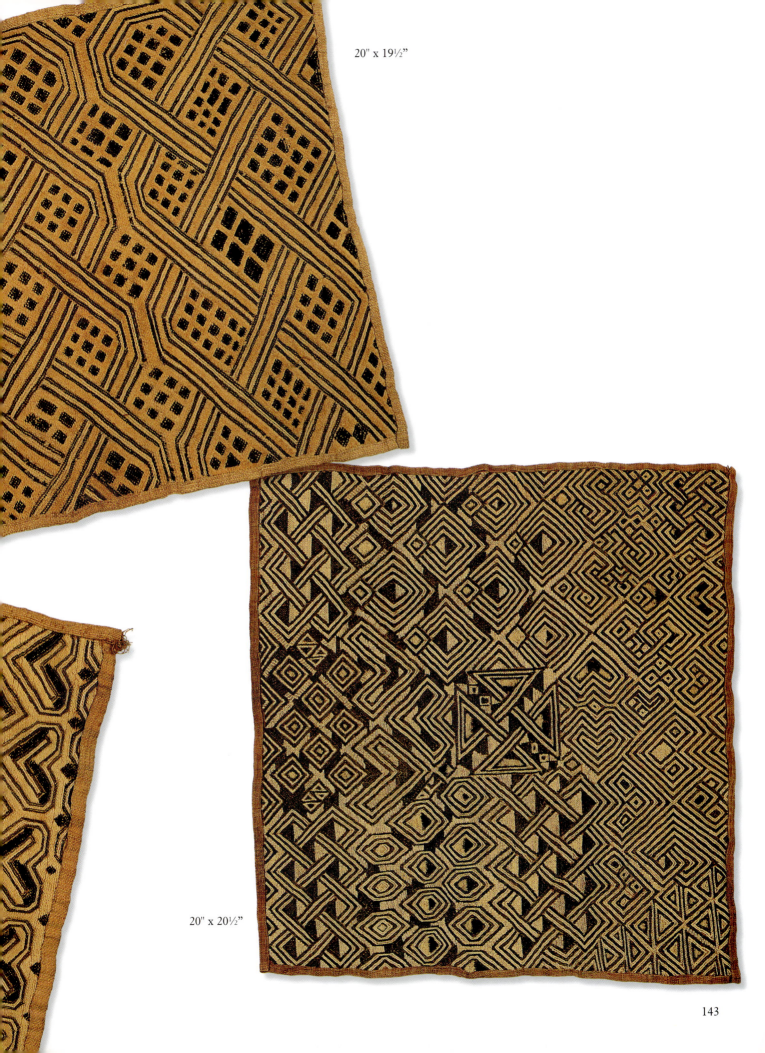

20" x 19½"

20" x 20½"

143

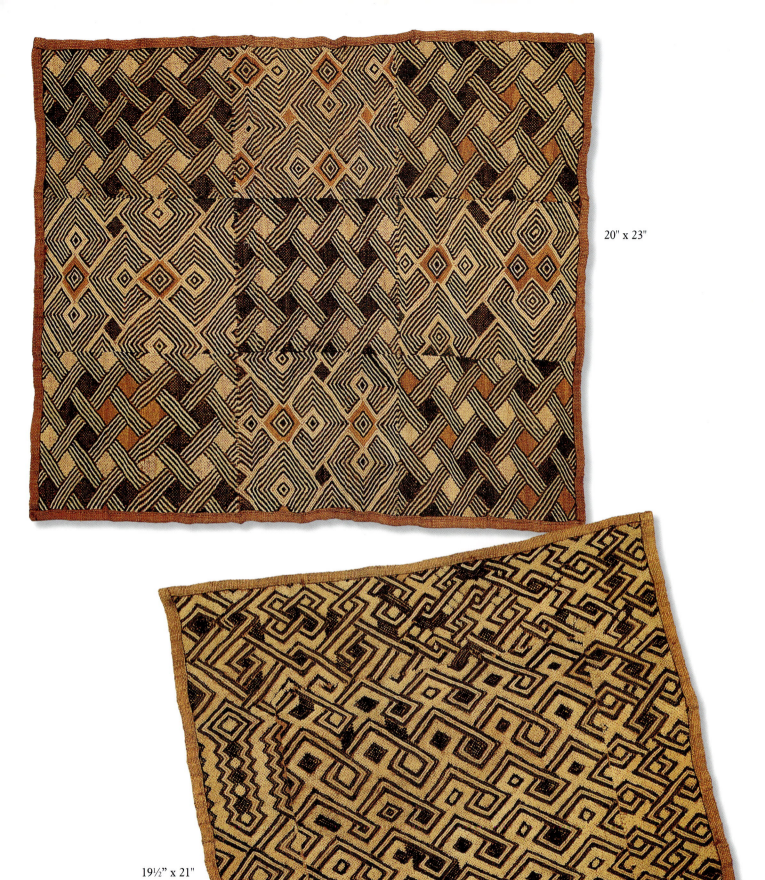

20" x 23"

19½" x 21"

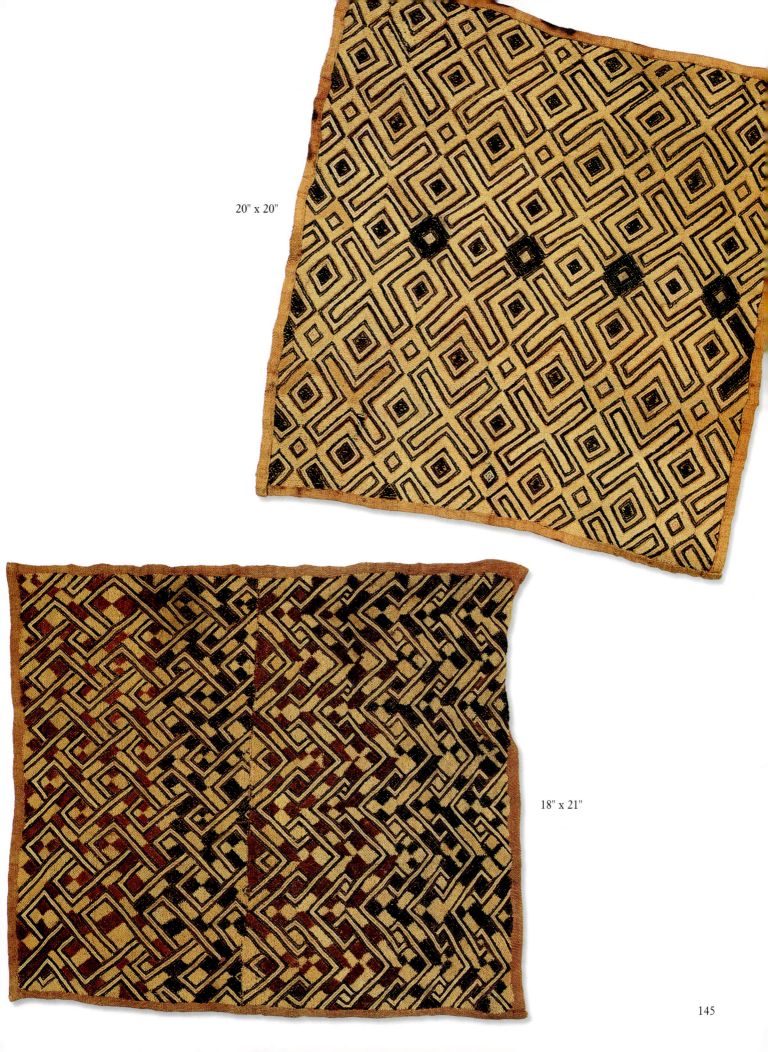

20" x 20"

18" x 21"

145

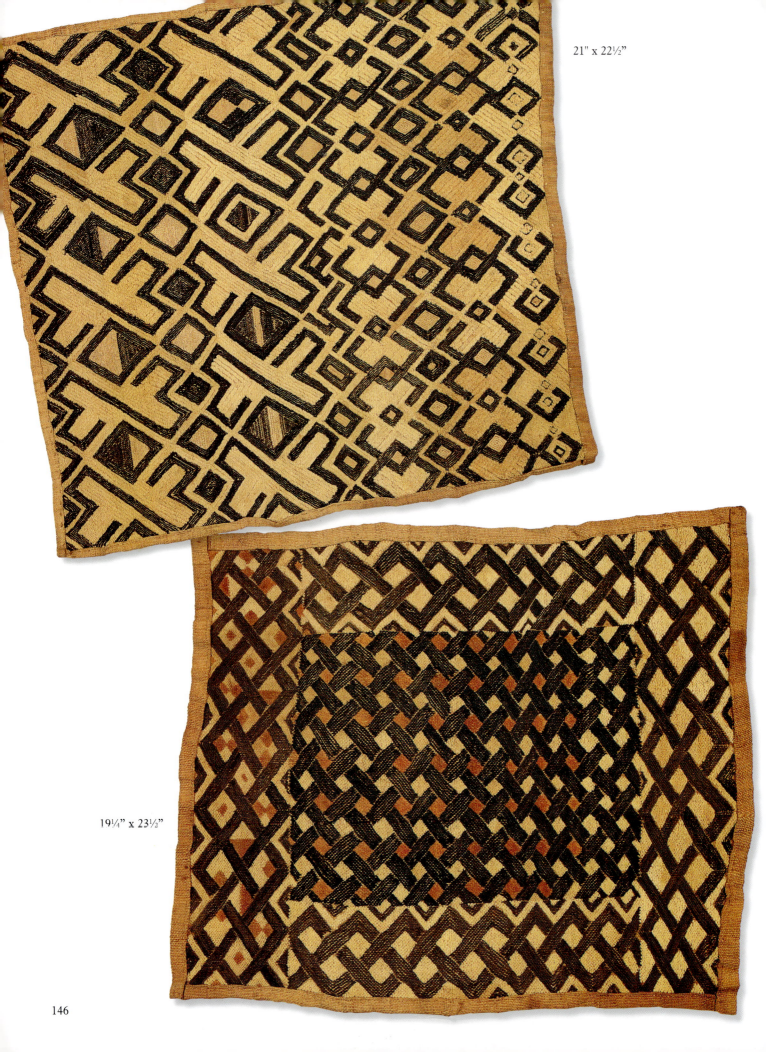

21" x 22½"

19¼" x 23½"

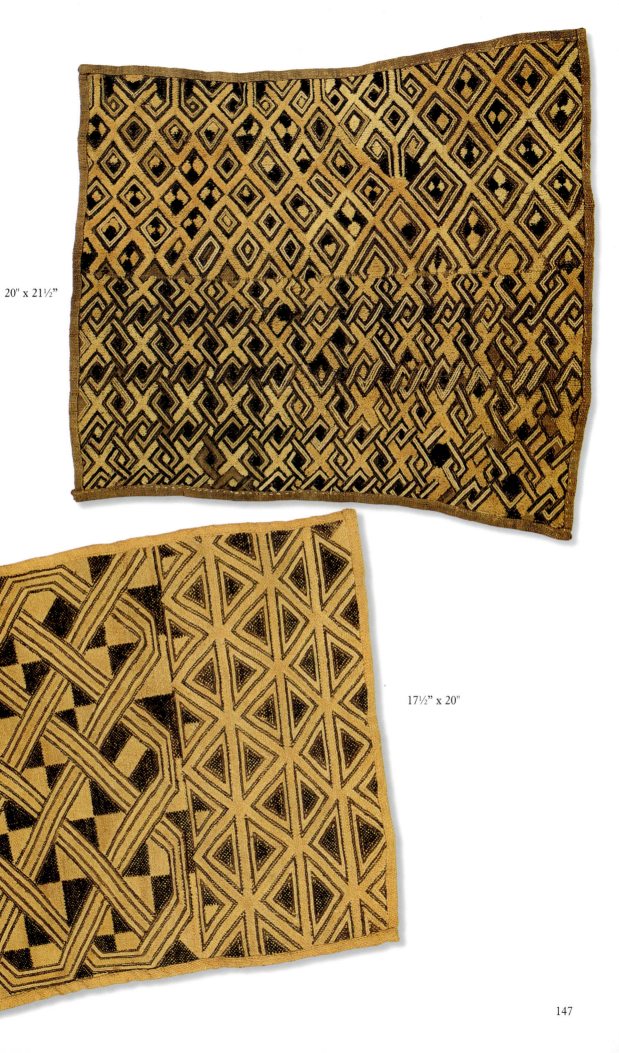

20" x 21½"

17½" x 20"

147

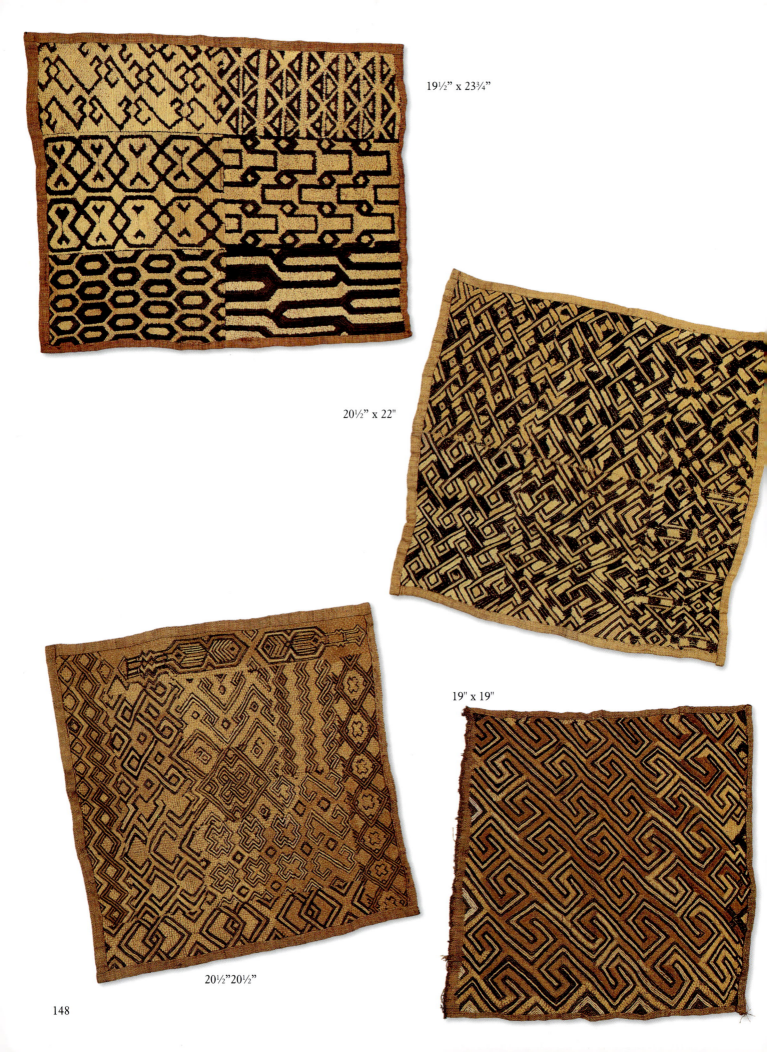

19½" x 23¾"

20½" x 22"

20½" 20½"

19" x 19"

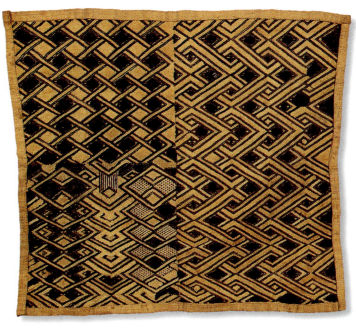

18½" x 20¼"

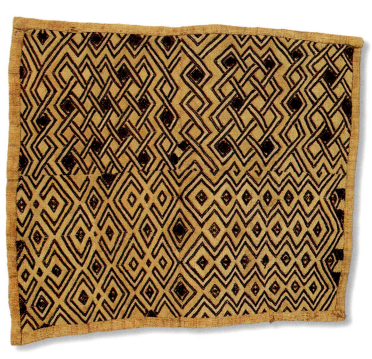

19½" x 22¼"

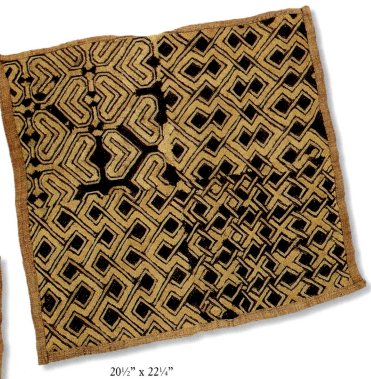

20½" x 22¼"

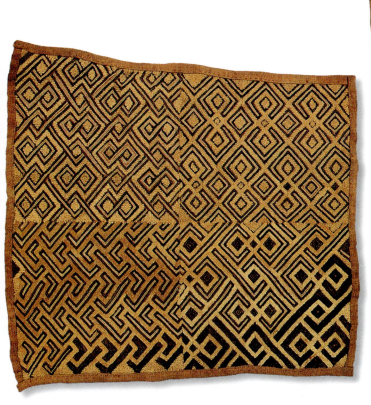

20½" x 22¼"

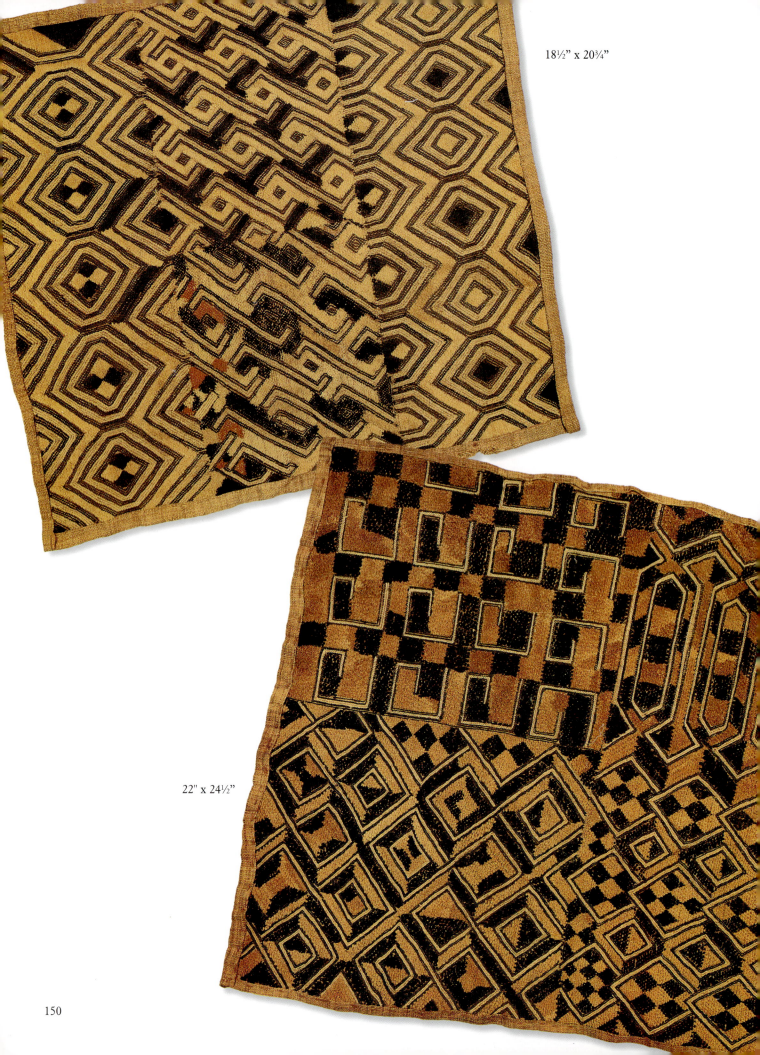

18½" x 20¾"

22" x 24½"

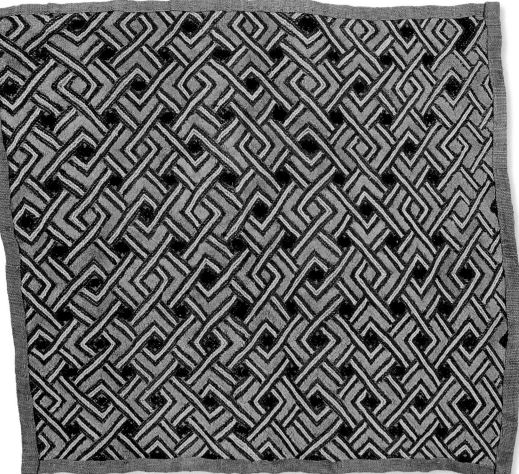

18½" x 21

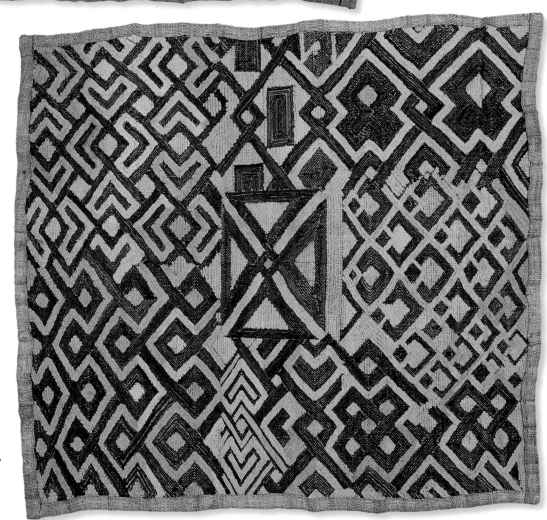

19½" x 21½"

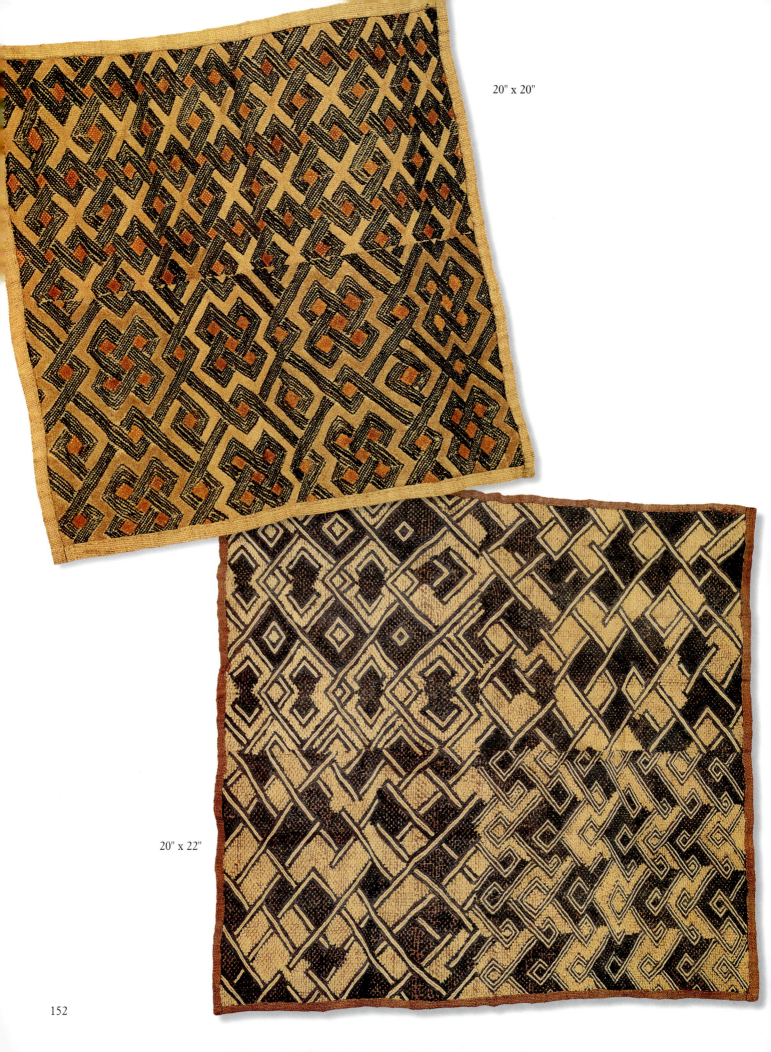

20" x 20"

20" x 22"

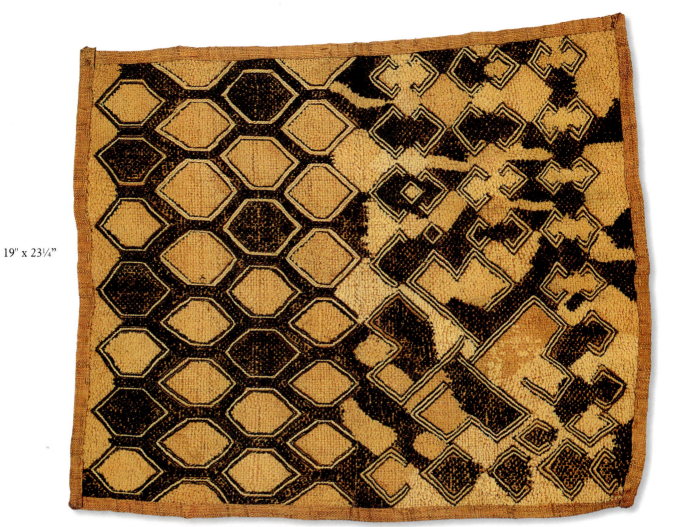

19" x 23¼"

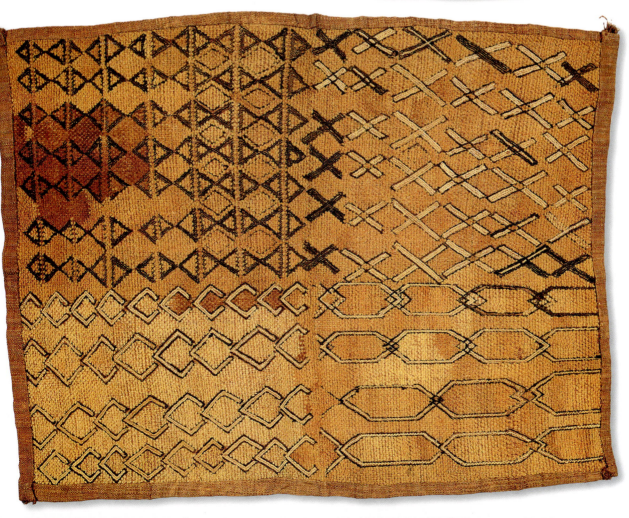

19" x 24½"

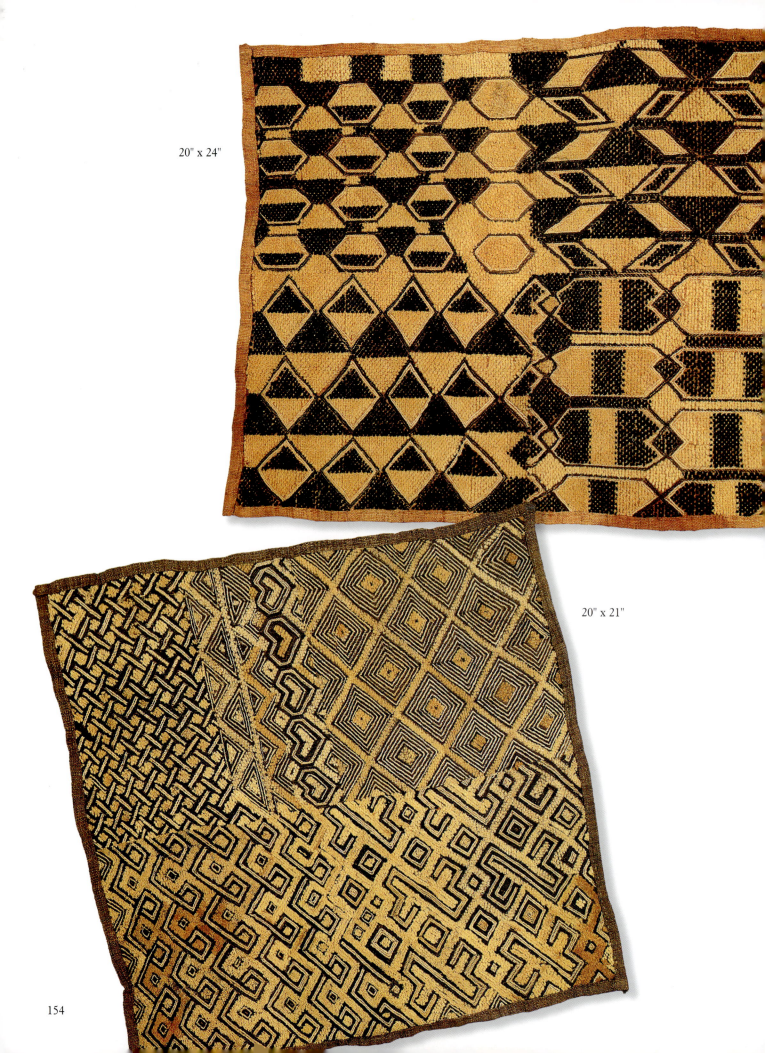

20" x 24"

20" x 21"

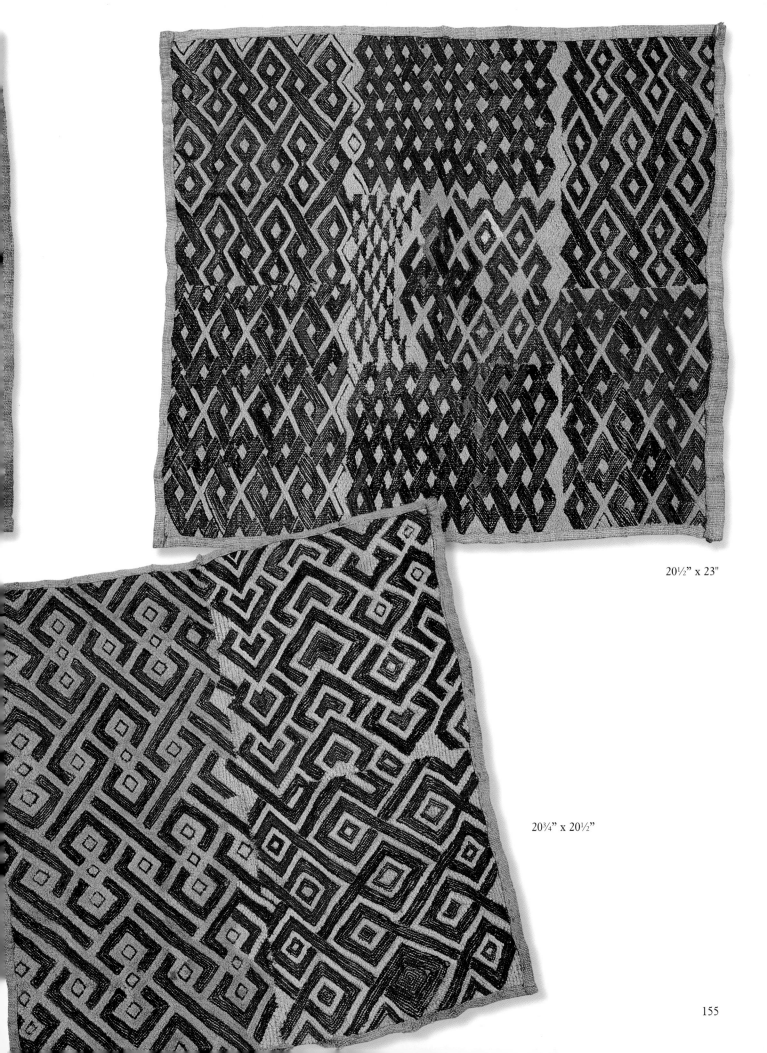

20½" x 23"

20¾" x 20½"

155

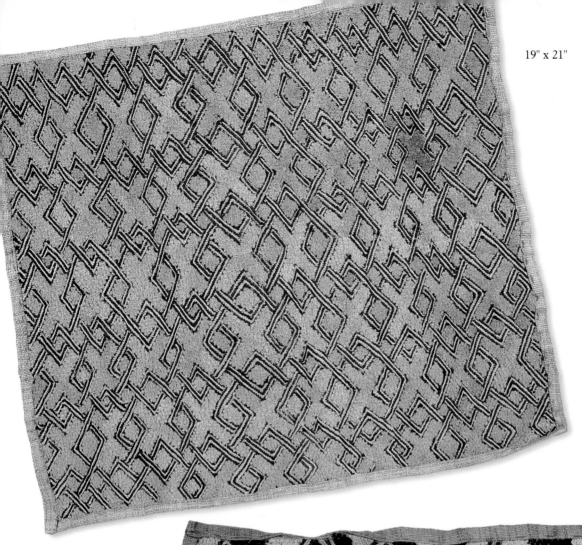

19" x 21"

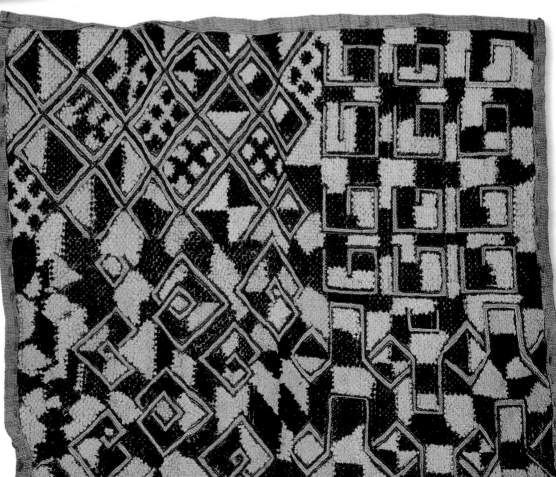

20" x 23"

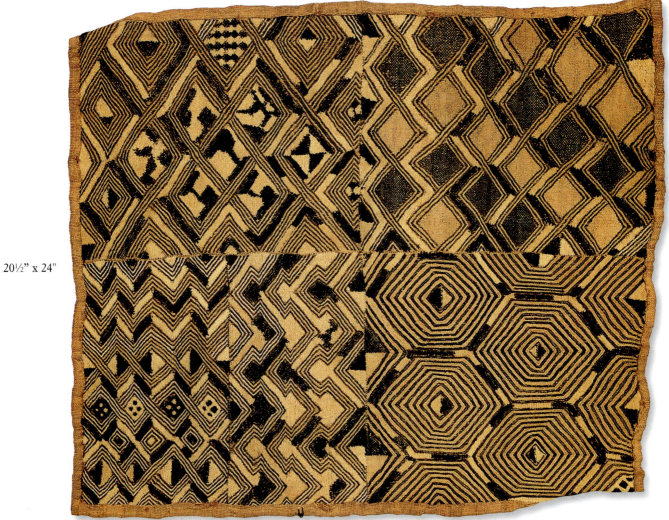

20½" x 24"

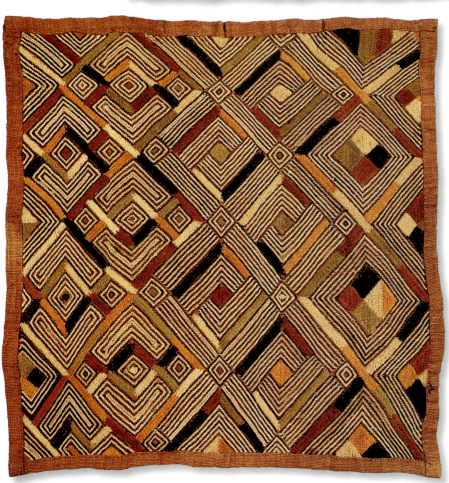

18" x 18"

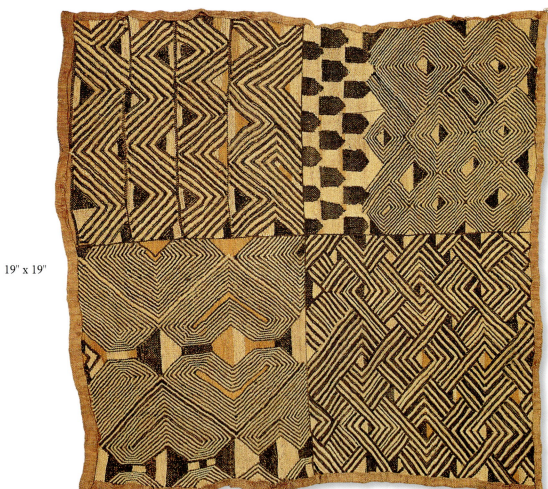

19" x 19"

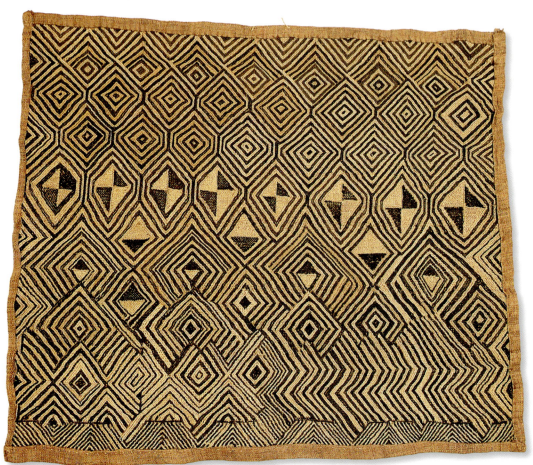

17¾" x 21"

158

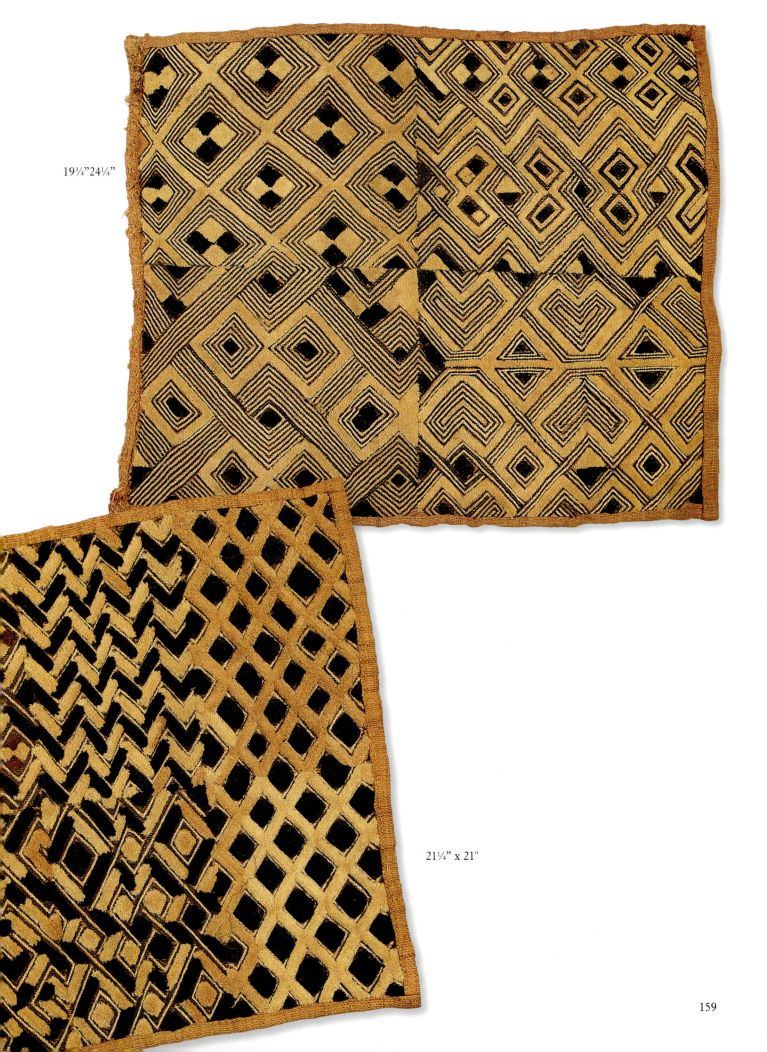

19¾" 24¼"

21¼" x 21"

159

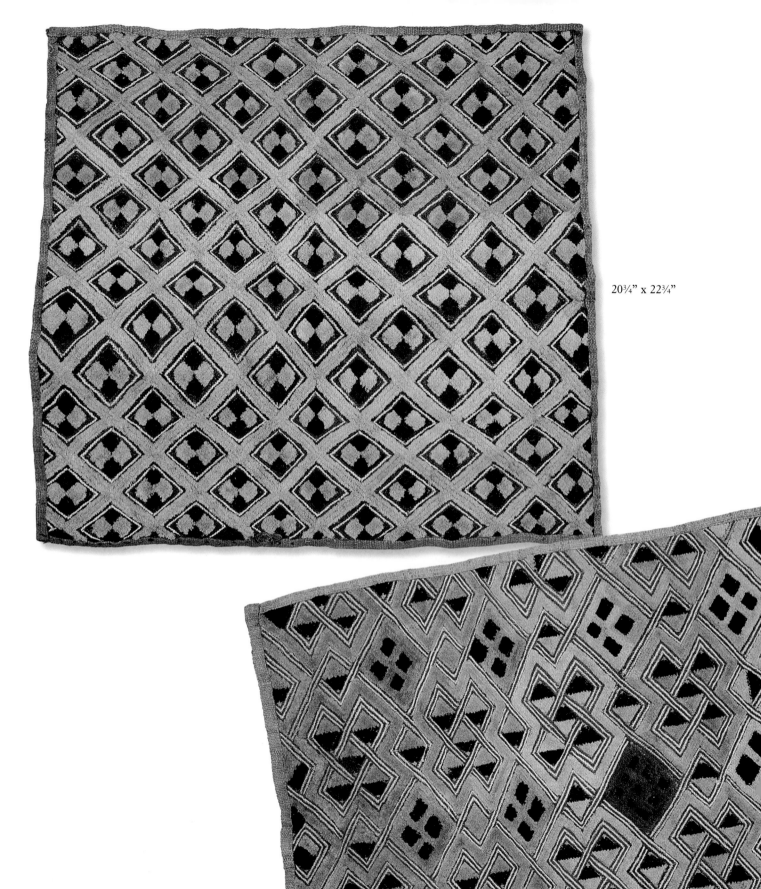

20¾" x 22¾"

19½" x 22¼"

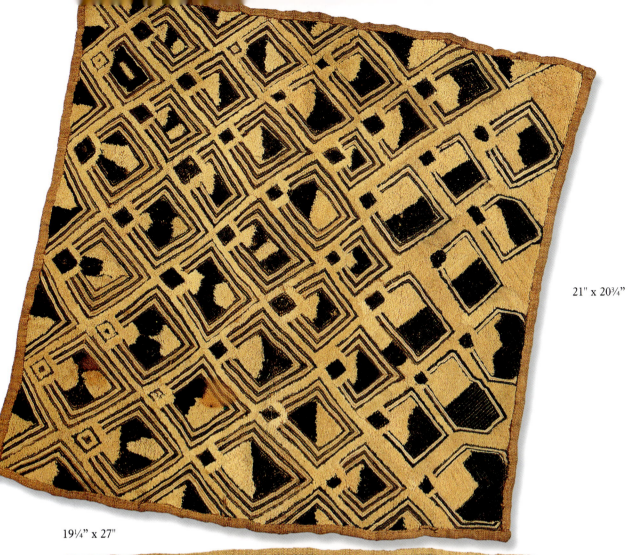

21" x 20¾"

19¼" x 27"

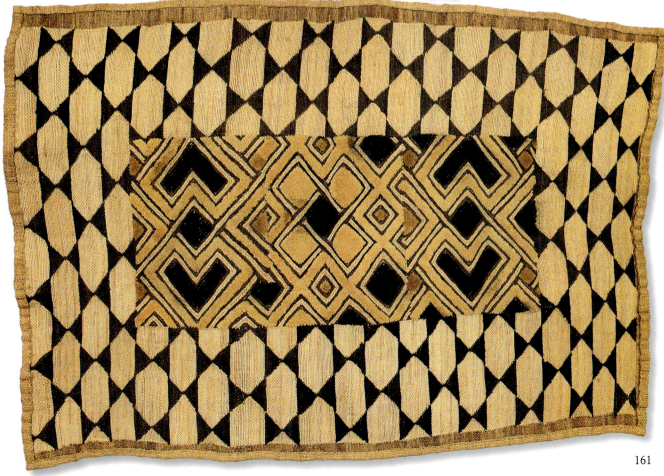

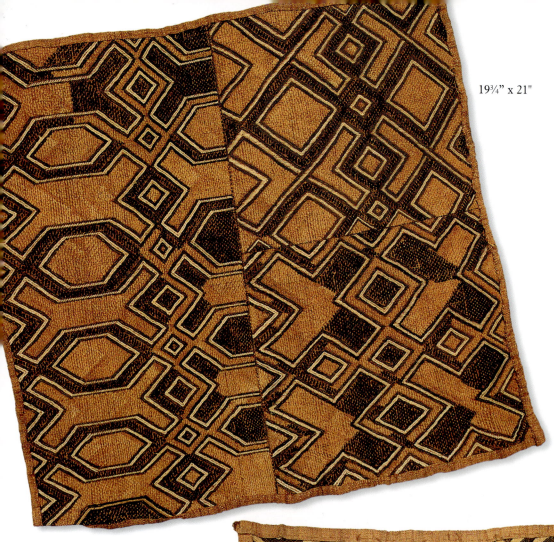

19¾" x 21"

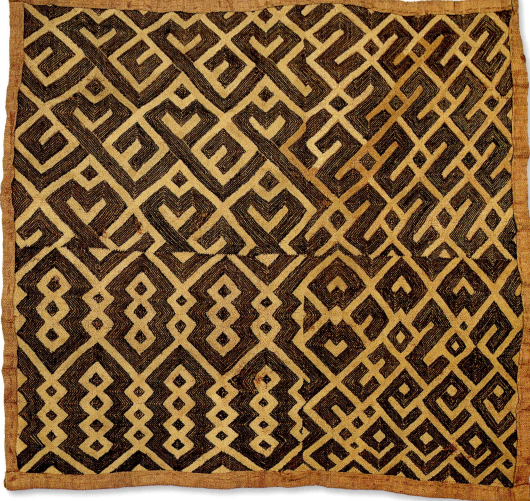

20" x 21½"

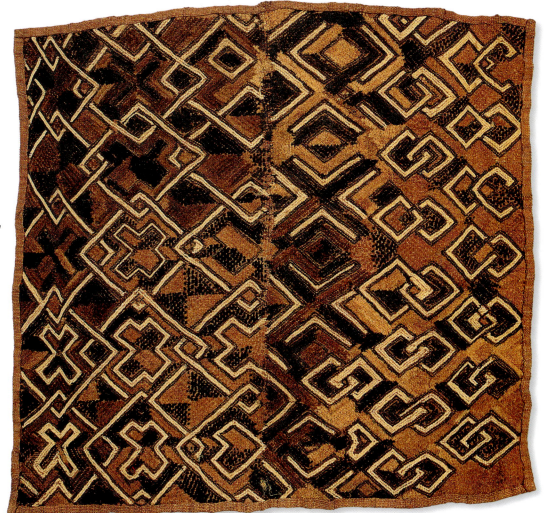

19½" x 21"

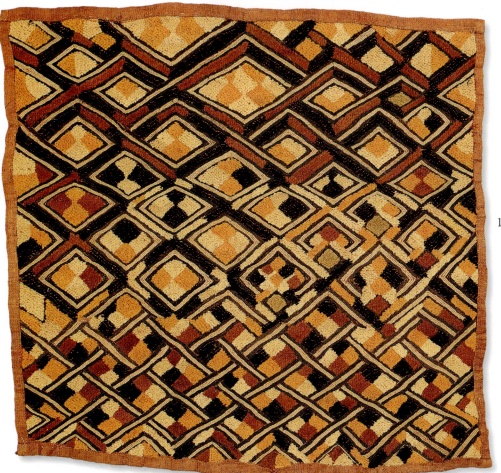

19½" x 18¾"

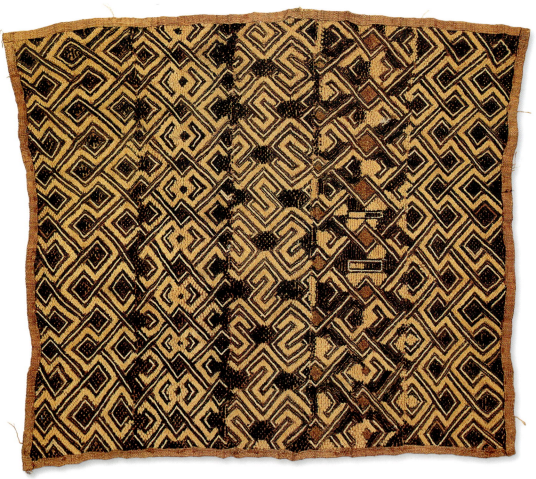

17" x 19½"

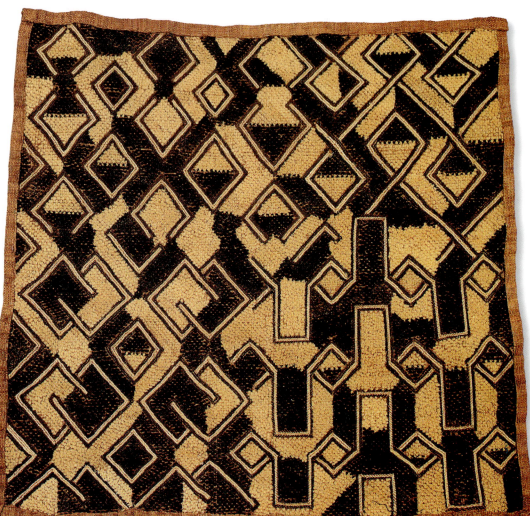

20" x 21"

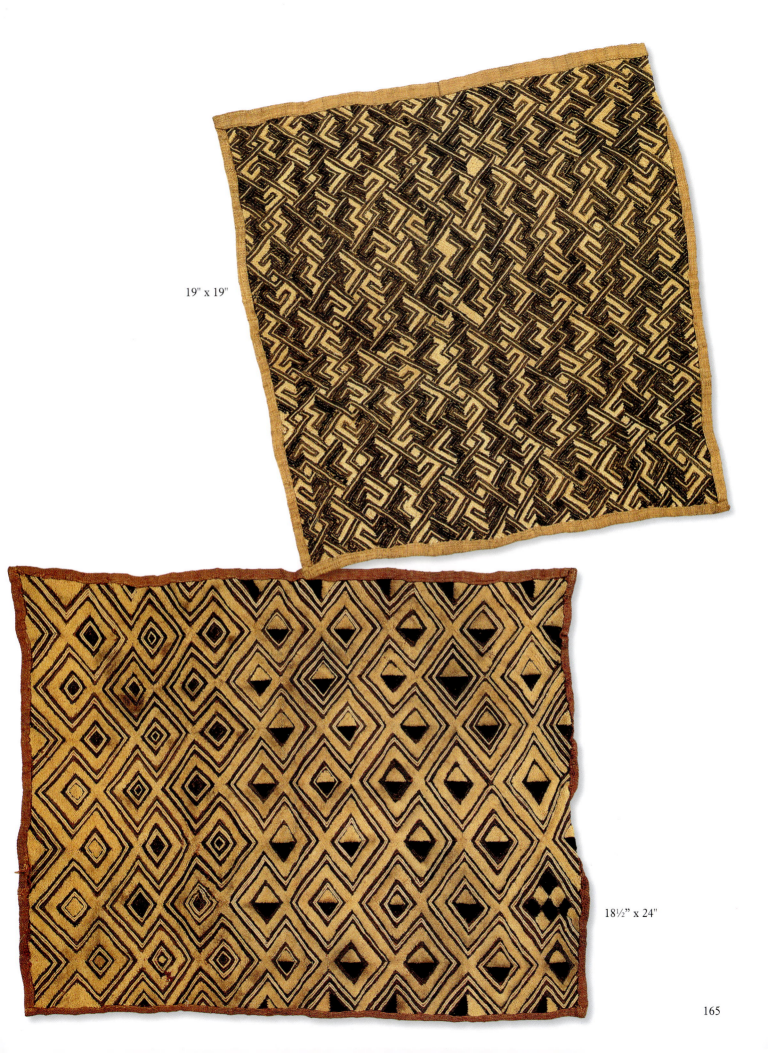

19" x 19"

18½" x 24"

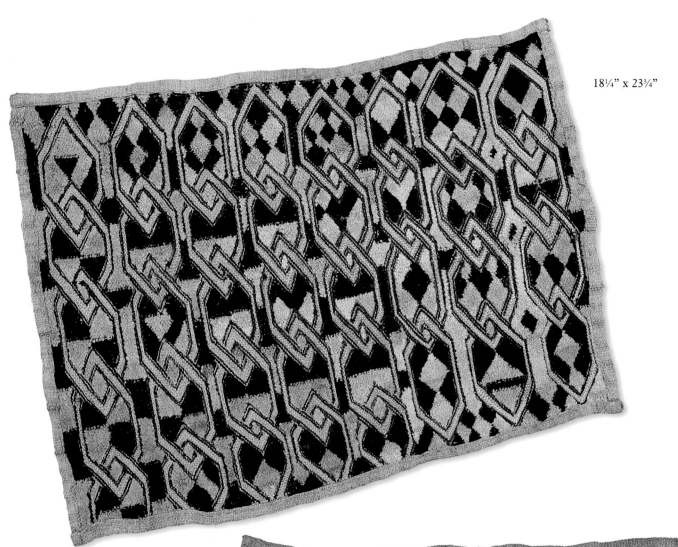

18¼" x 23¾"

19½" x 20½"

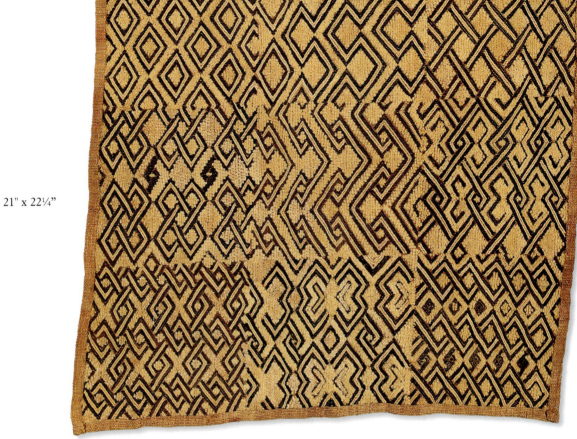

21" x 22¼"

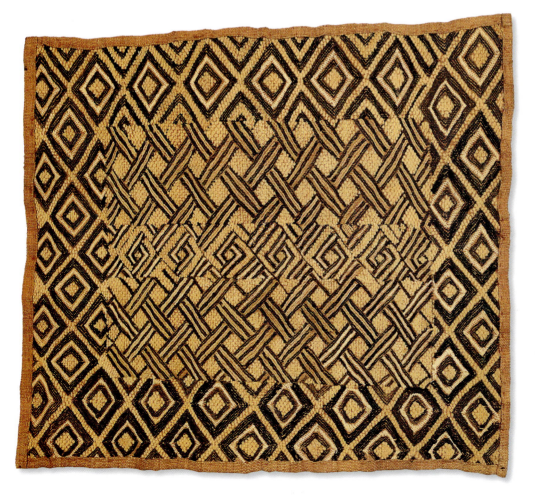

19½" x 21½"

167

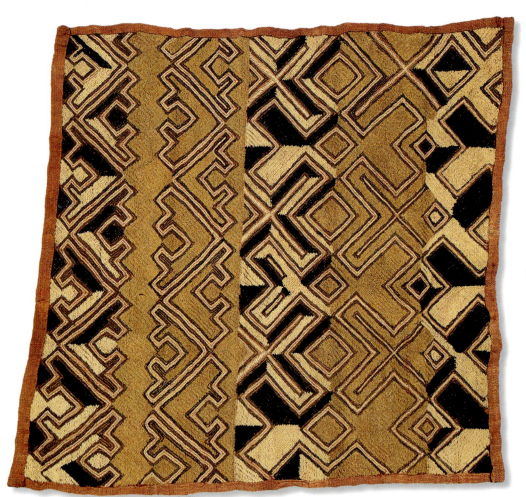

20" x 20¼"

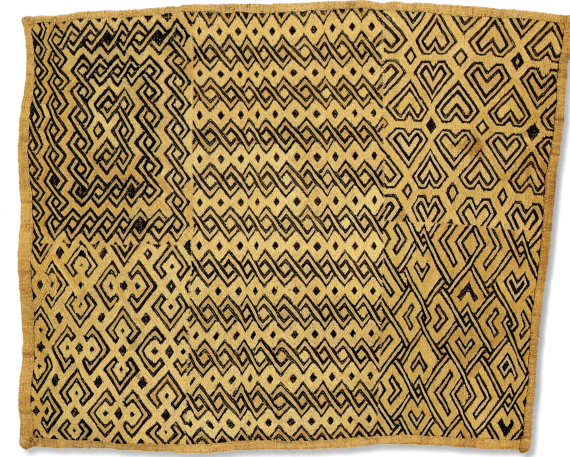

18¾" x 23"

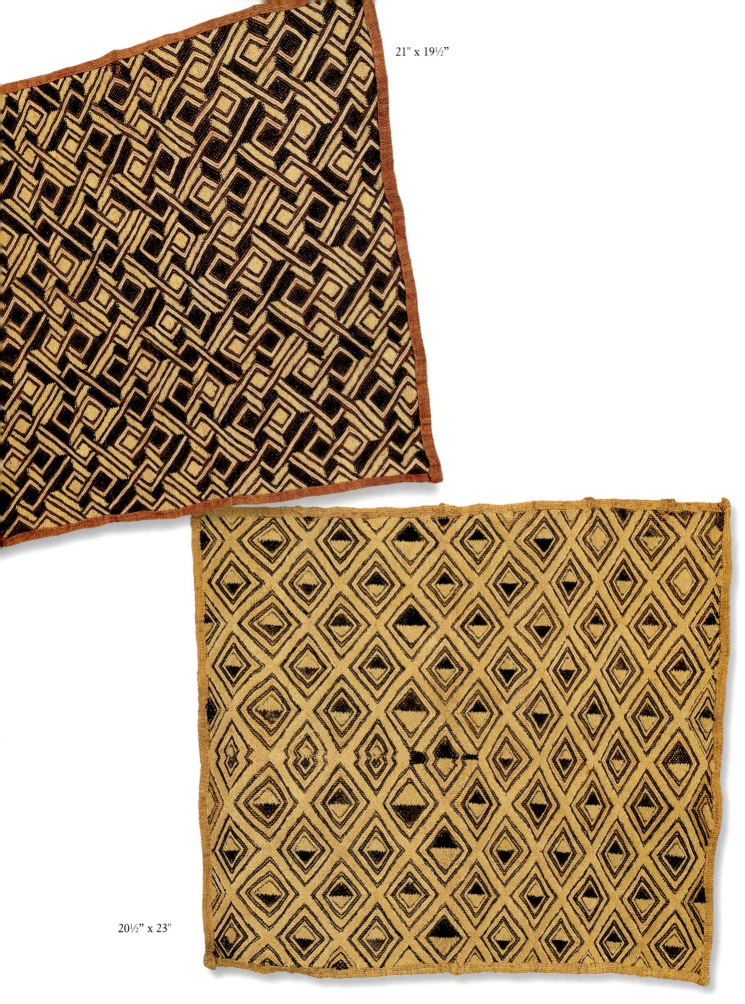

21" x 19½"

20½" x 23"

169

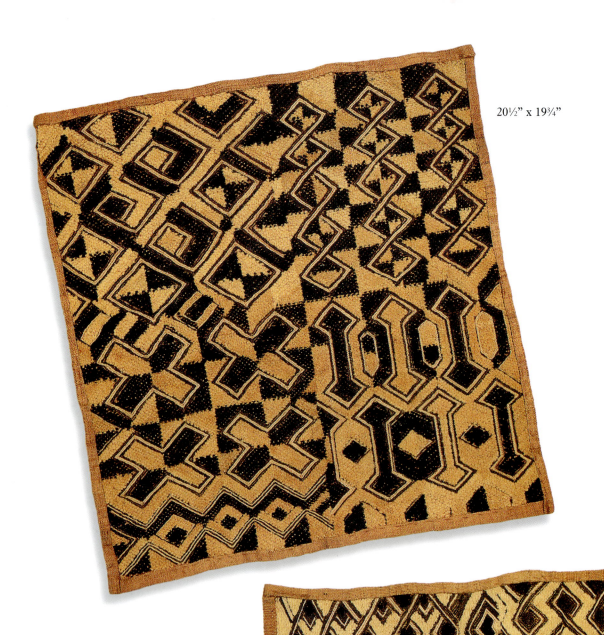

20½" x 19¾"

19¼" x 21"

170

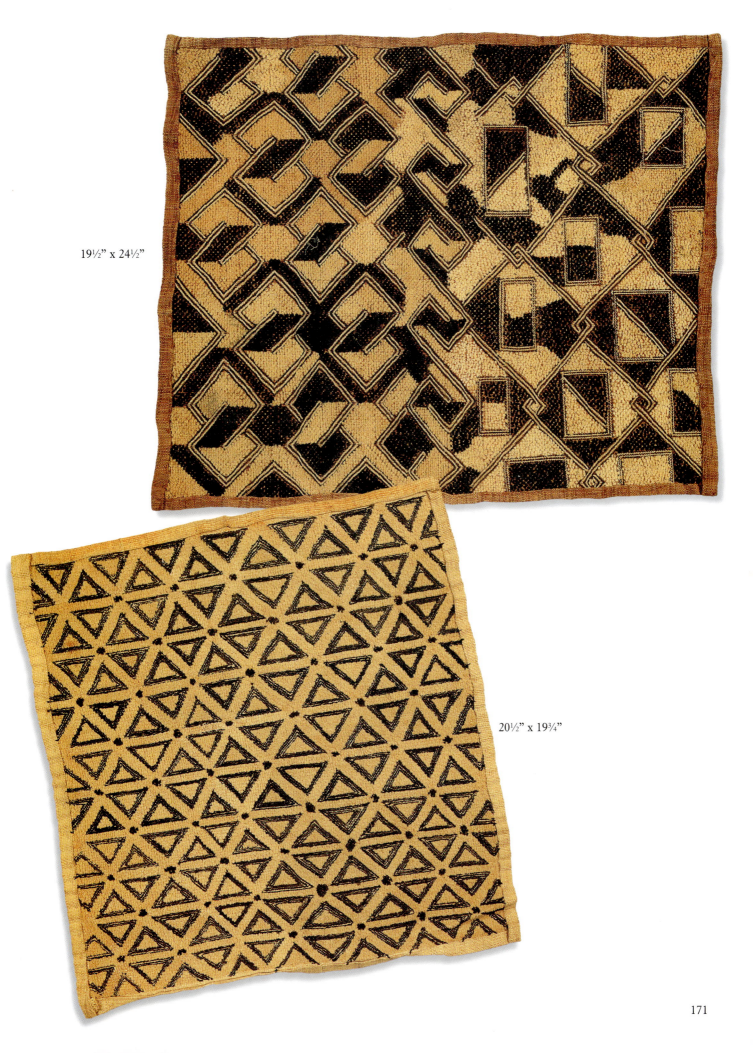

19½" x 24½"

20½" x 19¾"

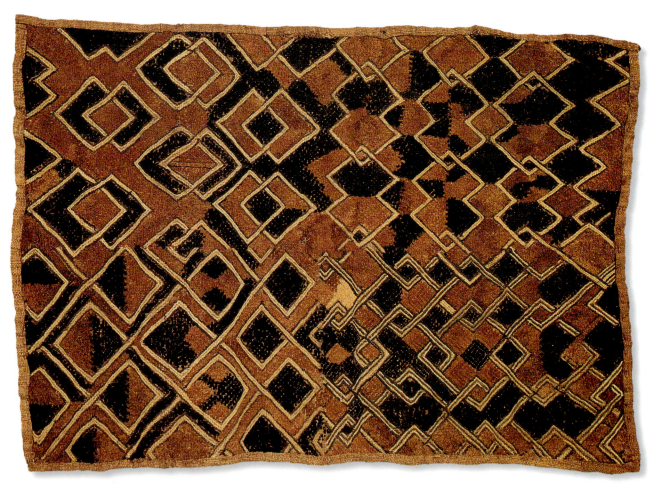

17½" x 25½"

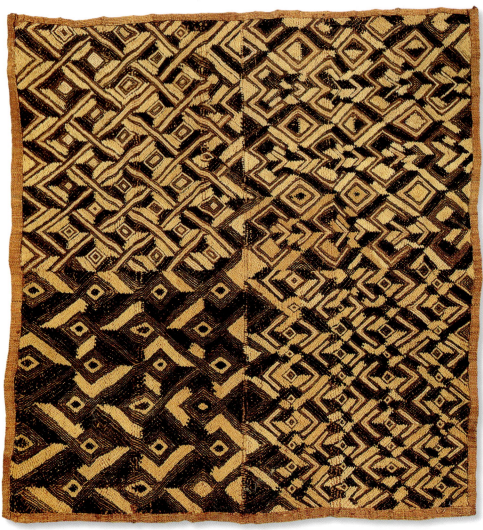

21" x 22"

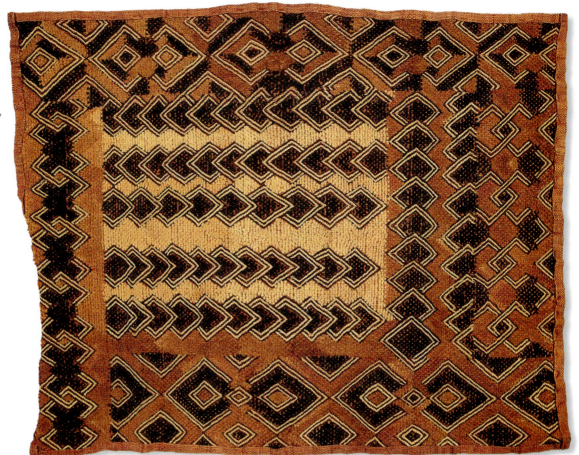

19" x 25"

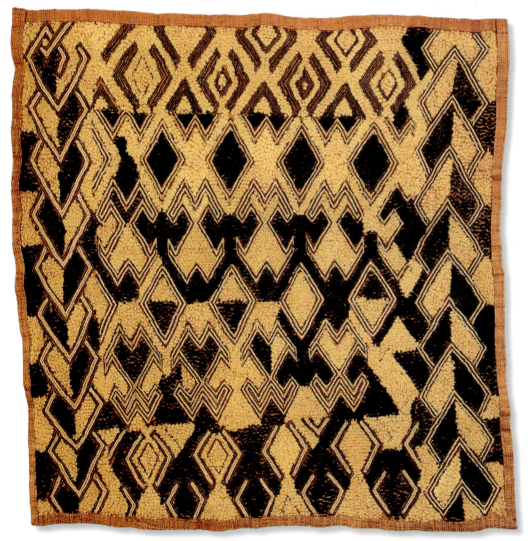

22½" x 22"

173

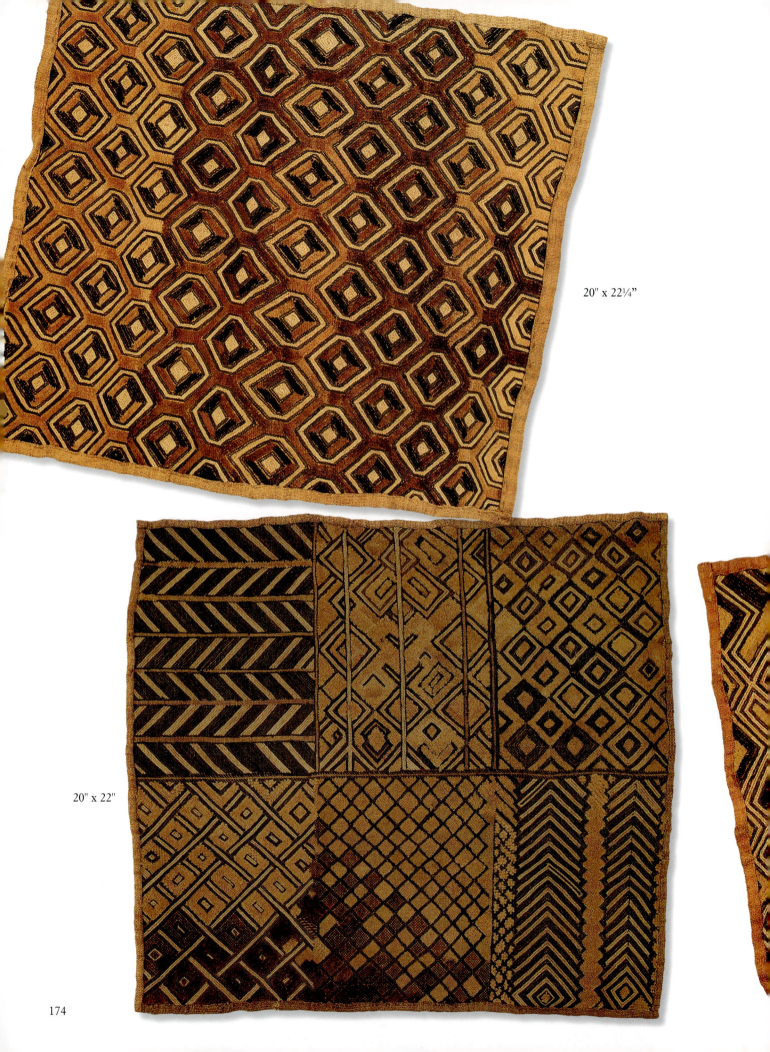

20" x 22¼"

20" x 22"

174

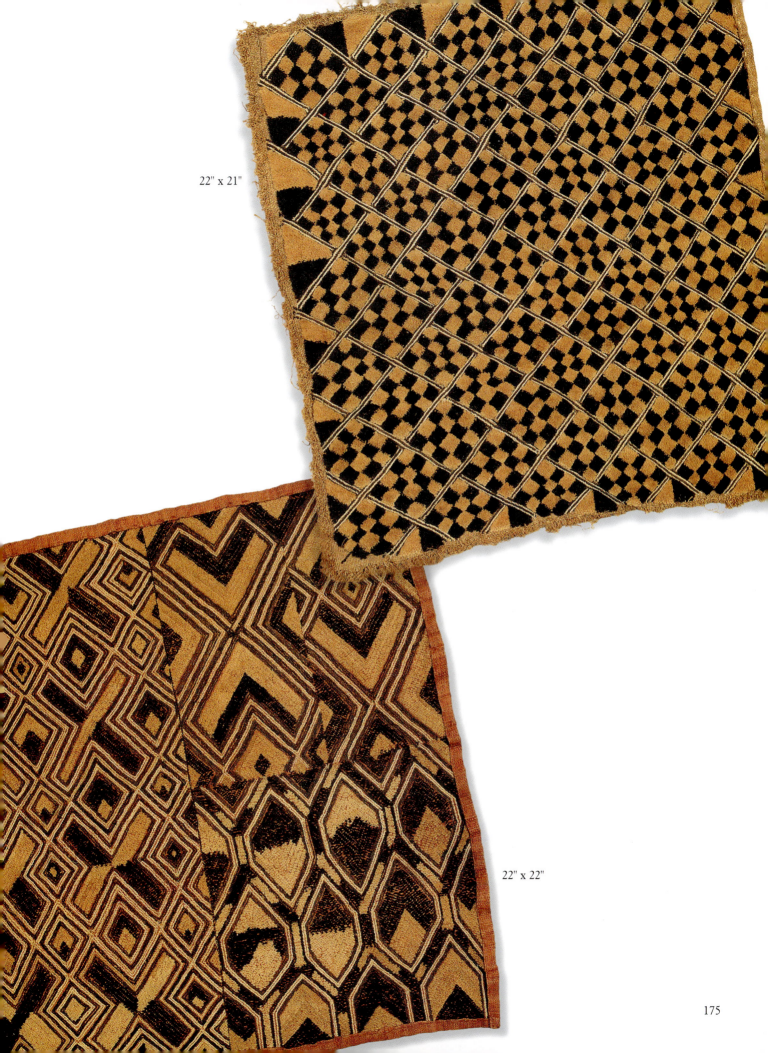

22" x 21"

22" x 22"

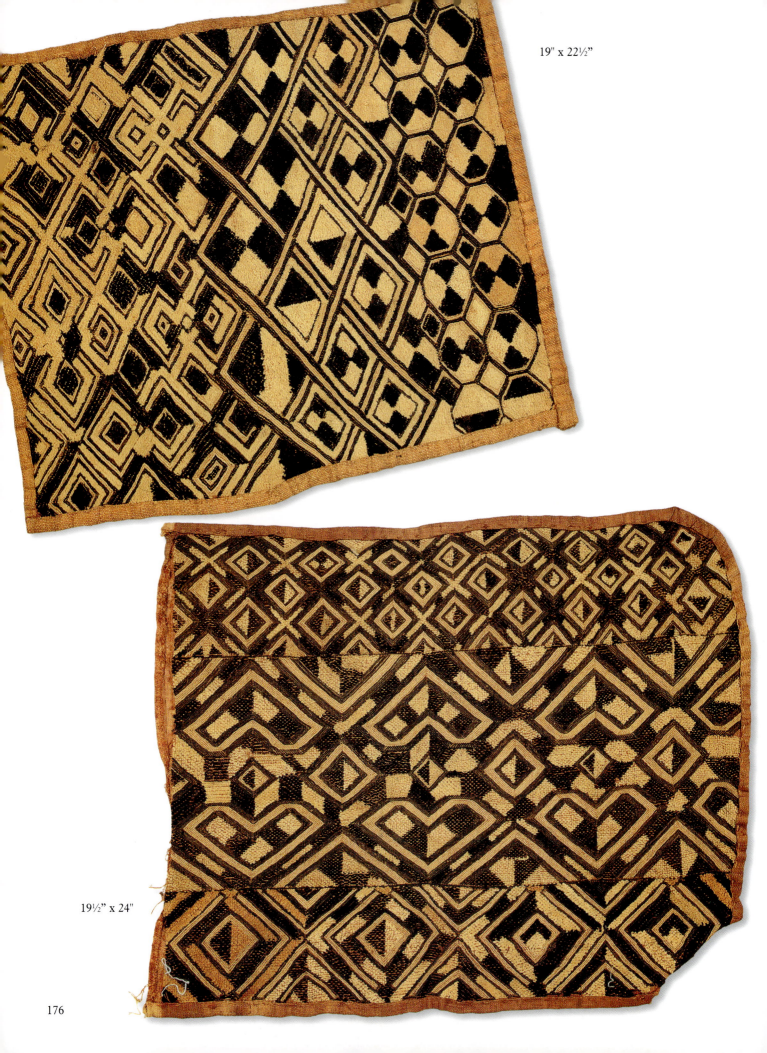

19" x 22½"

19½" x 24"

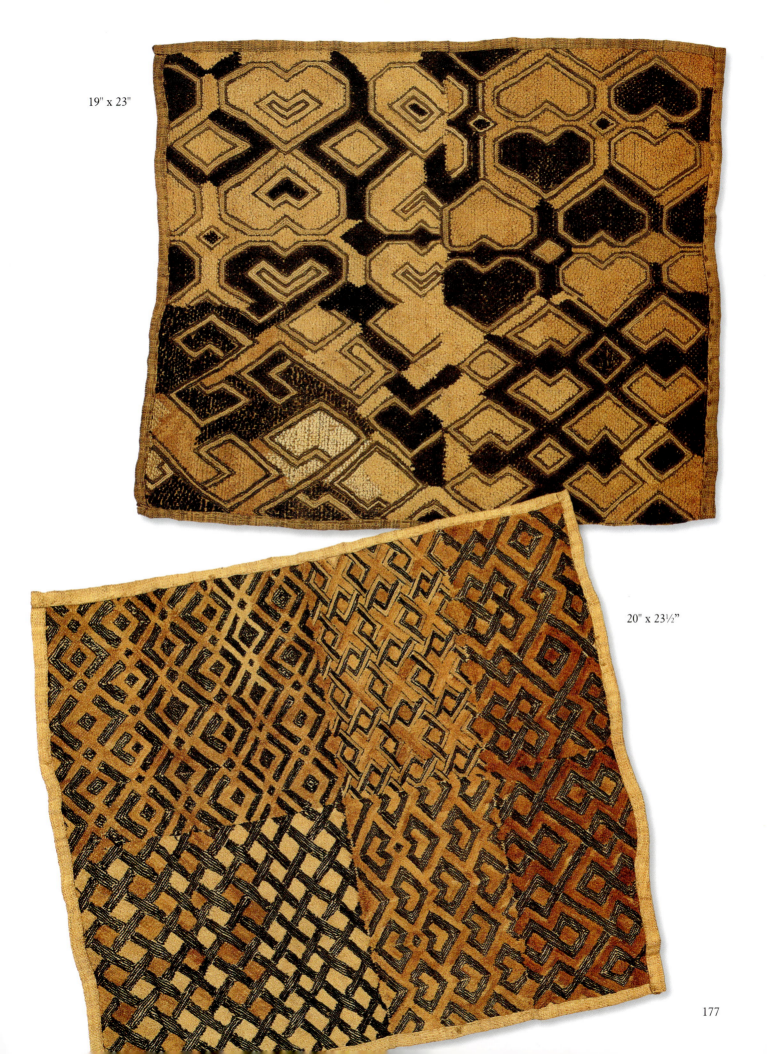

19" x 23"

20" x 23½"

177

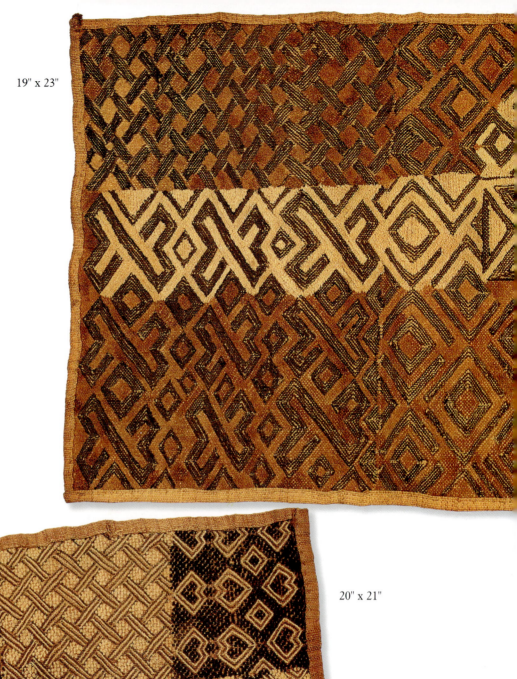
19" x 23"

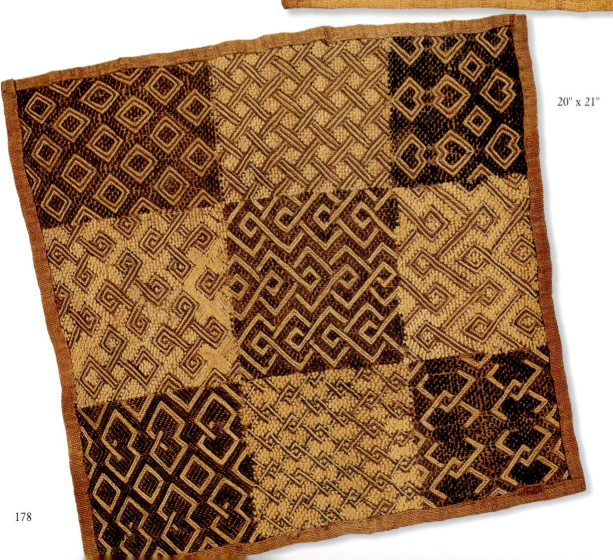
20" x 21"

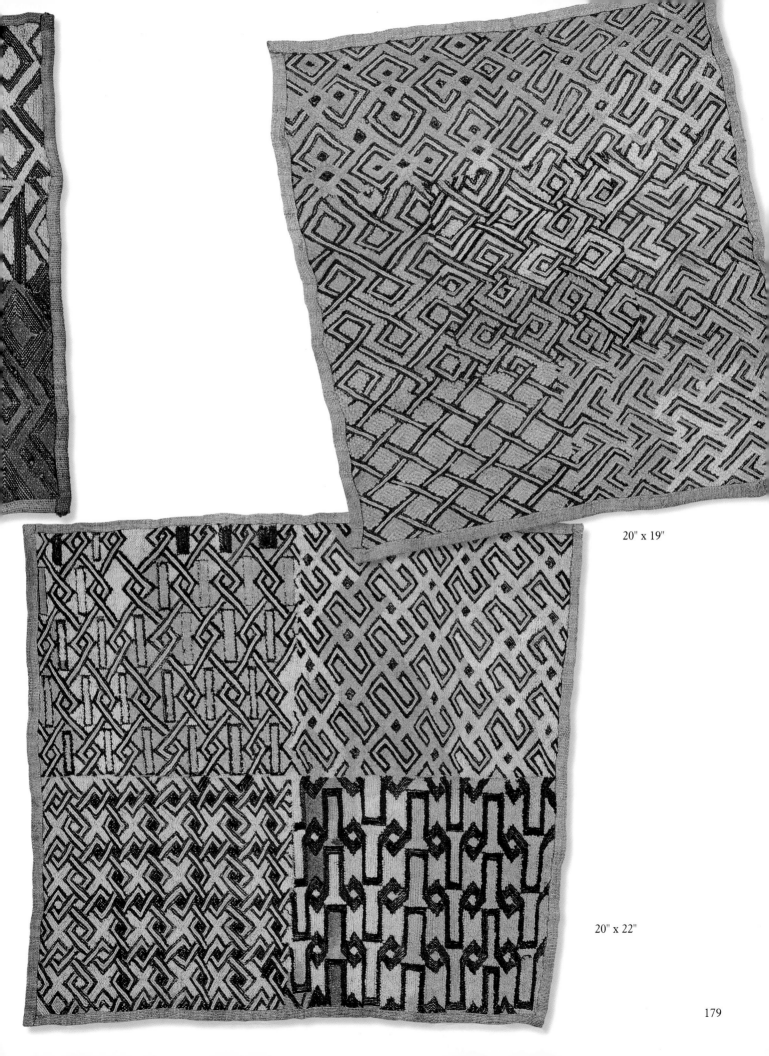

20" x 19"

20" x 22"

179

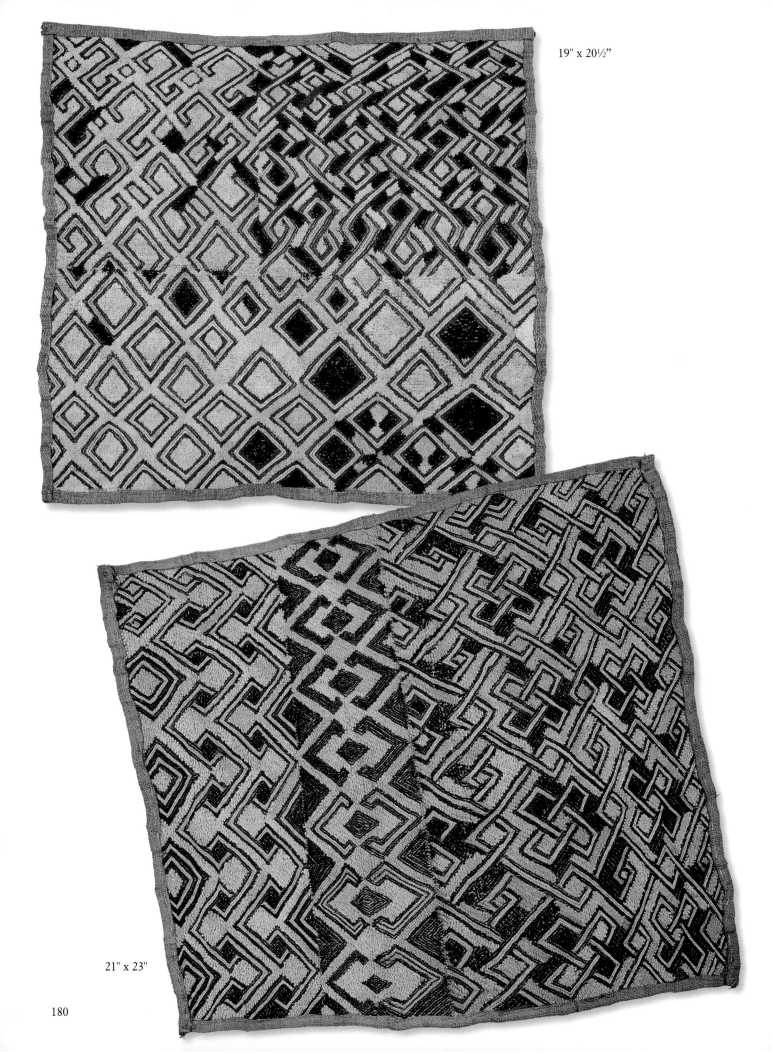

19" x 20½"

21" x 23"

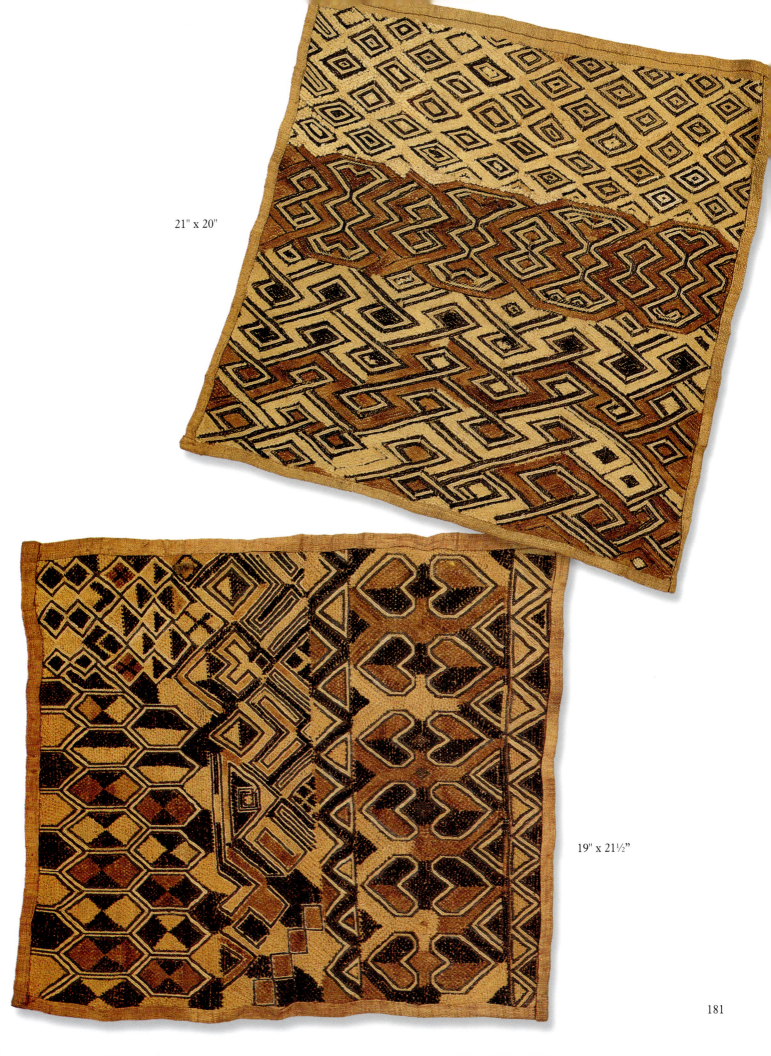

21" x 20"

19" x 21½"

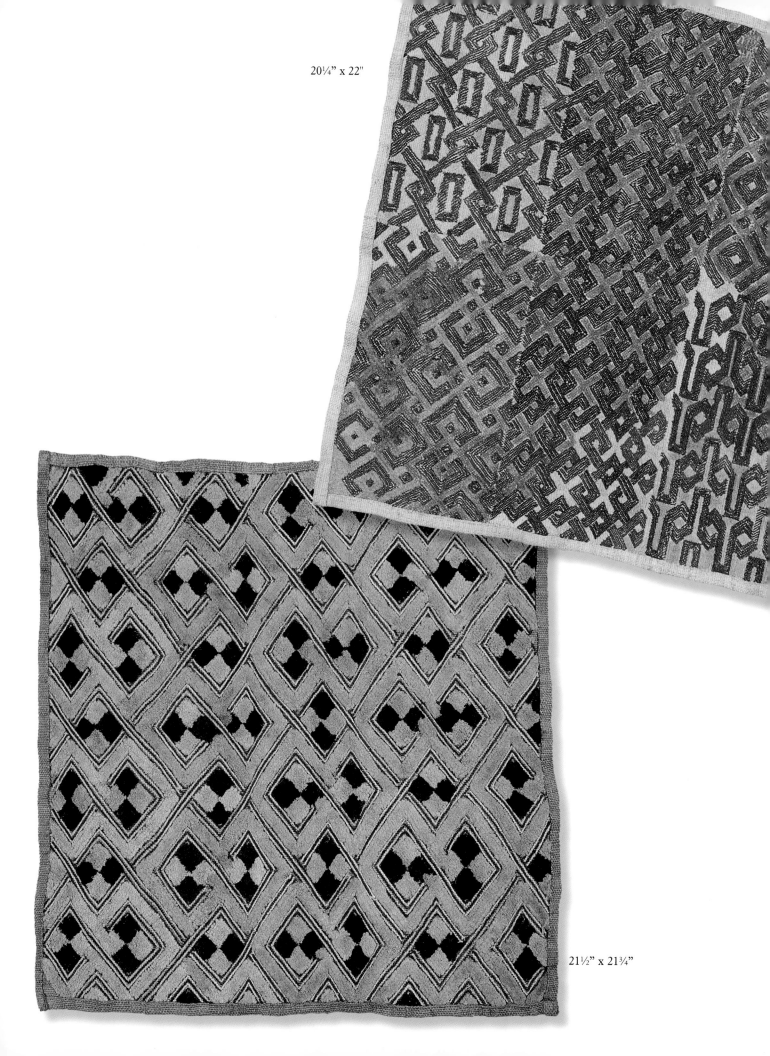

20¼" x 22"

21½" x 21¾"

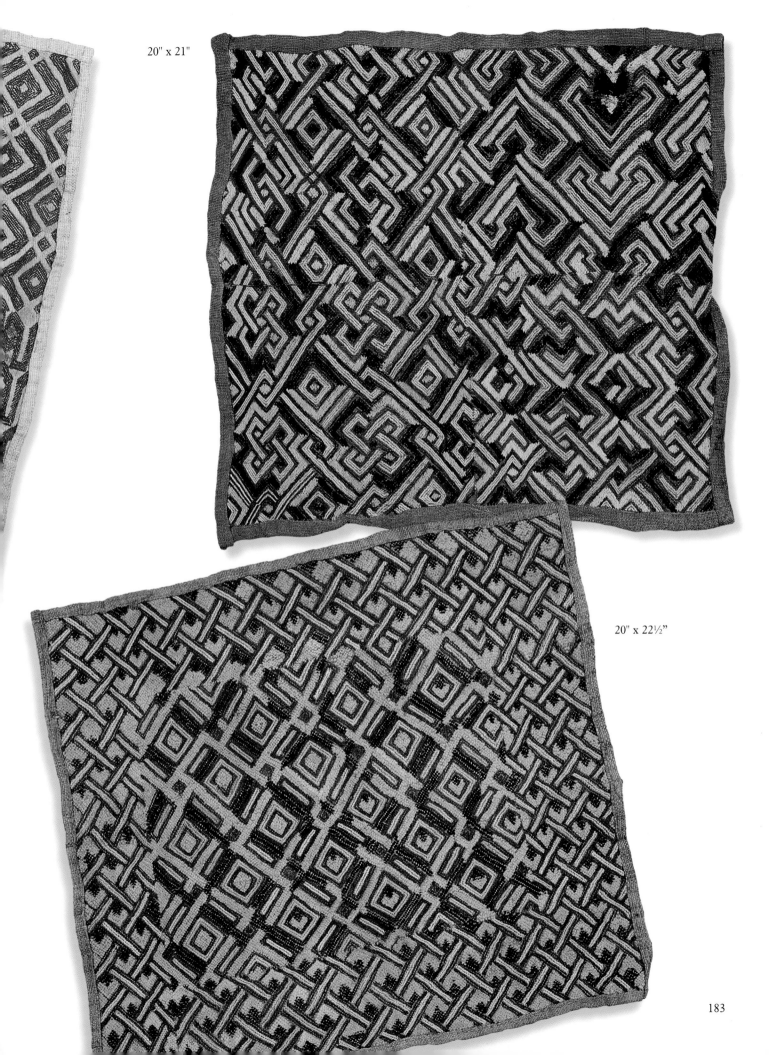

20" x 21"

20" x 22½"

183

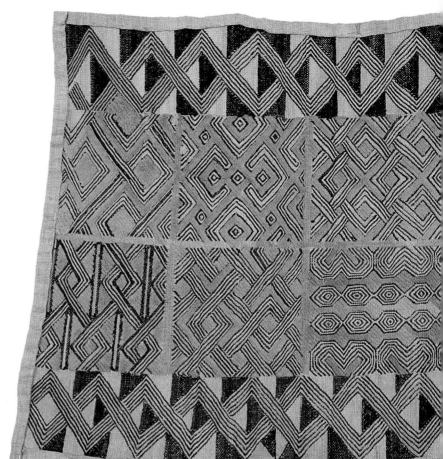

18" x 21"

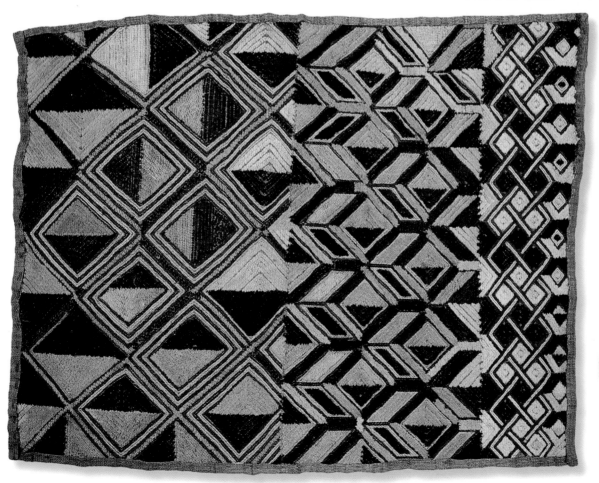

184

18" x 23"

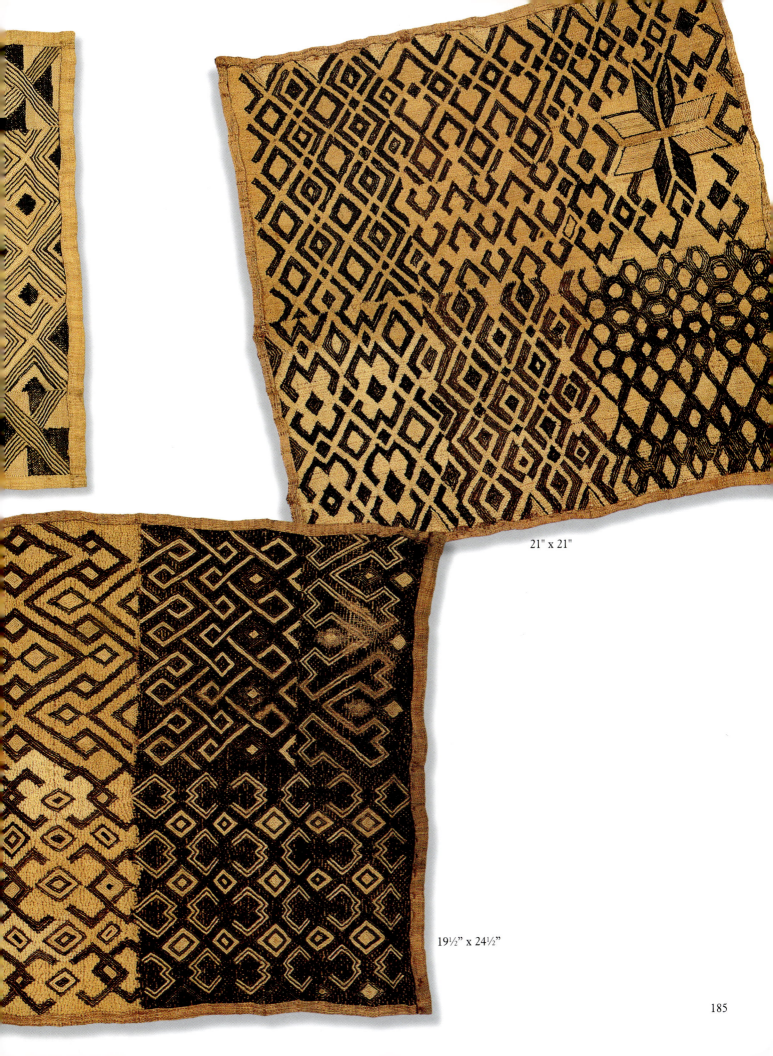

21" x 21"

19½" x 24½"

185

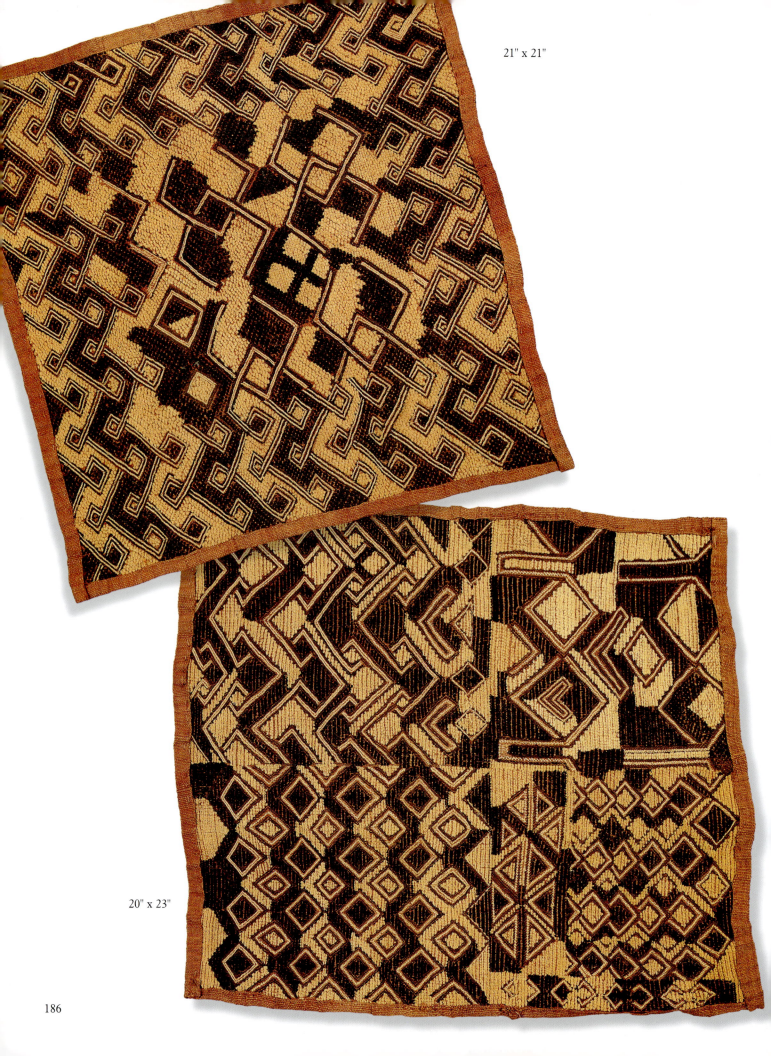

21" x 21"

20" x 23"

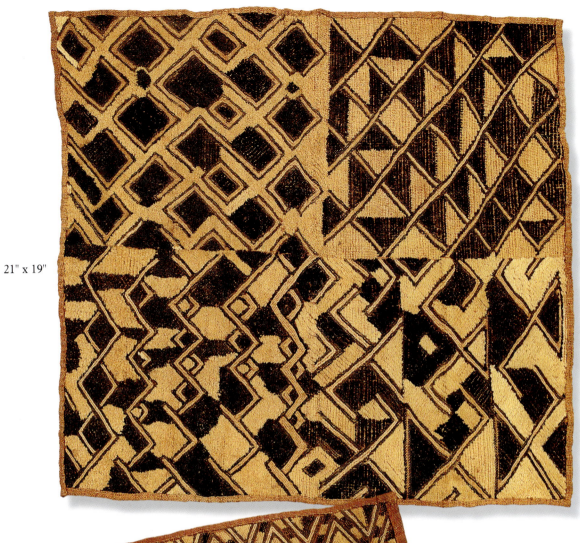

21" x 19"

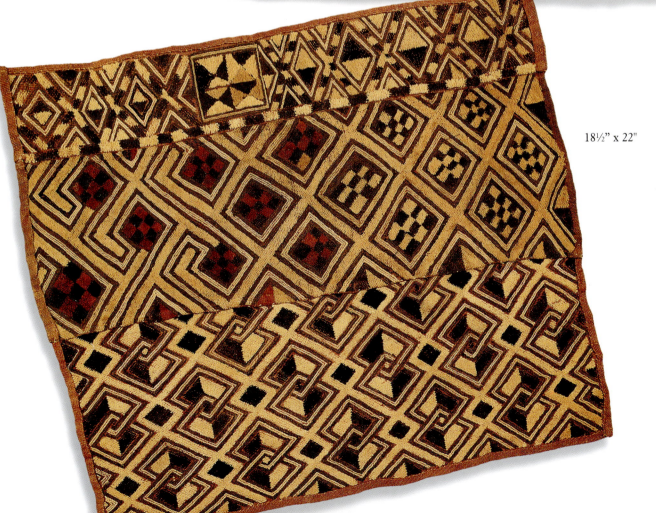

18½" x 22"

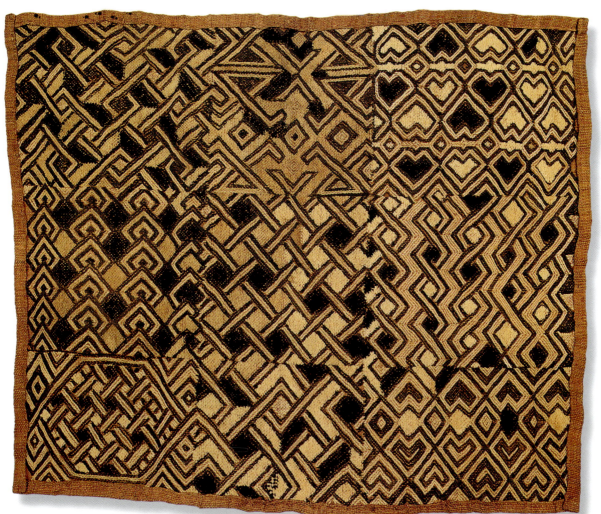
19½" x 23"

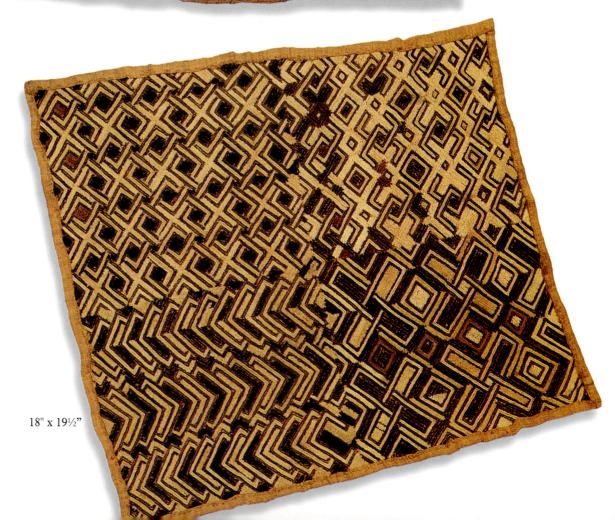
18" x 19½"

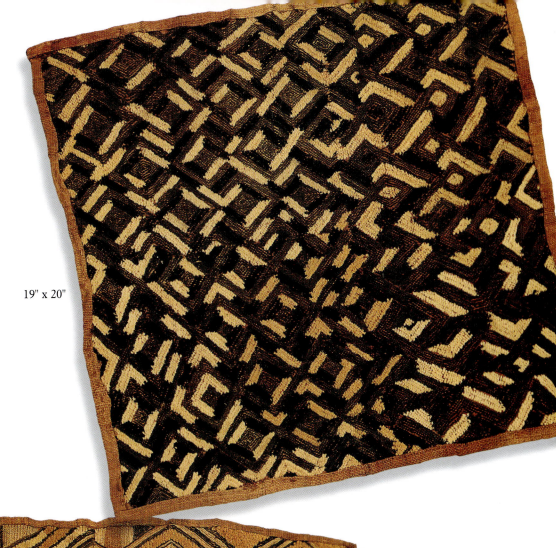

19" x 20"

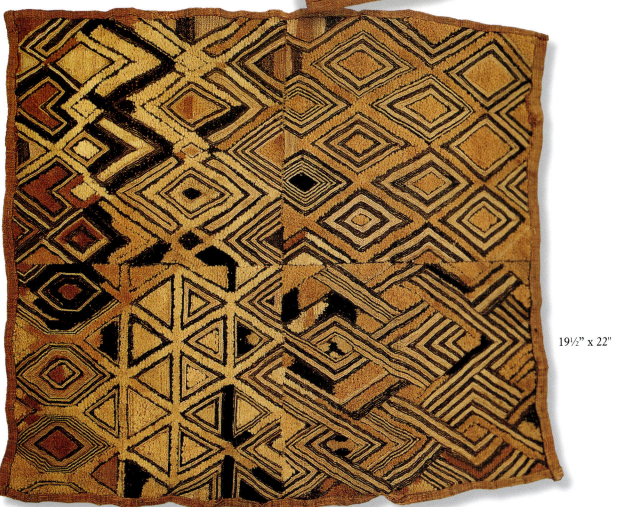

19½" x 22"

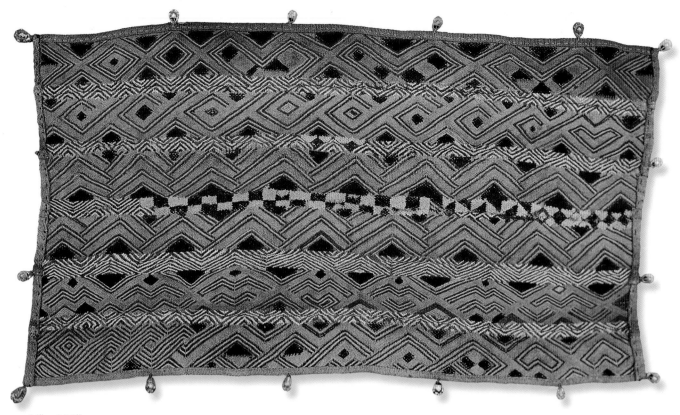

14" x 24½"

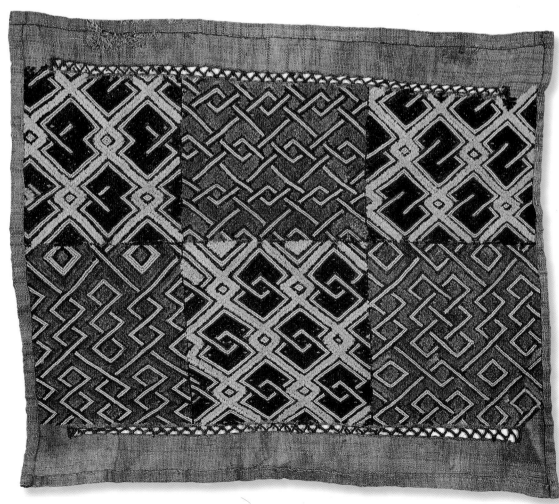

18¾" x 22"

190

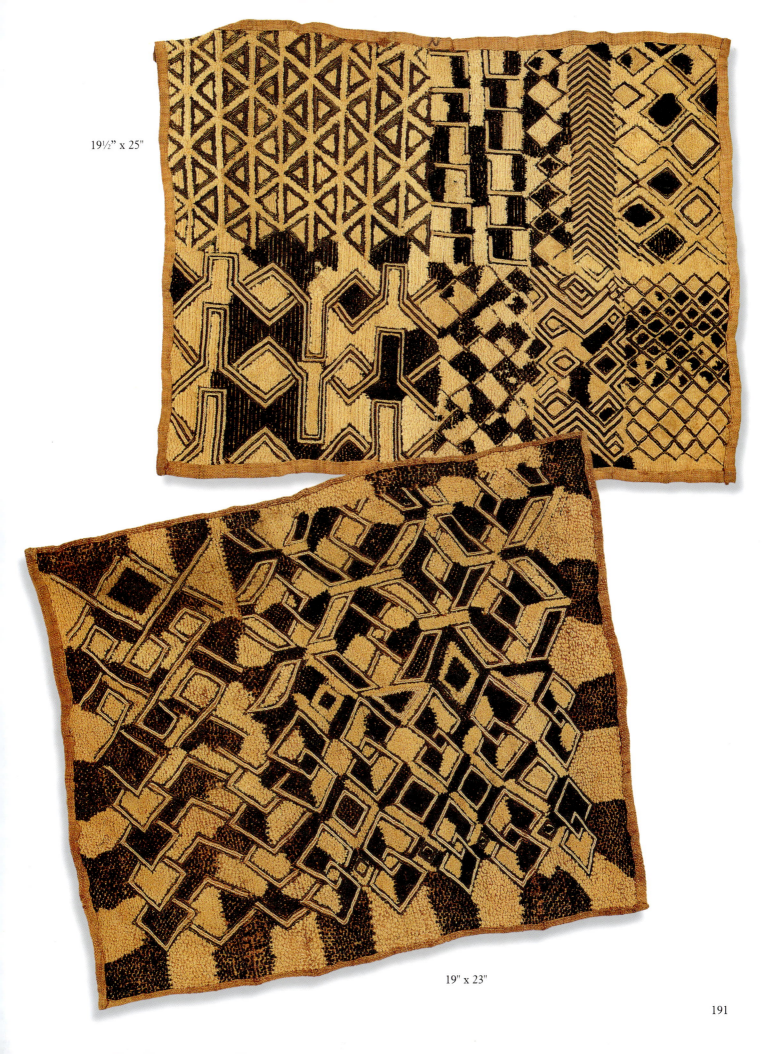

19½" x 25"

19" x 23"

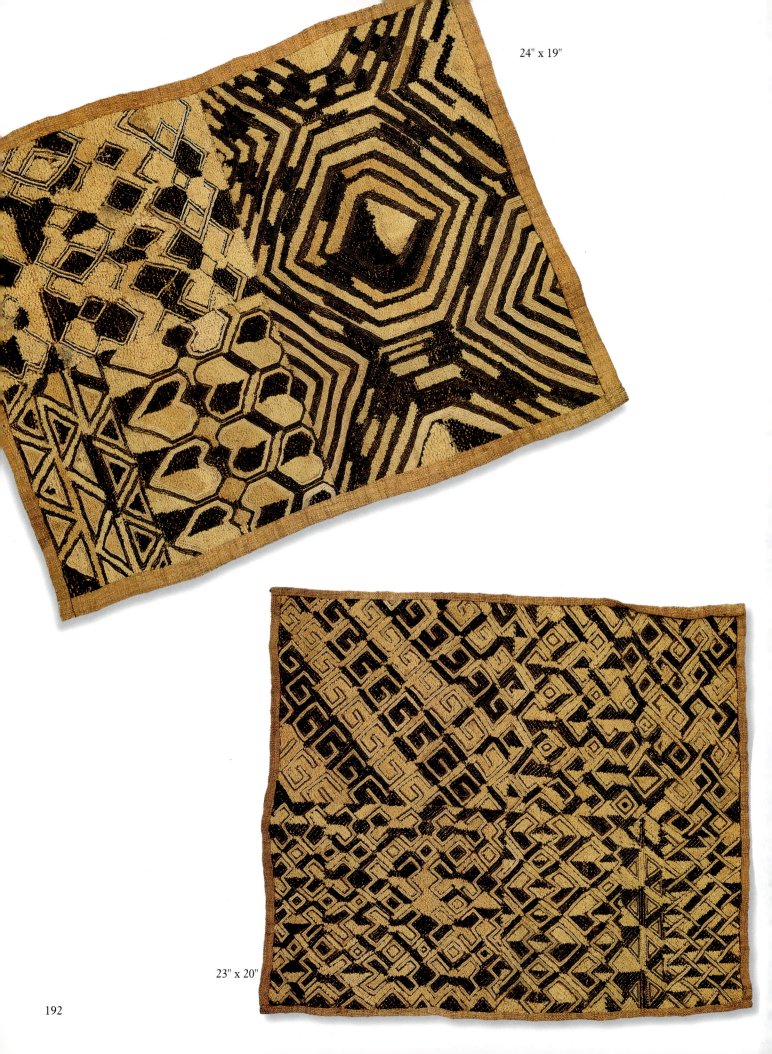

24" x 19"

23" x 20"

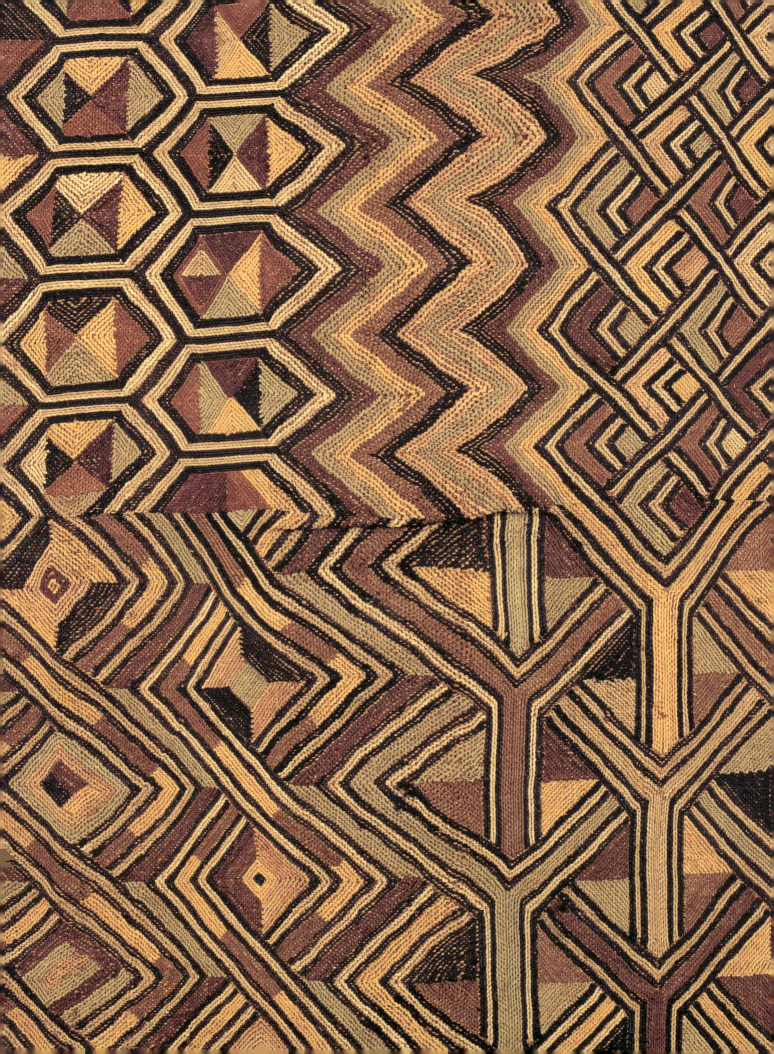